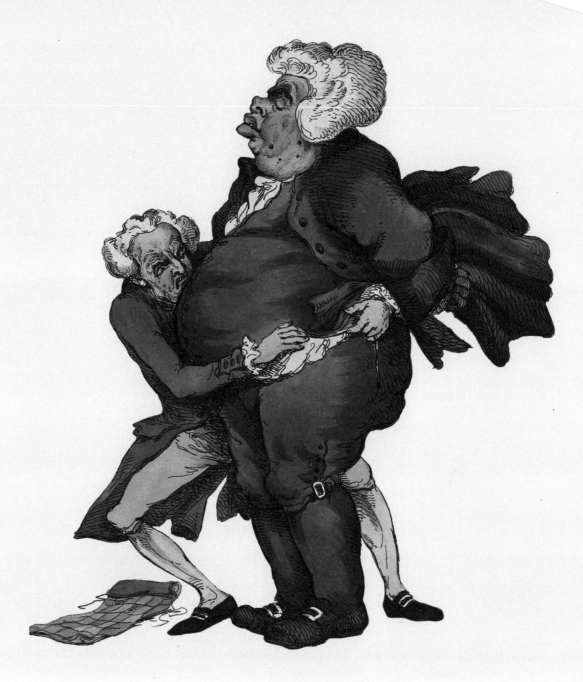

A LITTLE BIGGER, 1791
Thomas Rowlandson (1757–1827)
Hand-coloured etching

There is a charm about the
forbidden that makes it
unspeakably desirable.

MARK TWAIN

Dedicated to my book-loving grandchildren:
Tess, Oonagh, Conrad, Evie, Fraser, and Stanley

Published in 2018 by Unicorn,
an imprint of Unicorn Publishing Group LLP
101 Wardour Street, London W1F 0UG
www.unicornpress.org

Text © Kenneth Baker 2018
Images © as listed on page 236

ISBN 978-1-911604-13-6

Edited by Simon Kerry
Designed and typeset by Baseline Arts Ltd, Oxford
Printed in China for Latitude Press Ltd

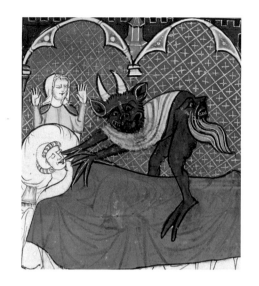

On the Seven Deadly Sins

KENNETH BAKER

UNICORN

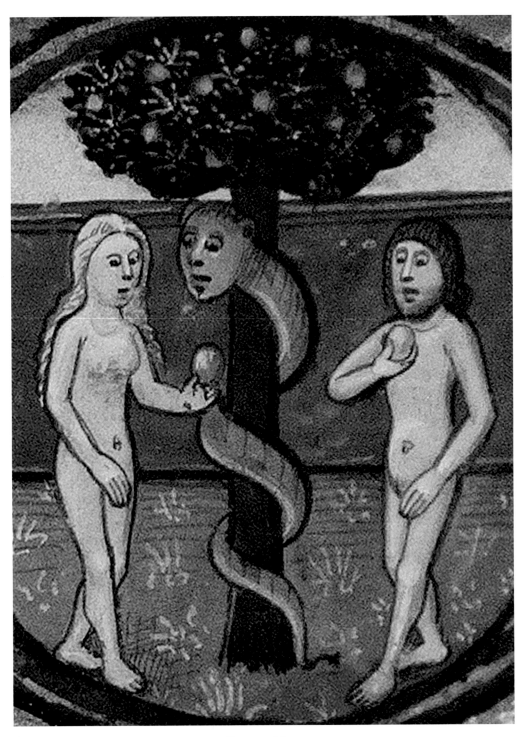

It all started here...

The Temptation of Eve, The Berners Hours, *c.* 1470

Contents

As literal madness is derangement of reason, so sin is derangement of the heart of the spirit, of the affection.

CARDINAL JOHN HENRY NEWMAN (1801–1890)

That deadly sin at doomsday shall undo them all.

Piers Plowman, WILLIAM LANGLAND (1370–1390)

He that once Sins, like him that slides on Ice,
Goes swiftly down the slippery ways of Vice;
Tho' Conscience checks him, yet, those Rubs gone o'er,
He slides on smoothly, and looks back no more;

Satire XIII, DECIMUS JUNIUS JUVENAL (*c.* 55 – *c.* 140)
Translated by Thomas Creech

Introduction

I BECAME AWARE OF THE SEVEN DEADLY SINS RATHER LATE IN LIFE. We were evacuated from the Blitz in London to Southport where I was fortunate to go to a Church of England primary school, which gave me an outstandingly good education. Each day began with a hymn and a prayer, for that was normal in all schools, and we were taken to church twice a year. We did learn about what was right and wrong, for each day we asked God to 'forgive us our trespasses', though these were never called sins and there was no mention of Hellfire and damnation. Neither in my later education nor in the many sermons I have sat through did I hear any mention of them.

It was only when I began collecting political caricatures that I came to the realisation that the cartoonists' victims were all being punished for their bad behaviour – 'sins'. The purpose of a cartoonist is to capture the moment when something silly, stupid, malevolent, careless, wrong, wicked or evil is done by their victims and then to castigate, with humour, their folly and errors. The seven deadly sins were apt signposts for Gillray, Rowlandson and Cruikshank in the late eighteenth and early nineteenth centuries to satirise those who had succumbed to pride, anger, sloth, envy, avarice, gluttony or lust, just as our contemporary cartoonists do today. Occasionally cartoonists want to recognise actions that are noble, courageous or right and portraying the seven virtues may be more suitable. But, in the struggle between sins and virtues, sins have the edge. Gerard Manley Hopkins reflected upon the unending battle against sin which he seldom won:

> Why do Sinners' ways prosper? And why must
> Disappointment all I endeavour end?
> ...Oh, the sots and thralls of lust
> Do in spare hours more thrive than I that spend,
> Sir, life upon thy cause...
> GERARD MANLEY HOPKINS (1844-1889)

Classifying and defining this panoply of bad behaviour and vice was started initially by philosophers and theologians, who made the seven deadly sins a central part of Christianity. Although this concept is rooted in that religion, other faiths that believe in an afterlife also teach ways to live in this world, for the benefit of their souls in the next.

In this book, I explore some aspects of the cultural history and western intellectual thinking on the seven deadly sins. I also try to show, how in today's more secular society, these sins still have some significance and bearing upon our behaviour.

The seven deadly sins were first listed by Pope Gregory in the sixth century and up to the seventeenth century formed a core element of Christian teaching. During that time

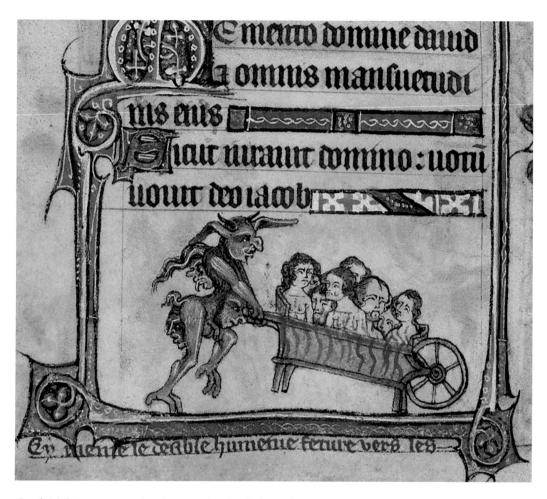

A demon with his cartload,
Taymouth Hours, c. 1350.

the faithful were taught that on the final day of judgement they would be weighed in the balance and if they were found to be sinners they would endure eternal punishment in Hell.

After the sixteenth century Reformation, Roman Catholics accepted a much stricter doctrine of sin than Protestants, but maintained the same belief in Hell, though over the years there was much less concentration on it. In 1996, the Church of England, in a report approved by the Synod, decreed that the traditional images of Hellfire and eternal torment were outmoded and that Hell was a state of un-being.

However, in 2000, a report by the Evangelical Alliance, which was welcomed by the Catholic Church, urged Church leaders to present the Biblical teaching on Hell: 'There are degrees of punishment and suffering in Hell related to the severity of sins committed on earth' and that 'those who through grace have been justified by faith in Jesus Christ will be received into eternal glory', while those who rejected the Gospel will be condemned to Hell. For some Christians, Hell is still a very real punishment, but for many in our secular society, the horrors of Hell simply do not exist. To them, the punishment of sinners happens in this world, not in the next.

Hell by Dieric Bouts (detail), 1450.

Bernard Quaritch Ltd, Catalogue, 2016.

Since the Reformation, science, medicine and psychology have created a secular basis for morality and it is usually governments and not religions which make laws influencing people's behaviour. Governments evaluate what is unacceptable, vicious or evil, and proceed to determine appropriate punishments for them. But, crime continues to rise in most countries throughout the world and politicians are slow to recognise that you can't be tough on crime and tough on the causes of crime, without being tough on sin.

So, in today's more secular society, have the deadly seven been relegated, surviving as a pub quiz question, or a feature in a weekend magazine, or as an amusing dinner party conversation? In 1995, the film *Seven*, starring Brad Pitt and Morgan Freeman, was one of the highest grossing films of that time. In 2016, a leading London bookseller published a whole catalogue on the seven deadly sins, using them as a hook to sell books covering all manner of misbehaviours. In 2017, a Google search produced 1,240,000 results for the seven deadly sins. So, they do linger on, exerting a powerful attraction on human nature, which itself has not changed all that much over the centuries. People today are just as likely to succumb to one of the deadly seven as at any time in the past.

There is a little bit of each of these sins in all of us. We have all experienced occasions when we have been too angry, too greedy, too lazy and too proud, and found that guilt, shame, embarrassment or silent anguish have been our lot. Sins are often difficult to resist because in moderation they can be enjoyed with pleasure. Moreover, it is quite possible

to enjoy such pleasure and not be tarnished by it. A sin becomes deadly when behaviour, which may appear to be natural, is transformed by obsession. Take greed for example. It is acceptable and socially necessary for people to work hard, be creative, innovative and competitive, to earn enough to feed and house their family, and to provide for their old age. However, the acquisition of money becomes a sin when it takes a person over and becomes an end in itself, transforming their personality and bringing in its wake another range of sins: selfishness, miserliness, deceit, deviousness, unscrupulousness and fraud. The same is true of lust. The physical attraction of a man and woman is essential for the continuation of the human race but if that turns into a preoccupation with sexual activity there are inevitable consequences, as Kipling wisely observed, 'for the sins they do by two and two, they must pay for one by one'.

Many people, have argued that the deadly seven are not relevant to the most common personal failings and temptations in society. In, *The Inferno*, Dante added some more sinners to the list.

> Is fraud, the latter sort seems but to cleave
> The general bond of love and Nature's tie;
> So the second circle opens to receive
> Hypocrites, flatterers, dealers in sorcery,
> Panders and cheats, and all such filthy stuff,
> With theft, and simony and barratry.

The Divine Comedy: The Inferno, Canto XI, **DANTE ALIGHIERI** (1265–1321)
Translated by Dorothy L. Sayers.

Simony is the sale of clerical offices and Dante was accused of barratry (the practice of trafficking in public offices), and for that he was exiled from Florence. Today, other misbehaviours compete for recognition, including disloyalty, abuse of children, cruelty, racial or religious bigotry, corruption, treason and revenge. This newer list shifts the emphasis from personal failure to the mutual responsibility that we owe to others. It is indicative of how our moral thinking has developed from personal concern for human weakness to shared concern for the weakness of society in general, for which we may have some responsibility.

It is not just ordinary people who may succumb. The deadly seven can also affect the leaders of a country. In my lifetime I have seen numerous wars launched through their overweening pride or hubris, as the Greeks called it; Hitler launching the battle of Moscow, the Japanese attacking Pearl Harbor, General MacArthur invading North Korea, Saddam Hussein occupying Kuwait and George W. Bush, with his enthusiastic ally Tony Blair, invading Iraq. They all believed themselves to be insuperable champions, and they and the world paid for it.

Buddies in hubris – Adolf
Hitler, preparing to invade
Russia, and Japanese Foreign
Minister, Yosuke Matsuoka,
preparing to attack Pearl
Harbor, March 1941.

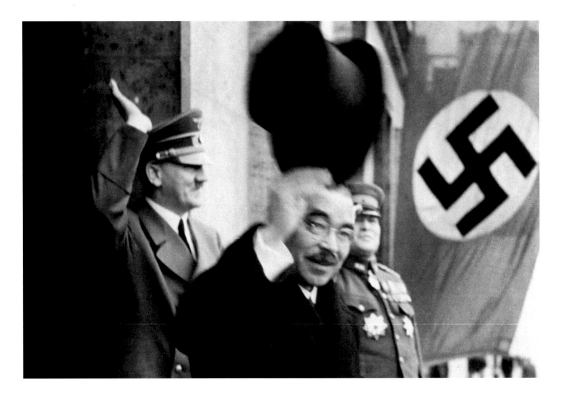

Today 'sins' are multi-faceted with several interpretations. Pride, for example, can be both good and bad. Envy can lead to vicious and vindictive acts, but it can also be a driver to a better standard of living. Anger can be righteous and also unforgivable. Sloth can be wilful laziness but also an amiable trait. Gluttony can be an act of self-harm but it can bring much pleasure and enjoyment. Avarice can be selfish greed but great fortunes can lead to great philanthropy. Of them all, lust is always what it has been; a sin without a better side.

All orders of society have succumbed to lust, including the 'high and mighty', as Arthur Schopenhauer identified:

> [Lust] is the ultimate goal of almost all human endeavour, exerts an adverse influence on the most important affairs, interrupts the most serious business at any hour, sometimes for a while confuses even the greatest minds, does not hesitate with its trumpery to disrupt the negotiations of statesmen and the research of scholars, has the knack of slipping its love-letters and ringlets even into ministerial portfolios and philosophical manuscripts.
> **ARTHUR SCHOPENHAUER** (1788–1860)

I have therefore included in a later chapter two recent cases where distinguished British politicians, one from the House of Lords and one from the House of Commons, have been disgraced through lust.

I don't think even Schopenhauer's prescience could have foreseen what two American Presidents said after they had succumbed to this deadly sin. One admitted it and one tried to deny it:

I have looked on a lot of women with lust, I have committed adultery in my heart many times. This is something that God recognises I will do and I have done it and God forgives me for it.
PRESIDENT JIMMY CARTER interviewed by *Playboy* magazine, November 1976

I did not have sexual relations with that woman, Miss Lewinsky.
PRESIDENT BILL CLINTON, January 1998

In 1996 it was rumoured that President Bill Clinton had had an affair with twenty-two-year-old, White House intern, Monica Lewinsky. At the time both she and Clinton denied having had sex in the Oval Office (dubbed the 'Oral' Office). But in August 1998, Clinton gave a nationally broadcast statement and admitted having 'an improper physical relationship'. He was acquitted on an impeachment charge of perjury and obstruction of justice. The issue came back to haunt the Clintons when in the presidential election of 2016 Donald Trump embarrassed Hilary Clinton by parading several women who claimed that they had had an affair with her husband.

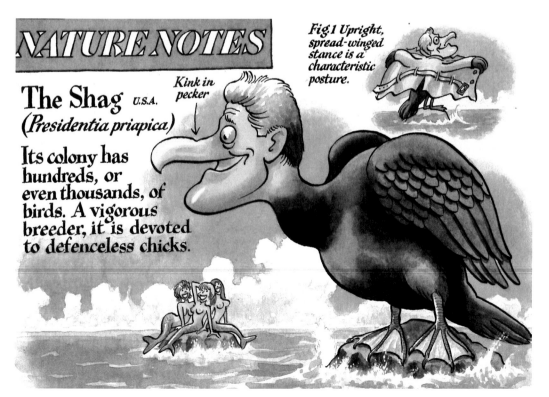

The Shag, Peter Brookes, 1998.

In my political life I have seen the consequences of indulging in one of the deadly seven, bring down Ministers and Members of Parliament:

- some brought down by pride and over-confidence
- some embittered by envy
- some angry at being passed over for promotion
- some seats lost through idleness
- some reputations destroyed by greed, both in and out of office
- some ruined by drink; and
- some ministerial careers ended through lust.

But do not think for a moment that MPs are more susceptible to sin than their constituents. Any group of people, who work or play together and compete with each other will be subject to the temptations of the deadly seven, whether in a business company, a tennis club, a university faculty, a newspaper group, a sporting team, or a trade union.

In this brilliant cartoon by Peter Brookes, the virtuous Theresa May enters No.10 stepping over the dead bodies of her rivals, each of whom was brought down by one of the deadly seven. I leave it to you Dear Reader to decide the different sins to which Boris Johnson, Andrea Leadsom, Michael Gove, Stephen Crabb and David Cameron succumbed and I hope you will be helped in making that decision from the many incidents in this book, and indeed from what you will be able to draw from your own experience.

Red Carpet Treatment, cartoon by Peter Brookes, 2016.

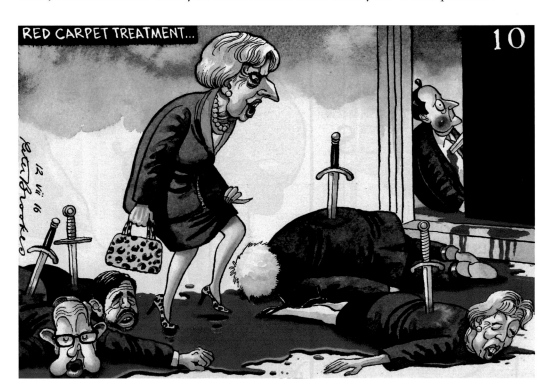

A short history

THE SEVEN DEADLY SINS ARE: PRIDE, ANGER, SLOTH, ENVY, AVARICE, GLUTTONY AND LUST. The first five are spiritual and the final two carnal sins.

Although no list of these sins appears in either the Old or New Testament, Biblical antecedents exist. The Book of Proverbs: Chapter Six, states that the Lord specifically regards, 'six things doth the LORD hate: yea, seven are an abomination unto him.' Ancient precedents for the seven deadly sins can also be found in Greek and Roman culture. These, however, concentrate on stories of the weakness of human nature in terms of the struggle between vices and virtues but not as sins explicitly.

In classical Greece and Rome individuals who chose to sin came to very sticky ends but their punishment was meted out in this world and not the next. Early Christians adapted such Greco-Roman thinking and put the concept of sin at the very centre of their religion. Sin was usually regarded as an attitude of defiance or hatred of God. In their zeal to convert people they taught that the punishment for sin was an everlasting torment in the next world. Hell was no longer a mythical place; it was the real destination of the damned, who would be eternally tormented by demons. Among the Apostles to teach the Gospel of Christ in the first century, St Paul affirmed that all men are implicated in Adam's sin: 'Therefore, as by one man sin entered into the world, and death by sin, so death passed onto all men, for all have sinned.'

St Augustine, in the third century, made use of this idea in developing his own doctrine on Original Sin. He took the view that the sin of Adam was inherited by all human beings and transmitted to his descendants. This concept has been embraced by some and totally rejected by others as a monstrous perversion of God's will.

Shortly before St Augustine achieved renown for his ideas on Original Sin, St Anthony became a leading father of Christian monasticism for his legendary combat against the Devil and temptation. According to his biographer, Athanasius, he spent thirteen years in the western desert of Egypt resisting the temptations of the flesh, food and lust, through prayer and fasting. Alone in the desert there was nothing to be angry about, no one to envy, virtually nothing to covet, little to be proud of and no place for laziness. But the carnal sins of the flesh were ever present.

Evagrius of Pontus, another desert father living in the third century, was the first to formulate a list of sins based on various forms of temptations. Intended for self-diagnosis, the list led by gluttony, contained eight sins: gluttony, lust, avarice, sadness, anger, sloth, vainglory and pride. Pope Gregory the Great, at the end of the sixth century, modified Evagrius's list by merging sadness with sloth, dropping vainglory and introducing envy. Establishing that these sins were the worst vices separating a person

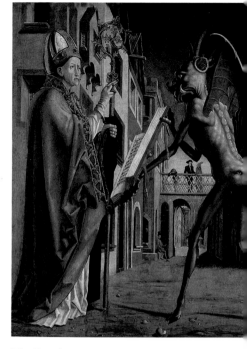

The Devil presenting Saint Augustine with The Book of Vices, Michael Pacher, 15th century.

The Torment of St Anthony, Michelangelo, *c.* 1487–1488.

from God's grace, he ranked them based on the degree from which they offended against love. Pride was the most serious offence and lust the least.

Gregory took sins out of a strictly monastic context and set them right in the centre of Christian teaching. This classification spread quickly through the early Christian Church. It became a simple and easily understandable way to instil the practice of good behaviour in the unlettered congregations across Europe. Everyone from the mightiest kings to the lowliest of peasants was reminded of the punishment of eternal damnation if they succumbed to temptation.

Although the Devil or Satan tempted Christ in the wilderness, his emergence as the ruler of Hell and indeed Hell itself as the penalty for sinning was largely a creation after the sixth century. Up until then the Devil appears in the Bible and other sources under many guises, both human and divine, to challenge men's faith. There is, however, no standard depiction of the Devil before the sixth century when Pope Gregory, having defined the deadly seven, urged his bishops to use iconography, sculpture, poetry and literature to spread the Christian message. The Mystery Plays, Chaucer's poems, Dante's *Inferno* and Milton's *Paradise Lost* created vivid and memorable pictures in which sinners were roasted, frozen, flogged by horned fiends with heavy whips, branded with irons, cut with sharp knives, plunged into vats of boiling oil or lead, gnawed by dogs, rats, savaged by boars with deep fangs and strangled by snakes. Satan ruled in his underworld assisted by a whole army of devils with cloven hooves, horns and reptilian wings. The exact number was a subject for debate. In 1467, a Spanish bishop, Alfonso de Spina, calculated that there were 133,366,616 demons, but a Dutch demonologist a century later reduced this to 4,439,556.

In visual art, Giotto, Memling, Brueghel, Hieronymus Bosch, Dürer, Cranach, Tintoretto and Fra Angelico all produced large, vivid pictures of the horrors that would befall the sinful. Medieval churches carried images of the damned in stained glass windows, in the capitals of columns, in tympanums over the doors of churches and cathedrals. The dangers of sinning were embedded in society. Across Western Europe superstition was manifest and witches, who were regarded as the agents of Satan on earth, were frequently tried and burnt at the stake.

Although the highly influential theologian Thomas Aquinas, contradicted the notion that the seriousness of the seven deadly sins should be ranked, they became the focus of considerable attention within the Catholic Church in the Medieval period, as either venial or mortal sin. They were classified as deadly not only because they constituted serious moral offences, but, also because they triggered other sins and further immoral behaviour. Delivering and saving humankind from such fundamentally negative conditions was offered to those willing to love one another and make a commitment to be good. Given such circumstances, medieval scholars produced guidebooks to serve as manuals for confessors.

Salvation was a bribe to be good. Archbishop Peckham, at the end of the fourteenth century, instructed priests to speak to their parishioners about the seven deadly sins at

Stained-glass Demon, St Mary's Church, Fairford, England, *c.* 1520.

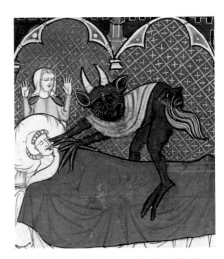

Satan visiting a man on his deathbed,
French miniature, *c.* 1300.

*The Powers of the Cross Protect Saint
Anthony*, Tom Morgan, 1996.

least 'four times a year' in the 'vulgar tongue' rather than Latin, the language of the sacraments. As far as the secular authorities were concerned the deadly seven were an effective way to persuade the lawless to behave and so bolster the coherence of society.

For all Christians, the prospect of being tormented in Hell by demons and serpents was a real possibility. The Devil was always scheming to tempt men and women to commit sins so that he could win their souls. He went under numerous names and was assisted by a whole galaxy of fallen angels: as Lucifer, the angel chosen by God, he was given the whole earth before he usurped God's seat and was thrust out from Heaven; as Satan, the Prince of Darkness, who collected souls in his sack; as Mephistopheles, the subtle seducer of man's vanity; as Belial, the arch-fiend whose sole occupation was the garnering up of sinners, he assumed various cunning disguises often as a serpent or confidant. As if fear of the Devil was not enough, Christians were also taught about the Last Judgement; the day at the end of time when God would decree the fates of all humans according to the good or evil behaviour of their earthly lives.

One of the most dramatic sculptures of the Last Judgement is over the west door of the Cathedral of Autun in Northern Burgundy, later described by Malreaux as 'an epic of Western Christendom'. This tympanum depicts Christ in majesty with St Peter on his right, with angels welcoming the saved souls, and on the left the cloven-hoofed Devil assisted by the Archangel Michael weighing the souls of the damned on a great scale, with those found wanting consigned to Hell. The sculptor of this dramatic carving

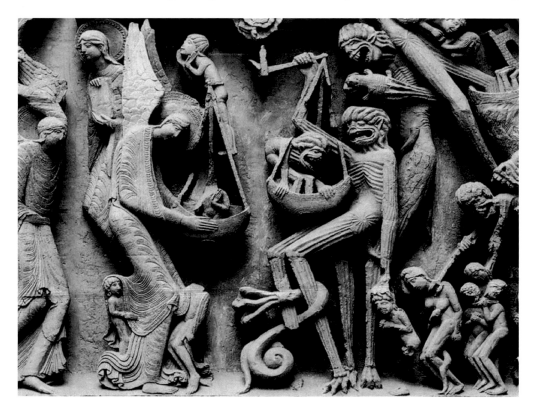

The Tympanum of the Cathedral of Autun.

was so proud that he actually signed his name under Christ, 'Gislerbertus Hoc Fecit'. In the eighteenth century Voltaire jibed at its crudity and in 1766, in a fit of political correctness, the priests of Autun plastered it over and it remained concealed until 1948. This meant that when Talleyrand, Autun's most famous bishop and a well-practiced sinner, made his one and only visit to the city in 1786 he would not have seen it; a disappointment for the Archangel Michael.

The Medieval mind was obsessed with the torment of Hellfire. Nowhere is this more evident than in Chaucer's *Canterbury Tales* where all the pilgrims believe in God, an afterlife, and the possibility of endless torture in Hell. The *Tales*, which include individuals who sin, make a homily on the dangers of sloth, avarice, gluttony, pride, anger, envy and lechery. Many of the Pilgrims travelling to Canterbury are directly involved in the church's mission to save souls including the Prioress, the Second Nun, the Friar, the Monk, the Nun's Priest and the Parson. Also included, operating on the periphery of the church, are the Pardoner, who sells indulgences, and the Summoner, who brings sinners before the ecclesiastical courts. All these pilgrims are supposed to be fighting the Devil and his works; a battered and war-weary army formed up against the deadly seven.

The Medieval church used the deadly seven not only to tighten its grip but also as a source of tax revenue. The Confessional was not enough to secure true forgiveness and so the church sold indulgences by which forgiveness was bought for cash. These were 'get-out-of-purgatory-free' cards. It was this tax gathering that led Martin Luther, a German priest, in 1517, to hammer his ninety-five theses on the door of a Wittenburg church, shattering the certainty and unity of Christianity.

The Reformation, which Luther initiated, changed everything, for it attacked the whole 'mumbo jumbo' which had been so carefully constructed around the deadly seven. The authority of the Roman Catholic Church was challenged by individualism and personal choice. Protestantism, as it developed, condemned immoral behaviour, but adopting a rigid line on personal sins was not at its core. The emerging Protestant traditions of Luther and Calvin and their doctrines on sin influenced the Anglican Church which settled for the simple words of the Anglican Confession: 'We have left undone those things which we ought to have done and we have done those things which we ought not to have done and there is no health in us.'

YANLUO, KING OF HELL

This is a reminder that many other religions accept that there is an afterlife and there is punishment for those who have sinned.

In East Asia and Buddhist mythology Yanluo is the wrathful God who judges the dead and presides over Hell. He is known in every country where Buddhism is practised – China, Korea, Japan, Vietnam, Bhutan, Mongolia, Thailand, Sri Lanka, Cambodia, Myanmar and Laos. In Hinduism the God of the dead is Yama.

Scroll painting of Yanluo presiding over Hell. Chinese Late Qing Dynasty.

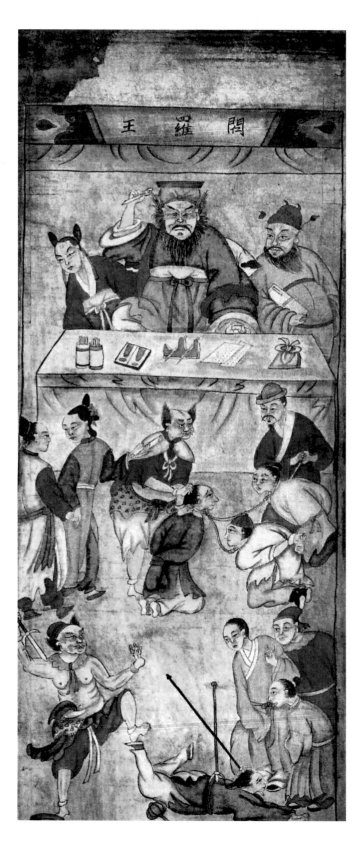

TO THE READER

Folly and error, avarice and vice,
Employ our souls and waste our bodies' force.
As mangey beggars incubate their lice,
We nourish our innocuous remorse.

Our sins are stubborn, craven our repentance.
For our weak vows we ask excessive prices.
Trusting our tears will wash away the sentence,
We sneak off where the muddy road entices.

Cradled in evil, that Thrice-Great Magician,
The Devil, rocks our souls, that can't resist;
And the rich metal of our own volition
Is vaporised by that sage alchemist.

The Devil pulls the strings by which we're worked:
By all revolting objects lured, we slink
Hellwards; each day down one more step we're jerked
Feeling no horror, through the shades that stink.

Just as a lustful pauper bites and kisses
The scarred and shrivelled breast of an old whore,
We steal, along the roadside, furtive blisses,
Squeezing them, like stale oranges, for more.

Packed tight, like hives of maggots, thickly seething
Within our brains a host of demons surges.
Deep down into our lungs at every breathing,
Death flows, an unseen river, moaning dirges.

CHARLES BAUDELAIRE (1821–1867)
Translated by Roy Campbell, *Poems of Baudelaire.*

PRIVATE VICES – PUBLIC BENEFITS

In the eighteenth century, one outspoken defender of the seven deadly sins was Bernard Mandeville. He was born in Holland in 1670 and was trained as a doctor specialising in the treatment of disorders arising from hypochondria and hysteria. He settled in England in the 1690s and published various works challenging some of the most respected ideas concerning social morality and religious ethics. These became popular best-sellers. The work for which he is most remembered is *The Fable of the Bees* which was first published anonymously in 1705, and again in 1714 and 1723. In this intriguing and witty poem he argues that society needs evil and vice to keep it going because from them springs the wider prosperity of the nation.

Human society is likened to a beehive where instinctively busy bees improve life for all other bees by bringing the great benefits of economic activity, markets and social structures. Mandeville suggests that people work because of greed, and keep the law out of cowardice. Avarice, self-interest, envy, vanity and a love of luxury are such driving forces in life that they too can be harnessed into doing good. 'Their crimes conspired to make 'em Great'. This paradoxical poem became very popular and it anticipated the doctrine of Utilitarianism which valued acts on the basis of how happy they made people.

The edition of 1723 occasioned a great deal of critical comment and the Grand Jury of Middlesex condemned the book as a public nuisance. Mandeville rigorously defended his views offering to burn it in public if the jury could find anything that was profane, blasphemous or immoral in it.

The Orgy, Rake's Progress, William Hogarth, 1733.
Ten women were employed in the brothel favoured by Hogarth's rake.

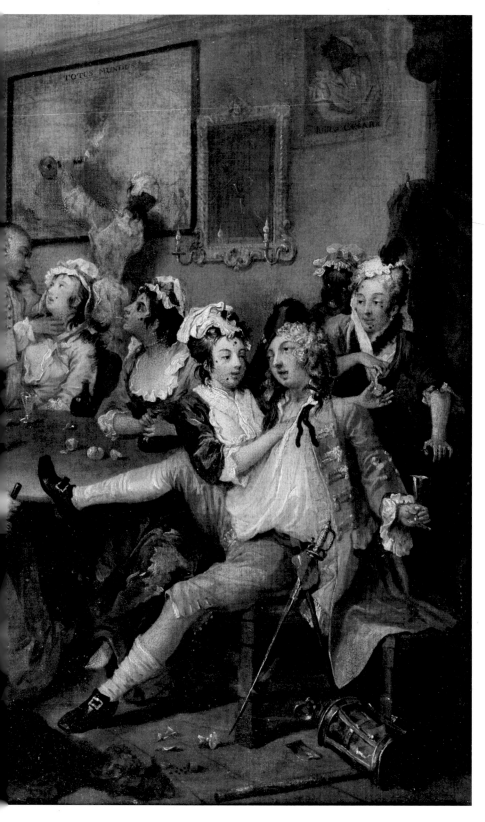

THE FABLE OF THE BEES

Thus every Part was full of Vice,
Yet the whole Mass a Paradice;
Flatter'd in Peace, and fear'd in Wars
They were th'Esteem of Foreigners,
And lavish of their Wealth and Lives,
The Ballance of all other Hives.
Such were the Blessings of that State;
Their Crimes conspired to make 'em Great;
And Virtue, who from Politicks
Had learn'd a Thousand cunning Tricks,
Was, by their happy Influence,
Made Friends with Vice: And ever since
The worst of all the Multitude
Did something for the common Good…
The Root of evil Avarice,
That damn'd ill-natur'd baneful Vice,
Was Slave to Prodigality,
That Noble Sin; whilst Luxury.
Employ'd a Million of the Poor,
And odious Pride a Million more
Envy it self, and Vanity
Were Ministers of Industry;
Their darling Folly, Fickleness
In Diet, Furniture, and Dress,
That strange, ridic'lous Vice, was made
The very Wheel, that turn'd the Trade…
Thus Vice nursed Ingenuity,
Which join'd with Time; and Industry
Had carry'd Life's Conveniencies,
It's real Pleasures, Comforts, Ease,
To such a Height, the very Poor
Lived better than the Rich before;
And nothing could be added more.

BERNARD MANDEVILLE (1670–1722)

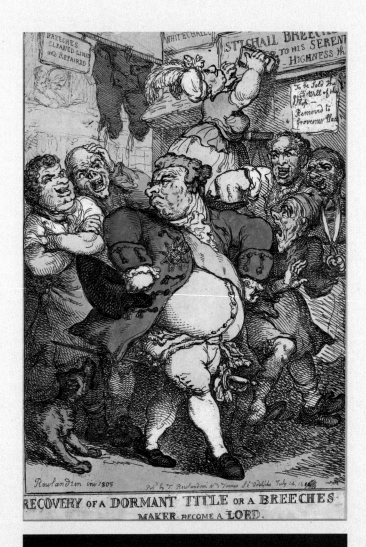

Pride

THE PRIDE OF THE NOUVEAU
Recovery of a Dormant Title or a Breeches Maker
becomes a Lord
Thomas Rowlandson, 1805.

Here we may reign secure, and in my choyce
To reign is worth ambition though in Hell
Better to reign in Hell: than serve in Heav'n.

Paradise Lost: Book I, **JOHN MILTON** (1608–1674)

Yes, I am proud: I must be proud, to see
Men not afraid of God, afraid of me.

ALEXANDER POPE (1688–1744)

– E'en then would be some stooping; and I chose
Never to stoop.

My Last Duchess, Section IV, **ROBERT BROWNING** (1812–1889)

Ante ruinam exaltatur – before destruction, the heart of man is exalted.

SAINT AUGUSTINE (354–430)

The devilish strategy of Pride is that it attacks us, not in our weakest points, but
in our strongest. It is preeminently the sin of the noble mind.

DOROTHY L. SAYERS (1893–1957)

Pride has always been one of my favourite virtues.
A proper pride is a necessity to an artist.

EDITH SITWELL (1887–1964)

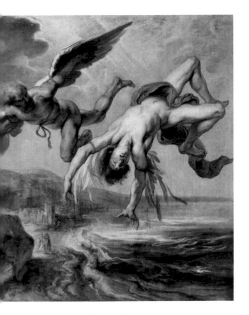

The Fall of Icarus,
Jacob Peter Gowy, 1636–38).

Icarus's father Daedalus
fashioned some wings from
feathers and wax so they could
escape from the Isle of Crete.
Icarus was told not to fly too
close to the sun as the heat
would melt the wax, which is
exactly what he did, and he fell
to his death in the sea below.
Pride came before the fall.

For many people today, pride is a virtue to be cherished and not a sin to be resisted. Pride drives athletes to reach for the Olympic medal, students to strive for better results, football fans to follow passionately their team and soldiers to die for their country. Black Pride and Gay Pride have made tens of millions more understood and more accepted, and they have rolled back the tides of prejudice, bigotry and hatred.

However, the writers and philosophers of Classical Greece and the early Christian Fathers were in no doubt that pride was the most grievous sin, precipitating disaster and damnation. In Greek tragedy, arrogant mortals who defied and challenged the gods, displayed excessive pride, or hubris. Such behaviour was followed by peripeteia (a reversal of fortune) and ultimately nemesis (divine retribution). History is crammed with stories where this happens.

The Old Testament was crystal clear: 'Pride goeth before destruction and a haughty spirit before a fall.' St Augustine maintained that pride was the commencement of sin, for man's judgement challenged God's authority and it was this that led Adam and Eve to disobey and be cast out of Eden. Thomas Aquinas took a similar view saying it was pride that turned man away from God and was the source of all the other sins. It was Lucifer's pride that drove him to abandon God in his Heaven. Milton, in *Paradise Lost*, beautifully captured this moment, giving Lucifer the famous phrase, 'Better to reign in Hell than serve in Heaven'. Later in the twentieth century, C.S. Lewis also emphasised the overwhelming significance of this sin, 'Pride leads to every other vice. It is the complete anti-God state of mind'.

Pope Gregory, in marshalling the list of the seven, put pride (in Latin *superbia*), at the top displacing gluttony, which had held that position in an earlier list. He condemned the arrogance of man 'who favours himself in his thoughts and walks with himself along the broad spaces of his thought and silently utters his own praise'. This interpretation is still recognised as an essential element in many of the world's religions but it also emerges strongly in the current debates on social policy. The opponents of abortion and of assisted dying believe that as God's greatest gift is the granting of life, it is God who should decide when it should end, not proud man.

DR ROWAN WILLIAMS, the former Archbishop of Canterbury, an outstanding theological writer, scholar and teacher is quoted as saying:

> The worst sin? No contest: it has always been seen as pride – that is the determination to put yourself at the centre of everything, to deny you depend on others and others on you; to behave as if you had the power to organise reality to suit yourself in every way. All the specific sins in matters of sex and money and personal relations and unfair structures, have their roots in this, one way or another.

The former Chief Rabbi, DR JONATHAN SACKS, takes a similar view:

> Sin means doing what I want while ignoring what you want, pursuing my pleasure even if it causes you pain... Sin means listening to the I but not the thou.

The essence of the sin of pride is disobedience and when carried to the extreme, leads to rebellion. It should be noted that it is the only sin that has this consequence. There are many examples of this from the disobedience of Satan to God to the disobedience of Martin Luther to the Catholic Church. Disobedience and the elevation of self is a road with two forks. One that is good leads to self-esteem and one that is bad leads to arrogance, self-aggrandisement and vainglory. The suicide bombers of Daesh were so proud of their religion, their prophet, their sharia, their cause and their control of over five million people in the lands they once occupied, that they will vaingloriously video themselves before committing suicide.

There is also military hubris. Alistair Horne in his brilliant book, *Hubris*, shows how five wars in the first half of the twentieth century were caused by the overweening pride of leaders and countries convinced that they were invulnerable, racially superior and chosen to be victorious. Japan's remarkable victory over Russia in 1905 created an illusion of racial superiority and military invincibility and opened the way to its attack on Pearl Harbor and the conquest of much of South East Asia. It also led to its nemesis with two atom bombs in 1945.

Similar hubris overtook Hitler when he decided to invade Russia and it overtook General MacArthur, who following his successful victory in South Korea, decided to cross the 38th parallel and invade North Korea. Disagreements over foreign policy in Korea led to him being sacked by President Truman, nicknamed the Missouri haberdasher. A further story of hubris rings true of Israel with its triumph in the Six Day War of 1967 and its nemesis in the Yom Kippur War in 1973.

BELSHAZZAR'S FEAST

The history of Belshazzar's feast in 539 BC, which was recorded by Daniel and later put into verse by Chaucer, originated many years earlier after the capture of Jerusalem by the Assyrian King, Nebuchadnezzar. Over 10,000 Jews, including Daniel himself, Shadrach, Meshach and Abednego were abducted and placed in captivity in Babylon. The prophet Jeremiah prophesied that Judah's captivity in Babylon would last seventy years. In that very year Belshazzar was co-regent of Babylon and his kingdoms were under attack by Cyrus the Great of Persia and Darius the Mede, who were extending their empire from the Indus Valley to the Mediterranean. Belshazzar supposed that the walls of Babylon were impregnable and in arrogant disdain he arranged a great feast and ordered that the sacred vessels, that had been seized from the temple of Jerusalem by Nebuchadnezzar,

should be brought to his table so that he, his wives and his concubines could drink wine from them. This blasphemous act was punished by a huge hand writing on the wall in Aramaic, 'Mene, Mene Tekel Upharsin', which was translated by Daniel, then an old man, foretelling the destruction of Belshazzar and his kingdom – 'God hath numbered thy kingdom, and finished it. Thou art weighed in the balances, and art found wanting. Thy kingdom is divided, and given to the Medes and Persians.' That night the forces of Cyrus and Darius burst through the city walls and killed Belshazzar, and after this victory they allowed the Jews to return to Jerusalem to rebuild their temple.

Belshazzar's Feast, Rembrandt, *c.* 1636.

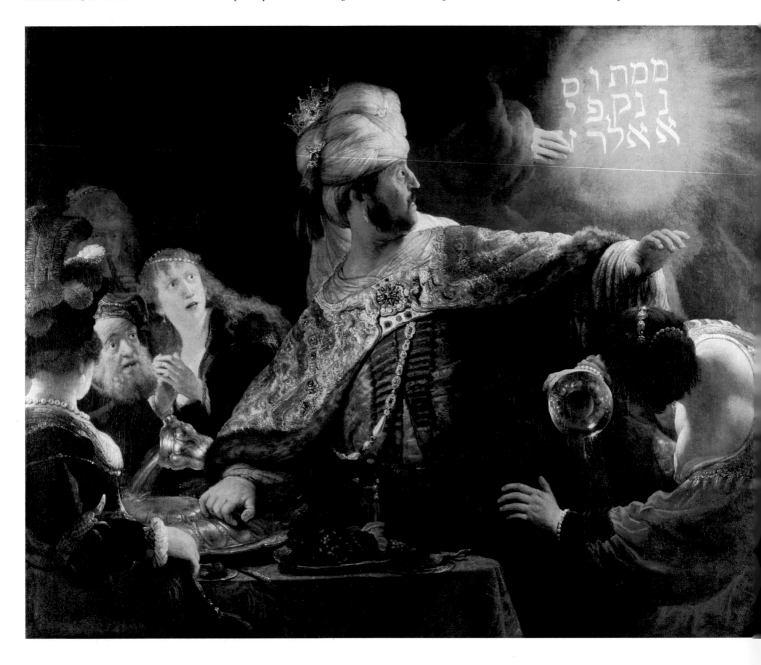

BELSHAZZAR

He had a son, Belshazzar was his name,
Who held the throne after his father's day,
But took no warning from him all the same,
Proud in his heart and proud in his display,
And an idolater as well, I say.
His high estate on which he so had prided
Himself, by Fortune soon was snatched away,
His kingdom taken from him and divided.

He made a feast and summoned all his lords
A certain day in mirth and minstrelsy,
And called a servant, as the Book records,
'Go and fetch forth the vessels, those,' said he,
'My father took in his prosperity
Out of the Temple of Jerusalem,
That we may thank our gods for the degree
Of honour he and I have had of them.'

His wife, his lords and all his concubines
Drank on as long as appetite would last
Out of these vessels, filled with sundry wines.
The king glanced at the wall; a shadow passed
As of an armless hand, and writing fast.
He quaked for terror, gazing at the wall;
The hand that made Belshazzar so aghast
Wrote *Mene, Tekel, Peres*, that was all.

In all the land not one magician there
Who could interpret what the writing meant;
But Daniel soon expounded it, 'Beware,
He said, 'O king! God to your father lent
Glory and honour, kingdom, treasure, rent;
But he was proud and did not fear the Lord.
God therefore punished that impenitent
And took away his kingdom, crown and sword.

... 'That hand was sent of God, that on the wall
Wrote Mene, Tekel, Peres, as you see;
Your reign is done, you have been weighed, and fall;
Your kingdom is divided and shall be
Given to Persians and to Medes,' said he.
They slew the King Belshazzar the same night,
Darius took his throne and majesty,
Though taking them neither by law nor right.

My lords, from this the moral may be taken
That there's no lordship but is insecure.
When Fortune flees a man is left forsaken
Of glory, wealth and kingdom; all's past cure.
Even the friends he has will not endure,
For if good fortune makes your friends for you
Ill fortune makes them enemies for sure,
A proverb very trite and very true.

Canterbury Tales, GEOFFREY CHAUCER (1343–1400)

CORIOLANUS

'What's the matter you dissentious rogues'

Gaius Marcius was the great Roman general who was given the name Coriolanus after he had driven the Volscians from the town of Corioli. But, in the first scene of the play, even before the battle, he shows his utter contempt for the ordinary plebeians of Rome.

Mar. Thanks. What's the matter, you dissentious rogues,
That rubbing the poor itch of your opinion,
Make yourselves scabs?

First Cit. We have ever your good word.

Mar. He that will give good words to thee will flatter
Beneath abhorring. What would have, you curs,
That like nor peace nor war? The one affrights you,
The other makes you proud. He that trusts to you,
Where he should find you lions, finds you hares;
Where foxes, geese: you are no surer, no,
Than is the coal of fire upon the ice,
Or hailstone in the sun. Your virtue is
To make him worthy whose offence subdues him,
And curse that justice did it.
Who deserves greatness
Deserves your hate; and your affections are
A sick man's appetite, who desires most that
Which would increase his evil. He that depends
Upon your favours swims with fins of lead,
And hews down oaks with rushes. Hang ye! Trust ye?
With every minute you do change a mind,
And call him noble that was now your hate,
Him vile that was your garland…

Act 1, Scene 1, *The Tragedy of Coriolanus*
WILLIAM SHAKESPEARE (1564–1616)

THE PRIDE OF LUCIFER

Better to reign in hell, than serve in heav'n

Is this the Region, this the Soil, the Clime,
Said then the lost Arch-Angel, this the seat
That we must change for Heav'n, this mournful gloom
For that celestial light? Be it so, since he
Who now is Sovran can dispose and bid
What shall be right: fardest from him is best
Whom reason hath equald, force hath made supream
Above his equals. Farewel happy Fields
Where Joy for ever dwells: Hail horrours, hail
Infernal world, and thou profoundest Hell
Receive thy new Possessor: One who brings
A mind not to be chang'd by Place or Time.
The mind is its own place, and in it self
Can make a Heav'n of Hell, a Hell of Heav'n.
What matter where, if I be still the same,
And what I should be, all but less than he
Whom Thunder hath made greater? Here at least
We shall be free; th'Almighty hath not built
Here for his envy, will not drive us hence:
Here we may reign secure, and in my choyce
To reign is worth ambition though in Hell:
Better to reign in Hell, than serve in Heav'n.
But wherefore let we then our faithful friends,
Th'associates and copartners of our loss
Lye thus astonish on th' oblivious Pool,
And call them not to share with us their part
In this unhappy Mansion, or once more
With rallied Arms to try what may be yet
Regained in Heav'n, or what more lost in Hell?

Paradise Lost, Book I, JOHN MILTON

CAST OUT OF HEAVEN

Him the Almighty Power
Hurled headlong flaming from th'ethereal sky,
With hideous ruin and combustion, down
To a bottomless perdition, there to dwell
In adamantine chains and penal fire,
Who durst defy th'Omnipotent to arms.

Paradise Lost, Book I, JOHN MILTON

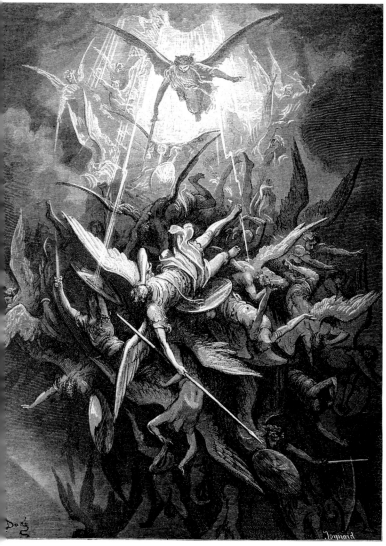

Michael Casts Out All Of The Fallen Angels, Gustave Doré, 1866.

LUCIFER BROODS

It is quite simple –
If God could be god
Why couldn't I?

All I asked for
Was equality and independence,
Primus inter pares –
With not too many *pares.*
A rotating chairmanship
Might have been the answer.

What happened to the question?

Better to reign in hell than serve in heav'n –
But better still to reign in both.

What, you might ask, is the point of it all?
Seduction, corruption, ruination –
All this hard labour I put in,
Day after night after day

– The solace of having companions …

Companions! Do these lost souls
Imagine they're as good as me?
Damn their eyes!

So I am the Spirit who always says No?
Once I was ready to say Oh yes!'

'I do wish he would stop brooding in my head …
Where are the aspirins?' Mephisto whispered.
'God knows!' yelled Meretrix.

Telling Tales: A Faust Book, DENNIS JOSEPH ENRIGHT
(1920–2002)

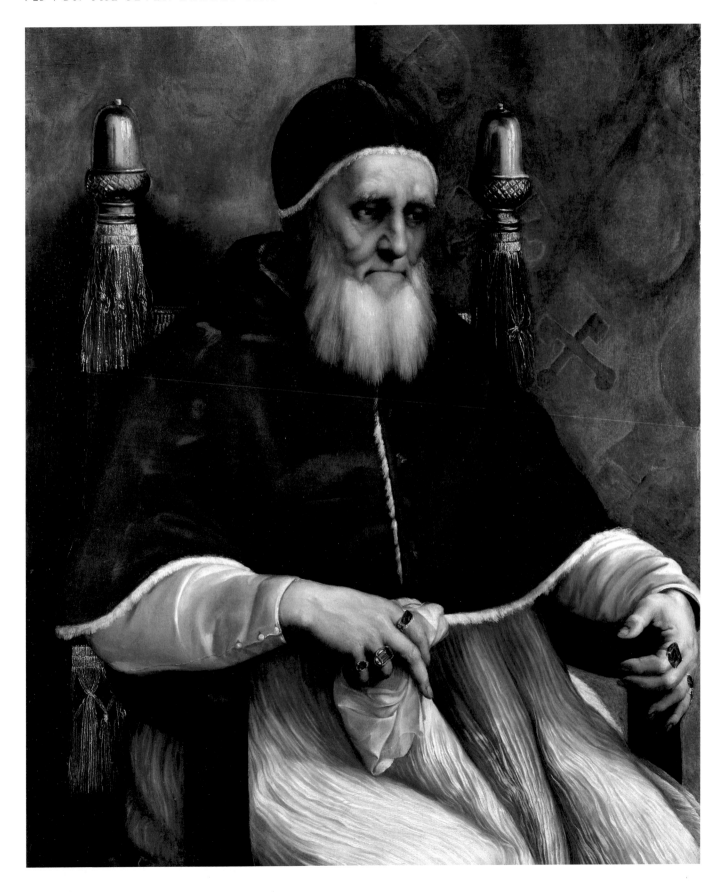

POPE JULIUS II: 'THE WARRIOR POPE'

… I have done more for the Church and Christ than any pope before me… I annexed Bologna to the Holy See, I beat the Venetians. I jockeyed the duke of Ferrara. I defeated a schismatical council by a sham council of my own. I drove the French out of Italy, and I would have driven out the Spaniards, too, if the Fates had not brought me up here. I have set all the princes of Europe by the ears. I have torn up treaties, kept great armies in the field, I have covered Rome with palaces… And I have done it all myself, too. I owe nothing to my birth, for I don't know who my father was; nothing to learning, for I have none; nothing to youth, for I was old when I began; nothing to popularity, for I was hated all round… This is the modest truth, and my friends in Rome call me more god than a man.

Julius Exclusus, DESIDERIUS ERASMUS (1466–1536)

Julius II, the Pope from 1503–1513, did virtually nothing to respond to the growing clamour for the reform of the abuses of the church. Known as 'the Warrior Pope', because of his inclination towards war, most of his papacy was spent in resisting the invasion of the Papal States by Louis XII of France, whose army, in 1513, was close to conquering northern Italy when it suffered a severe defeat at the hands of Swiss mercenaries at the battle of Novarra. Rome burst into celebration at the sight of the French fleeing. Julius, who had died shortly before the battle, was hailed as the saviour of Italy, and honoured because he had freed the Holy League from the detested French. Erasmus offered a contrary view, penning a satirical dialogue called *Julius Exclusus*. In this passage Julius put his case to St Peter at the pearly gates.

In one of Erasmus' most famous satires, *Julius Excluded*, the highly militaristic pope of the time, Julius II, is shown, just after death, standing at the gates of heaven, military armour under his papal robes, demanding that St Peter open the door and roll out the red carpet. Julius has in his hand a huge golden key but unfortunately it doesn't fit – it turns out to be the key of worldly power, not a key to the kingdom of heaven. Despite Julius's furious demands to clear the way, Peter – though only a mere fisherman, as Julius has pointed out – won't budge. 'I admit only those,' Peter tells Julius, 'who clothe the naked, feed the hungry, give drink to the thirsty, visit the sick and those in prison.'

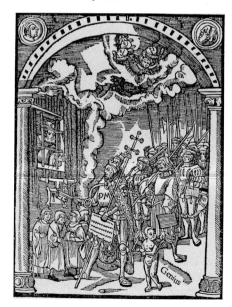

Pope Julius II,
Raphael, 1511.

WRITTEN UNDER A PICTURE OF A PEACOCK

'Beauty breeds pride'

The bird of Juno glories in his plumes;
Pride makes the fowl to prune his feathers so.
His spotted train, fetched from old Argus' head,
With golden rays like to the brightest sun,
Inserteth self-love in a silly bird,
Till, midst his hot and glorious fumes,
He spies his feet, and then lets fall his plumes.
Beauty breeds pride, hatcheth forth disdain,
Disdain gets hate, and hate calls for revenge,
Revenge with bitter prayers urgeth still;
Thus self-love, nursing up the pomp of pride,
Makes beauty wrack against an ebbing tide.

ROBERT GREENE (*c.* 1560–1592)

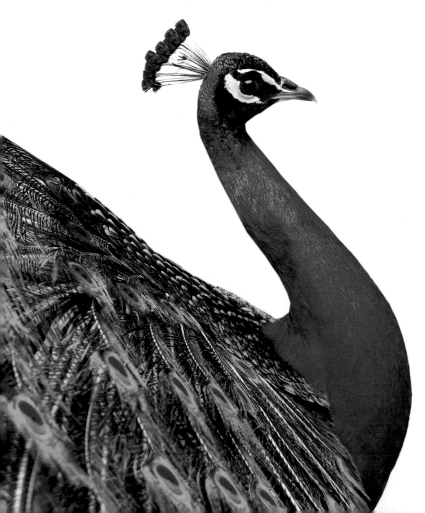

AS IF SHE RANKED MY GIFT OF A NINE-HUNDRED-YEARS-OLD NAME WITH ANYBODY'S GIFT

That's my last Duchess painted on the wall,
Looking as if she were alive. I call
That piece a wonder, now; Fra Pandolf's hands
Worked busily a day, and there she stands.
Will't please you sit and look at her? I said
'Fra Pandolf' by design, for never read
Strangers like you that pictured countenance,
The depth and passion of its earnest glance,
But to myself they turned (since none puts by
The curtain I have drawn for you, but I)
And seemed as they would ask me, if they durst,
How such a glance came there; so, not the first
Are you to turn and ask thus. Sir, 'twas not
Her husband's presence only, called that spot
Of joy into the Duchess' cheek; perhaps
Fra Pandolf chanced to say, 'Her mantle laps
Over my lady's wrist too much,' or 'Paint
Must never hope to reproduce the faint
Half-flush that dies along her throat.' Such stuff
Was courtesy, she thought, and cause enough
For calling up that spot of joy. She had
A heart – how shall I say? – too soon made glad,
Too easily impressed; she liked whate'er
She looked on, and her looks went everywhere.
Sir, 'twas all one! My favour at her breast,
The dropping of the daylight in the West,
The bough of cherries some officious fool
Broke in the orchard for her, the white mule
She rode with round the terrace – all and each
Would draw from her alike the approving speech,
Or blush, at least. She thanked men – good! but thanked
Somehow – I know not how – as if she ranked
My gift of a nine-hundred-years-old name
With anybody's gift. Who'd stoop to blame
This sort of trifling? Even had you skill
In speech – which I have not – to make your will

Quite clear to such an one, and say, 'Just this
Or that in you disgusts me; here you miss,
Or there exceed the mark' – and if she let
Herself be lessoned so, nor plainly set
Her wits to yours, forsooth, and made excuse –
E'en then would be some stooping; and I choose
Never to stoop. Oh, sir, she smiled, no doubt,
Whene'er I passed her; but who passed without
Much the same smile? This grew; I gave commands;
Then all smiles stopped together. There she stands
As if alive. Will't please you rise? We'll meet
The company below, then. I repeat,
The Count your master's known munificence
Is ample warrant that no just pretense
Of mine for dowry will be disallowed;
Though his fair daughter's self, as I avowed
At starting, is my object. Nay, we'll go
Together down, sir. Notice Neptune, though,
Taming a sea-horse, thought a rarity,
Which Claus of Innsbruck cast in bronze for me!

My Last Duchess, ROBERT BROWNING

In this drama-filled poem, Robert Browning was almost
certainly writing about Alfonso II, the fifth Duke of
Ferrara. His first wife was Lucrezia, daughter of Cosimo
I de Medici, whom he married in 1558 when he was
twenty-five and she was fourteen years old. She died in
1561 and there was suspicion that she had been poisoned.
After her death, Alfonso wished to marry Barbara,
daughter of Ferdinand I. Acting as the intermediary
for the arranged marriage, was Nikolaus Madruz of
Innsbruck. Alfonso, with his illustrious aristocratic
lineage, would probably have looked upon the Medicis
as relatively 'nouveau upstarts'. A similar attitude is
found in the second part of *The Divine Comedy* where
Dante meets in purgatory a proud noble, Omberto Aldo
Brandesco:

My ancient lineage, the gallant deeds
of my forebears had made me arrogant:
forgetful of our common Mother Earth,
I held all men in such superb disdain,
I died for it, as all Siena knows
and every child in Compagnatico.
I am Omberto. And the sin of Pride
has ruined not only me but all my house,
dragging them with it to calamity.

The Divine Comedy: Purgatory, Canto XI,
DANTE ALIGHIERI – translated by Mark Musa.

Alfonso II d'Este, Girolamo da Carpi, 16th century.

'SHALL OUR BLOOD, THE ROYAL BLOOD OF ARRAGON AND CASTILE BE THUS ATTAINTED?'

Webster based his play, *The Duchess of Malfi*, upon a Spanish-Italian family. The Duchess had noble, if not royal, blood in her veins, being the granddaughter of Ferdinand I of Naples. One of her brothers became the Cardinal of Aragon and another, Ferdinand, was the Duke of Calabria. Married off at an early age to a much older man, she is widowed at the age of twenty. Subsequently she falls in love and has children with her steward, Antonio. Although Antonio comes from a professional and academic family, the Duchess's brothers regard this as a blow to their family pride and they plot to destroy their sister using as their tool the vilest villain in any Jacobean drama; Bosola. In this scene Ferdinand's perception of his own superiority allows him to dismiss Antonio in the classic description of an accountant:

Act 3, Scene 3

Ferd. Antonio?
A slave, that only smelled of ink, and counters,
And ne'er in's life, looked like a gentleman
But in the audit time – Go, go presently,
Draw me out an hundredth and fifty of our horse,
And meet me at the foot bridge.

The murdering brothers are not, however, entirely motivated by family pride, for with their sister and her children out of the way they can inherit her vast estates.

Act 2, Scene 5

Enter Cardinal, and Ferdinand, with a letter.

Ferd. I have this night digg'd up a mandrake.
Card. Say you?
Ferd. And I am grown mad with't.
Card. What's the prodigy?

Ferd. Read there – a sister damn'd: she's loose i'th'hilts,
Grown a notorious strumpet.
Card. Speak lower.
Ferd. Lower!
Rogues do not whisper't now, but seek to publish't,
(As servants do the bounty of their Lords)
Aloud; and with a covetuous searching eye,
To mark who note them: Oh confusion seize her!
She hath had most cunning bawds to serve her turn,
And more secure conveyances for lust
Than towns of garrison, for service.
Card. Is't possible?
Can this be certain?
Ferd. Rhubarb, oh, for rhubarb
To purge this choler! Here's the cursèd day
To prompt my memory; and here't shall stick
Till of her bleeding heart, I make a sponge
To wipe it out.
Ferd. Why do you make yourself
So wild a tempest?
Ferd. Would I could be one,
That I might toss her palace 'bout her ears,
Root up her goodly forests, blast her meads,
And lay her general territory as waste,
As she hath done her honours.
Card. Shall our blood
(The royal blood of *Arragon*, and *Castile*)
Be thus attainted?
Ferd. Apply desperate physic:
We must not now use balsamum, but fire,
The smarting cupping-glass, for that's the mean
To purge infected blood, such blood as hers
There is a kind of pity in mine eye,
I'll give it to my handkercher, and now 'tis here,
I'll bequeath this to her bastard.
Card. What to do?
Ferd. Why, to make soft lint for his mother's wounds,
When I have hew'd her to pieces.

The Duchess of Malfi, JOHN WEBSTER (*c.* 1580–1634)

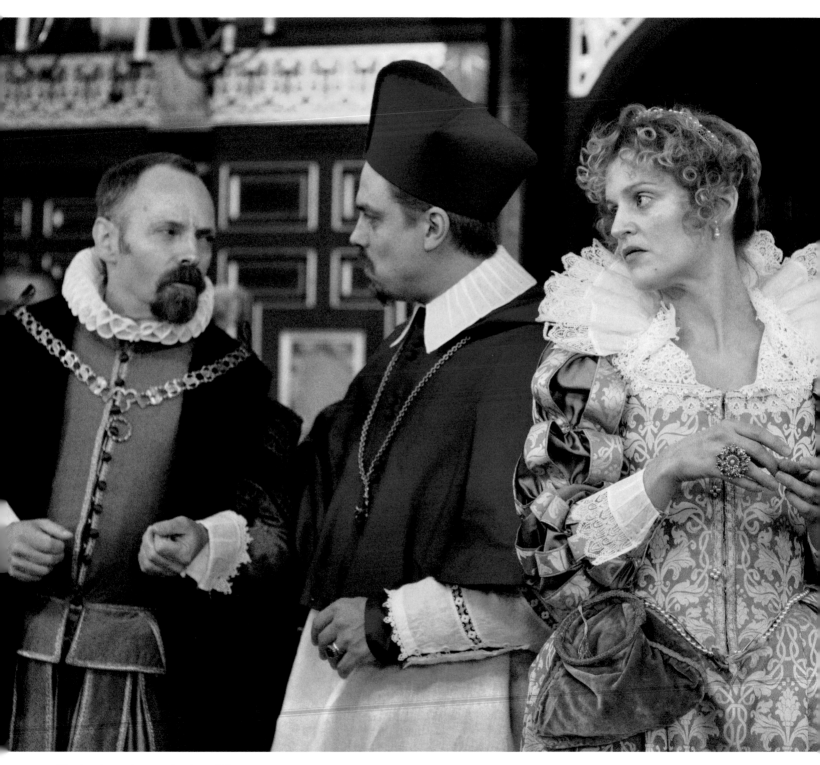

The brothers plotting the downfall.
The Duchess of Malfi performed at the Sam Wanamaker
Playhouse, London, 2014.

THE CONCEIT OF BEAUTY

Beauty accurst

I am so fair that wheresoe'er I wend
Men yearn with strange desire to kiss my face,
Stretch out their hands to touch me as I pass,
And women follow me from place to place.

A poet writing honey of his dear
Leaves the wet page, – ah! leaves it long to dry.
The bride forgets it is her marriage-morn,
The bridegroom too forgets as I go by.

Within the street where my strange feet shall stray
All markets hush and traffickers forget,
In my gold head forget their meaner gold,
The poor man grows unmindful of his debt.

Two lovers kissing in a secret place,
Should I draw nigh, – will never kiss again;
I come between the king and his desire,
And where I am all loving else is vain.

Lo! when I walk along the woodland way
Strange creatures leer at me with uncouth love,
And from the grass reach upward to my breast,
And to my mouth lean from the boughs above.

The sleepy kine move round me in desire
And press their oozy lips upon my hair,
Toads kiss my feet and creatures of the mire,
The snails will leave their shells to watch me there.

But all this worship, what is it to me?
I smite the ox and crush the toad in death:
I only know I am so very fair,
And that the world was made to give me breath.

I only wait the hour when God shall rise
Up from the star where he so long hath sat,
And bow before the wonder of my eyes
And set me there – I am so fair as that.

RICHARD LE GALLIENNE (1886–1947)

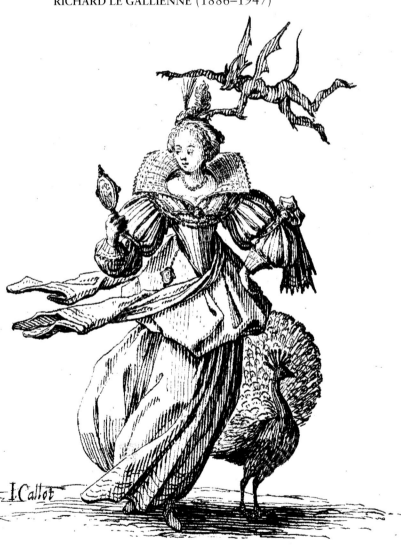

Pride (Superbia), Jacques Callot, etching and engraving,
after 1621.

'IT WAS VERY MUCH TO BE MEMBER FOR WESTMINSTER.'

As he was sitting at his solitary dinner this evening, – for both his wife and daughter had declined to join him, saying that they had dined early, – news was brought to him that he had been elected for Westminster. He had beaten Mr. Alf by something not much less than a thousand votes. It was very much to be member for Westminster. So much had at any rate been achieved by him who had begun the world without a shilling and without a friend, – almost without education! Much as he loved money, and much as he loved the spending of money, and much as he had made and much as he had spent, no triumph of his life had been so great to him as this. Brought into the world in a gutter, without father or mother, with no good thing ever done for him, he was now a member of the British Parliament and member for one of the first cities in the empire. Ignorant as he was he understood the magnitude of the achievement, and dismayed as he was as to his present position, still at this moment he enjoyed keenly a certain amount of elation. Of course he had committed forgery; – of course he had committed robbery. That, indeed, was nothing, for he had been cheating and forging and stealing all his life. Of course he was in danger of almost immediate detection and punishment. He hardly hoped that the evil day would be very much longer protracted, and yet he enjoyed his triumph. Whatever they might do, quick as they might be, they could hardly prevent his taking his seat in the House of Commons. Then if they sent him to penal servitude for life, they would have to say that they had so treated the member for Westminster!

The Way We Live Now, ANTHONY TROLLOPE (1815–1882)

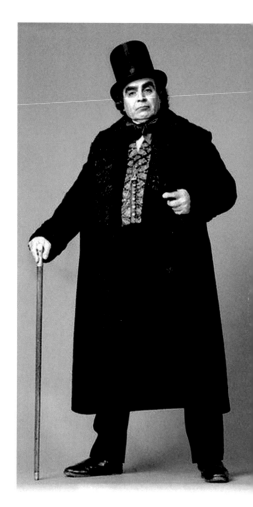

David Suchet as Melmotte, 2001

Augustus Melmotte, the central figure in Trollope's novel, *The Way We Live Now*, is a forerunner of Robert Maxwell. Members of the royal family, ministers and bishops attend Melmotte's lavish parties at his grand house in Grosvenor Square and MPs and peers sit on the boards of his fraudulent companies, which back such alluring projects as Central American Railways. He is, in fact, a forger and a thief, but this does not prevent him winning a by-election to become the MP for Westminster. When his frauds begin to unravel, he realises that his time is up, but nonetheless, reflects with pride on his achievements in deceiving so many people and becoming a member of the 'Mother of Parliaments' in the greatest city in the world. Left desperate and friendless and facing the prospect of prison, he avoids further humiliation by taking a fatal dose of Prussic acid.

RECESSIONAL

God of our fathers, known of old,
Lord of our far-flung battle-line,
Beneath whose awful Hand we hold
Dominion over palm and pine –
Lord God of Hosts, be with us yet,
Lest we forget – lest we forget!

The tumult and the shouting dies;
The Captains and the Kings depart:
Still stands Thine ancient sacrifice,
An humble and a contrite heart.
Lord God of Hosts, be with us yet,
Lest we forget – lest we forget!

Far-called, our navies melt away;
On dune and headland sinks the fire:
Lo, all our pomp of yesterday
Is one with Nineveh and Tyre!

Judge of the Nations, spare us yet,
Lest we forget – lest we forget!

If, drunk with sight of power, we loose
Wild tongues that have not Thee in awe,
Such boastings as the Gentiles use,
Or lesser breeds without the Law –
Lord God of Hosts, be with us yet,
Lest we forget – lest we forget!

For heathen heart that puts her trust
In reeking tube and iron shard,
All valiant dust that builds on dust,
And guarding, calls not Thee to guard,
For frantic boast, and foolish word –
Thy mercy on Thy People, Lord!

RUDYARD KIPLING (1865–1936)

This poem first appeared in *The Times* on 17 July 1897, shortly after the celebration of Queen Victoria's Diamond Jubilee. Going against the celebratory mood of the time, Kipling explained the motivation for his poem: 'Enclosed please find my sentiments on things – which I hope are yours. We've been blowing up the Trumpets of the New Moon a little too much for White Men, and it's about time we sobered down.'

GODOLPHIN HORNE, WHO WAS CURSED WITH THE SIN OF PRIDE, AND BECAME A BOOT-BLACK

Godolphin Horne was Nobly Born;
He held the Human Race in Scorn,
And lived with all his Sisters where
His Father lived, in Berkeley Square.
And oh! The Lad was Deathly Proud!
He never shook your Hand or Bowed,
But merely smirked and nodded thus:
How perfectly ridiculous!
Alas! That such Affected Tricks
Should flourish in a Child of Six!
(For such was Young Godolphin's age).
Just then, the Court required a Page,
Whereat The Lord High Chamberlain
(The Kindest and the Best of Men),
He went good-naturedly and took
A Perfectly Enormous Book
Called *People Qualified to Be*
Attendant on His Majesty,
And murmured, as he scanned the list
(To see that no one should be missed),
'There's William Coutts has got the Fl
And Billy Higgs would never do,
And Guy de Vere is far too young,
And... wasn't D'Alton's Father hung?
And as for Alexander Byng! –
I think I know the kind of thing,
A Churchman, cleanly, nobly born,
Come let us say Godolphin Horne?'
But hardly had he said the word
When Murmurs of Dissent were heard
The King of Iceland's Eldest Son
Said, 'Thank you! I am taking none!'
The Aged Duchess of Athlone
Remarked, in her sub-acid tone,
'I doubt if He is what we need!'

With which the Bishops all agreed;
And even Lady Mary Flood
(So Kind and oh! So *really* good)
Said, 'No! He wouldn't do at all,
He'd make us feel a lot too small.'
The Chamberlain said, '... Well, well, well!
No doubt you're right... One cannot tell!'
He took his Gold and Diamond Pen
And Scratched Godolphin out again.
So now Godolphin is the Boy
Who blacks the Boots at the Savoy.

HILAIRE BELLOC (1870–1954)

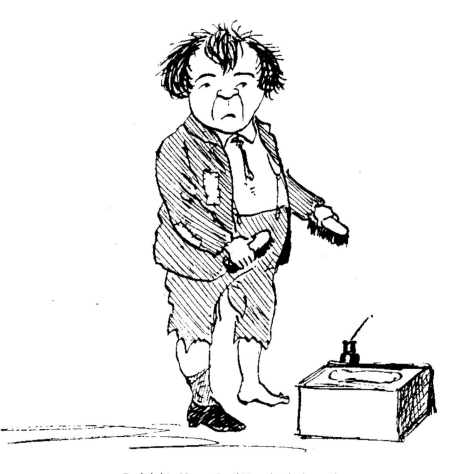

Godolphin Horne, Basil Temple Blackwood, 1907.

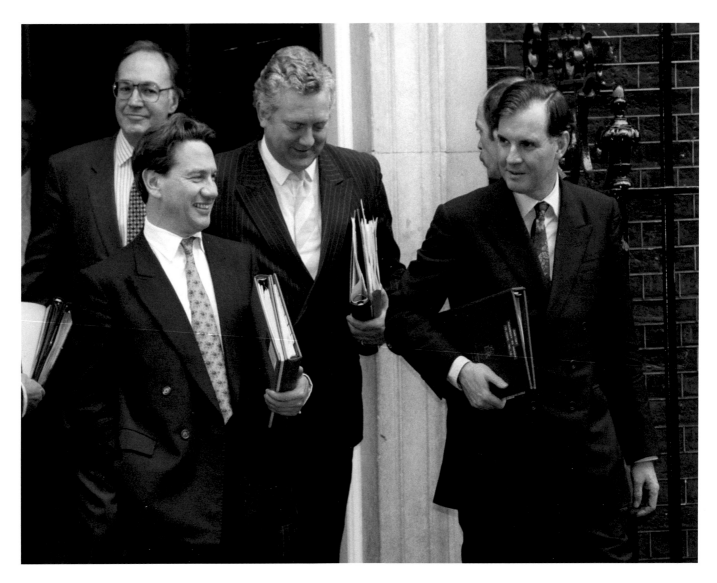

Cabinet members, Michael
Howard, Michael Portillo,
Jeremy Hanley and
Jonathan Aitken leaving
10 Downing Street, 1995.

JONATHAN AITKEN

The Confession

In the early 1990s I suppose I could have been described as a successful politician.
I was in my fifth term as a Member of Parliament in the House of Commons and
had held two portfolios as a Minister of the Crown. One of them was Minister of
State for Defence and the other was the post of Chief Secretary to the Treasury.
They were powerful posts. And I was getting quite frequently tipped as a possible
future leader of my party and as a successor to John Major.

The political graveyards are littered with the long-forgotten corpses of ex-
future prime ministers, so any such label should have made a wise man humble.

PRIDE | 37 |

In fact, it did quite the reverse. The combination of what Shakespeare in *Hamlet* calls 'the insolence of office' and in *Macbeth* 'vaulting ambition which o'erleaps itself', gave me a surfeit of hubris. Pride is the deadliest of sins, but I was bursting with pride. I took myself far too seriously, especially when I was made a target of a campaign by the *Guardian*.

It does not really matter now what the *Guardian* said in their attacks, because all feelings of resentment about them having long since left me. Suffice it to say that, in a long series of articles, they made a number of allegations against me, some of which were true, some of which were untrue, and all of which were given a strongly negative spin. In the face of this campaign I was full of prideful anger and went for the journalists' jugular. I initiated a big lawsuit for libel and announced my libel lawsuit in a ferocious television speech which contained the peroration, 'I will cut out the cancer of bent and twisted journalism with the simple sword of truth'. These were insensitive words of pride which came back to haunt me.

Let me pause here to tell you where I was as a Christian when I was riding high as a politician. To put it simply, I called myself a Christian without actually being one. I was strong on the externals. I went to church fairly regularly; I supported Christian causes; and was even a churchwarden at St. Margaret's, Westminster. However, I do not think I had fully appreciated the simple truth that being a Christian has little to do with external appearances and everything to do with the internal commitment of the heart.

I think I bore a disturbing resemblance to that Pharisee in the story of the Pharisee and the publican who go into the church to pray (Lk 18). Even if I did not boast about my external piety quite as loudly as the Pharisee did, the humility of the publican was far removed from me. I was certainly not saying 'God be merciful to me, a sinner', nor was I doing the will of the Father. And that brings me back to the libel case. In order to win it, I felt I had to do something that was against the will of the Father: I told a lie.

It did not seem at that time a terribly important lie, at least in relation to the lies I was accusing others of telling about me. It was a lie about who paid a $1,500-hotel bill of mine in the Ritz Hotel in Paris while I had been a government minister. I told this lie. I told it on oath in my evidence in court. To my eternal shame, I even got my wife and daughter to back me up with witness statements supporting my lie. But then my opponents ambushed me in the middle of the trial with clear documentary evidence that I had told a lie on oath. My credibility as a witness was shattered.

I had to withdraw from the libel case. And within twenty-four hours my whole life was shattered too. The former Cabinet Minister had impaled himself on his own sword of truth, with explosive and apocalyptic consequences. Some people have expressed surprise that I am still in one piece after being so torn

to shreds in the onslaught of media vilification and castigation I received at the height of my dramas. A great deal of the criticism of me was vitriolic; some of it was vicious; and I deserved most of it.

When these thunderbolts were raining in on me from all directions, I turned to my Christian faith, imperfect though it was, and began to ponder more deeply than ever before on the great themes in the gospels of love, penitence, redemption and resurrection. Although I am sceptical of fox-hole conversion, nevertheless the time when I was the nadir of my misfortunes was the time when I turned more humbly and penitently than ever towards Our Lord Jesus Christ.

I had escaped from the hot pursuit of the British *paparazzi* by travelling incognito to one of the most beautiful parts of the United States that I know – Sonoma County, California. There, amidst the majestic stillness and silences of unspoilt nature, at its most glorious, I felt the first glimmerings of *metanoia* – which is the Greek word for repentance. The starting point of my *metanoia* was the rock bottom I had hit in terms of defeat, disgrace, dejection and despair.

JONATHAN AITKEN's Confession, *The Tablet* (June 1999)

Two days before this article appeared in the International Catholic newspaper, *The Tablet*, Jonathan Aitken had been sentenced to eighteen months' imprisonment for perjury and obstruction of justice. His fall from power as a member of the Cabinet and from grace in public opinion, he attributes, like Lucifer, to pride.

HUBRIS IN WAR

Japan's military hubris, 1941–45

The Japanese Admiral Isoroku Yamamoto, who planned the attack on Pearl Harbor on Sunday, 7 December 1941, had been a junior officer in the sea battle of Tsushima in 1905 when the Japanese Navy inflicted a decisive defeat on the Russian Navy. Dismissed previously by the Tsar, as the 'little yellow men from whom Europeans have nothing to fear', the Japanese victory redrew the balance of power in Far East Asia. The Samurai code of honour, hyper-nationalism and the illusion of invincibility at sea resulting from the defeat of the Russians convinced the Japanese Emperor and his military advisers that there was no foe 'Divine Japan' could not vanquish. The Japanese invasion of China in the 1930s was propelled by an inflated belief in Japan's racial and cultural supremacy, not just over the Chinese but also over the British imperial presence in the Far East. Between 1942 and 1945 they occupied Singapore after defeating the British Army. This dangerous philosophy resulted in Japan's nemesis five years later when atomic bombs were dropped on Hiroshima and Nagasaki.

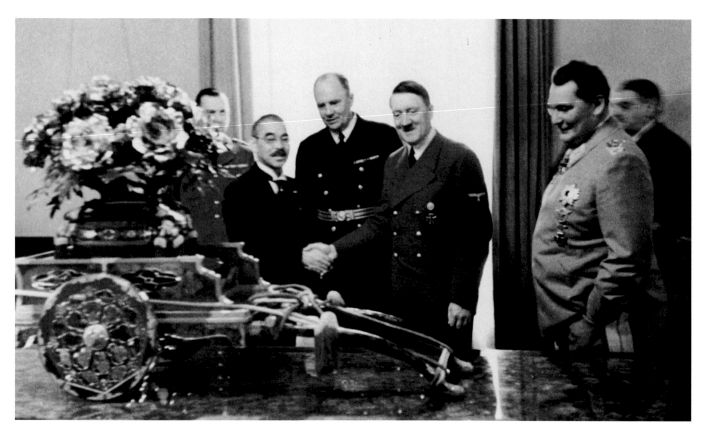

THE HUBRIS OF HITLER

Hitler and Japan united by hubris.

The Battle of Moscow, June 1941 – January 1942

In the early months of 1941, Hitler, supremely confident of Germanic superiority following the defeat and conquest of France, Holland and Belgium, believed that he could control the whole of Europe. This led to him making three fatal mistakes.

The first was envisaging an invasion of Russia, his former ally, under the codename Operation Barbarossa. The attack was originally planned for May, but Hitler postponed this until 22 June, losing vital days of warm weather in what he expected to be a victory march to Moscow. Ironically it was almost the same day on which Napoleon launched his invasion in 1812.

Hitler's second mistake was to launch a central attack across a long front not only to capture Moscow but sweep right through Russia. Stalin was caught unaware refusing to listen to reports from his spies, including Anthony Blunt, a British academic, who told him that Hitler was about to invade Russia. The size of the German attack was one of the largest invasions in the history of the world: 3.8 million men; 4,300 tanks; 4,389 aircraft; and 7,200 artillery pieces supported by 600,000 motor vehicles and 750,000 horses. Hitler expected to conquer Russia in six to eight weeks: 'Before three

months have passed we shall witness the collapse of Russia, the like of which has never been seen in world history.' This was hubris on stilts.

Within days most of the unsuspecting Russian air force was destroyed and by July the Germans had taken Minsk and Smolensk. In September Kiev fell, and panzers were at the gates of Leningrad. During those few weeks, the Russians had lost 341,000 soldiers, 4,799 tanks and 1,777 aircraft. Like Napoleon, the German advance followed a scorched earth policy, and their ruthless cruelty in handling prisoners consolidated the resistance of the Russian people.

On 5 October, Zhukov, who had beaten the Japanese and had saved Leningrad, was ordered by Stalin to save Moscow. The first thing he did was to stiffen the resolve of the Russian troops who would stand, fight or die. To restore national morale, Stalin ordered a great military parade for 7 November in Red Square and Zhukov marshalled 600,000 citizens to build a tall defensive position around the city. Not for the first time in the history of that vast country, the Russian winter came to their aid. Temperatures plunged to the harshest ever recorded. In this deadly cold snap, Moscow experienced a drop to minus fifty degrees centigrade.

Such was Hitler's hubristic overconfidence that he neither factored in that Barbarossa might overrun into the winter nor accepted that there might be any outcome but victory. He believed 'that the surrender of Moscow would not be accepted even if it is offered by the enemy'. In November, Zhukov mounted a counter-offensive deploying many soldiers diverted from Siberia where they had been protecting Russia from a Japanese attack. The German advance was halted, and they began to retreat.

In this six-month battle, over 926,000 Russians were killed, which was more than the combined casualties of Britain and America in the whole war. But the Wehrmacht had been stopped. On 9 December, enraged with his generals, Hitler assumed direct command of the German Army. Two days later he made his third great mistake of 1941, by declaring war on the United States of America. As Alistair Horne says, 'He was about to become Lord of the Universe.'

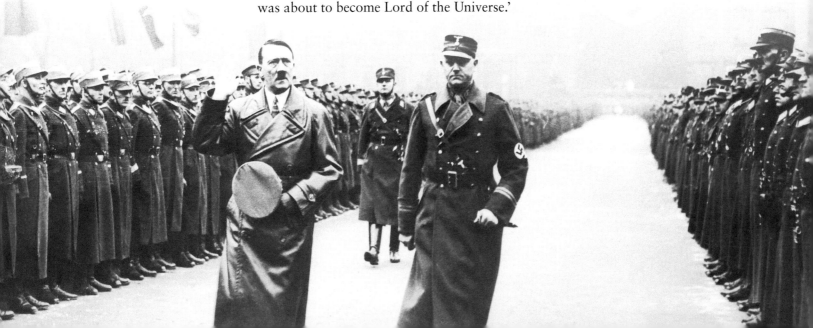

IRAQ – 'WE DID IT OUR WAY' 2003

President George W. Bush and Prime Minister Tony Blair had total confidence that Saddam Hussein had weapons of mass destruction (WMD) and that these were a real danger to the peace of the world. They also believed that once Hussein had been overthrown peace and stability would reign supreme in the Middle East.

His WMD programme is active and detailed and growing. The policy of containment is not working. The WMD is not shot down. It is up and running.

TONY BLAIR, House of Commons, September 2002

We have absolutely no doubt at all that the WMD exist.

TONY BLAIR, Press Conference, March 2003

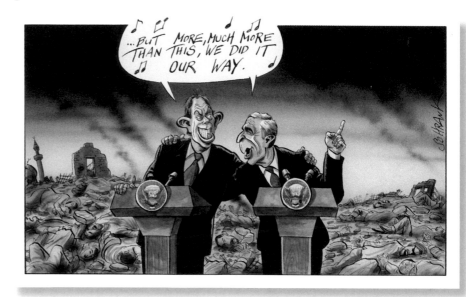

More than this we did it our way, Peter Schrank, 2006.

On WMD we know that the regime has them, we know that as the regime collapses we will be led to them.

TONY BLAIR, Press Conference, April 2003

Sir John Chilcot in presenting his report on Iraq concluded:

The judgements about the severity of the threat posed by Iraq's weapons of mass destruction were presented with a certainty that was not justified.

Despite explicit warnings, the consequences of the invasion were under-estimated. The planning and preparations for Iraq after Saddam Hussein were totally inadequate.

Report of the Iraq Inquiry, SIR JOHN CHILCOT, July 2016

So, with flimsy evidence and no awareness of the consequences, Iraq was invaded. Two hundred British and over 100,000 Iraqi lives were lost, and chaos resulting from the break-up of Iraq eventually led to the ISIS caliphate.

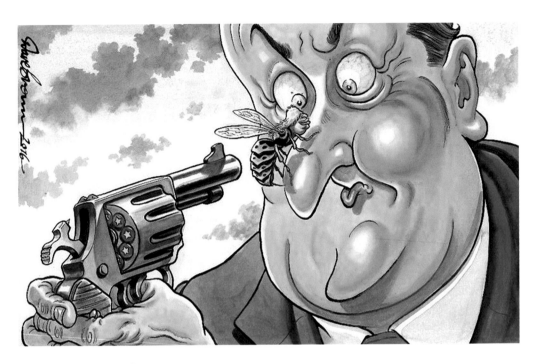

David Cameron dealing with Boris, Dave Brown, 2016.

BREXIT – HUBRIS

Tony Blair's remark on David Cameron's announcement of a referendum on the EU was that it reminded him of the Mel Brooks comedy *Blazing Saddles* in which the sheriff holds a gun to his head and says, 'If you don't do what I want I will blow my brains out.'

On 23 January 2013, at Bloomberg's headquarters in London, the Prime Minister, David Cameron, announced there would be a referendum after the 2015 election on whether Britain should stay in the European Union or leave, adding that he would campaign 'heart and soul' to remain in the EU. He did this for three reasons. First, to check the rising popularity of the United Kingdom Independence Party (UKIP) led by the popular and easily recognisable Nigel Farage; secondly, to take on the growing number of troublesome Eurosceptic Tory MPs threatening him as they had threatened John Major; and thirdly, to check the rising ambitions of Boris Johnson, who was recognised as the most popular Tory and having the rare distinction of being known by his Christian name. Johnson had said it was 'high time for the British people to be consulted on Europe', and Cameron wanted to take that card away from him.

The Eurosceptics rejoiced and Farage declared, 'Bring it on.' Cameron was completely confident that he would win the Europe referendum because he had won the Alternative Vote referendum in 2011 and the Scottish Independence referendum in 2014. However, the package of concessions which Cameron had negotiated with the European Union were trivial, and he had lost the opportunity to argue for a two-tier Europe which was beginning to emerge as a result of the refugee crisis. Moreover, the Remain campaign was complacent and the downside of BREXIT was massively exaggerated: an immediate

financial crisis, rising unemployment, the collapse of growth. He had lost touch with the public's feelings, particularly in the north of England over immigration.

Cameron was so convinced of victory that no plans had been put in hand to handle a BREXIT victory and he had not prepared a speech in the event of defeat. He decided to resign immediately. His past successes including; making the Tory Party electable between 2005 and 2010, managing the first peacetime coalition and leading the Tories to a majority in the 2015 election, were all forgotten. His place in history will be as the Prime Minister who allowed Britain to be taken out of the EU against his own wishes.

THE PUNISHMENT OF HUBRIS

In the eighth circle of Hell, Dante and his guide Virgil, find the chained giants, whose overwhelming pride had led them to rebel against the Olympian Gods. The consequences of their failure to drive the Gods from Mount Olympus are severe. In this image, the giant bound in chains is Ephialtes who had taken on Apollo, one of whose arrows blinded him:

– When the giants made
The gods to tremble, great was he in fright:
No more he moves the arms which then he sway'd.

The Divine Comedy: The Inferno, Canto XXXI. **DANTE ALIGHIERI**
Translated by Ichabod Charles Wright.

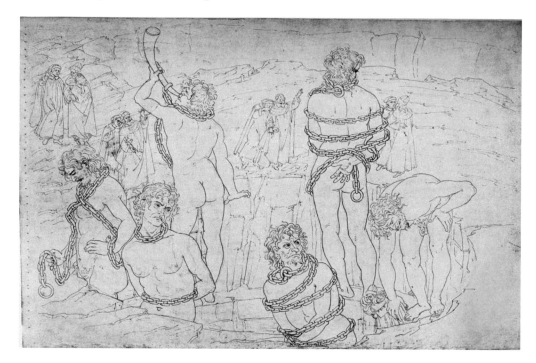

The Drawings for Dante's Divine Comedy, Sandro Botticelli, *c.* 1485.

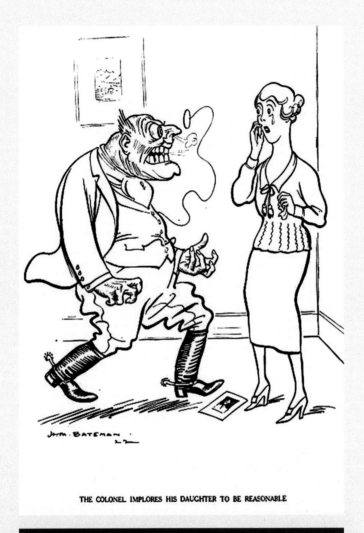

THE COLONEL IMPLORES HIS DAUGHTER TO BE REASONABLE

Anger

Cartoon by H.M. Bateman, 1922.

Ye have heard it was said by them of old time, Thou shalt not kill; and whosoever shall kill shall be in danger of the judgment: But I say unto you, That whosoever is angry with his brother without a cause shall be in danger of judgment.

From the Sermon on the Mount, Matthew 5: 21–22

'Righteous Anger' is a dubious term. Does it mean anything more than that there are occasions when the sin of anger is a lesser evil than cowardice or sloth? I know that a certain state of affairs or the behaviour of a certain person is morally evil and I know what should be done to put an end to it; but, without getting angry, I cannot not summon up the energy and the courage to take action. Righteous anger can effectively resist and destroy evil, but the more one relies upon it as a source of energy, the less energy and attention one can give to the good which is to replace the evil once it has been removed. That is why, though there may have been some just wars, there has been no just peace.

The Seven Deadly Sins, W.H. AUDEN (1907–1973)

Anger raiseth invention, but it overheateth the oven.

1ST MARQUESS OF HALIFAX (1633–1695)

The tigers of wrath are wiser than the horses of instruction.

WILLIAM BLAKE (1757–1827)

[Anger] the most hideous and frenzied of all the emotions… some of the wise, accordingly, have described anger as 'brief insanity'.

SENECA (*c.* 3 BC–65 AD)

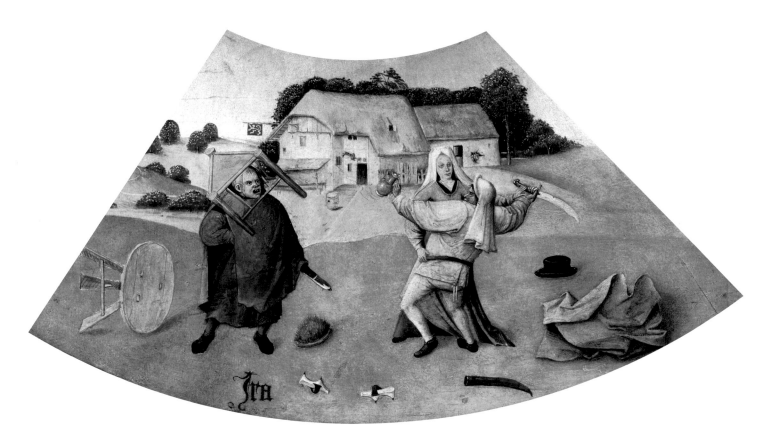

Wrath from *The Table of the Deadly Sins*, Hieronymous Bosch, *c.* 1500.

ANGER IS A MULTI-LAYERED SIN. It encompasses: indignation at not getting a table at one's favourite restaurant; the frustration of getting stuck in the longest passport queue; the annoyance of being behind a very slow car in the fast lane leading to road rage; the loss of self-control that ends up in a pub brawl; the hatred and resentment in a marriage or relationship resulting in verbal or physical abuse; vindictiveness when proper respect is not shown; hooliganism on the football terraces; sudden outbursts of fury; and an overmastering passion verging on madness such as that which destroyed King Lear, Coriolanus and Timon of Athens

Anger is very much alive and deadly in the real world. Owing to the wide range of destructive weapons now available, terrorist anger is now the deadliest of sins. Terrorists are driven by their hatred of non-believers, and their anger is manipulated by militant radical preachers, by friends who have seen the 'light' and by a belief in martyrdom through killing. No race or religion has suffered so much hatred and anger directed against it as the Jews. In his speeches, Hitler used anger to arouse the hatred of his followers, which led to the murder of six million Jews in the Nazi extermination camps.

Revolutionaries are motivated by anger. Their anger is directed against the status quo, the unequal distribution of wealth, the exclusiveness of establishments, the corruption of the ruling elite, the arrogance of power, and the conspicuous consumption of the wealthy. G.K. Chesterton, described the French Jacobins as 'ragged men dead for an idea'. But revolution, as experienced in England, can have a long fuse of slow burning resentment starting with the peculiar English vices of grudge and sulk which lead on to

disgust and envy. Other sins feed into this resentment. A glutton can become enraged if his appetite is not met; the lecher can be inflamed by rejection and revenge can be both a consequence of anger and an impetus to it.

Anger is also a slippery sin since there are occasions when anger is righteous. In the Sermon on the Mount, Christ referring possibly to Cain who killed his brother Abel, declared that anger could lead to exclusion from the grace of God. 'Whosoever is angry with his brother, without a cause, shall be in danger of the judgement.' The key phrase is 'without a cause' because it implies that if anger has a well-rooted reason to right wrongs, reveal cruelty, resist oppression, unveil hypocrisy, and puncture pomposity, then it is not a sin.

In the late eighteenth and early nineteenth centuries righteous anger played a part in the campaign to end slavery. Today it is also part of the response to human trafficking and child abuse. But St Augustine inveighed against it as it could get out of hand. 'It is better to deny entrance to just and reasonable anger than to admit it. Once it is admitted it is driven out again only with difficulty. It comes in as a little twig and in less than no time it grows big and becomes a beam.'

Wrath can claim some precedence in the list of sins since God himself fell victim to it. The wrath of God was directed against man because the very man he created disobeyed him. This Original Sin was so grave that it doomed all mankind to eternal damnation. But the God of Love prevailed over the God of Wrath as He mitigated the doom of all humanity by sending His own son to earth to redeem their sins.

ANGER IN ANCIENT GREECE

The tragic trilogy of *The Oresteia* by Aeschylus in 458 BC, tells of the generational sins of the House of Atreus, where one killing leads to another. King Agamemnon, the head of the family, kills his eldest daughter, Iphigenia, to placate the goddess Artemis and make the wind change so that his fleet can sail to Troy. On his return to Greece Agamemnon's wife, Clytemnestra, angry at the death of her daughter, decides that she and her lover Aegisthus will kill Agamemnon and his Trojan concubine Cassandra. Then Agamemnon's son Orestes decides to kill his mother Clytemnestra and Aegisthus. The curse of the House of Atreus demands that blood should follow blood in a cycle passing from one generation to the next, leading to the family being destroyed by revenge.

The Vengeance of Orestes, Vera Willoughby, 1925.

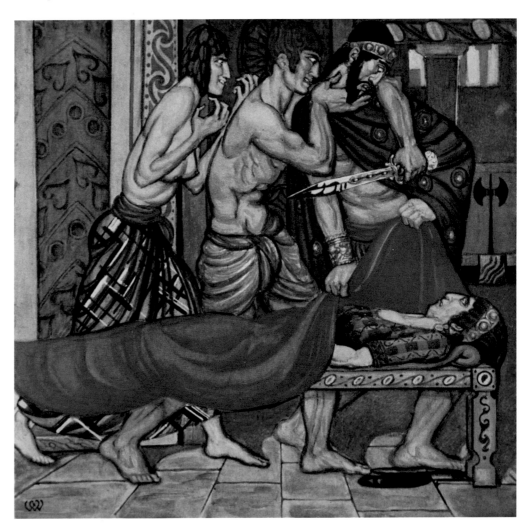

FEMALE REVENGE

The Murder of Alboin, King of the Lombards, 28 June 573

The reign of the founder was splendid and transient; and before he could regulate his new conquests, Alboin fell a sacrifice to domestic treason and female revenge. In a palace near Verona, which had not been erected for the barbarians, he feasted with the companions of his arms: intoxication was the reward of valour, and the king himself was tempted by appetite, or vanity, to exceed the ordinary measure of his intemperance. After draining many capacious bowls of Rhaetian or Falernian wine, he called for the skull of Cunimund, the noblest and most precious ornament of his sideboard. The cup of victory was accepted with horrid applause by the circle of the Lombard chiefs. 'Fill it with wine,' exclaimed the inhuman conqueror; 'fill it to the brim; carry this goblet to the queen, and request in my name that she would rejoice with her father.' In an agony of grief and rage, Rosamond [the daughter of Cunimund] had strength to utter, 'Let the will of my lord be obeyed!' and touched it with her lips, pronounced a silent imprecation, that the insult should be washed away in the blood of Alboin.

Some indulgence might be due to the resentment of a daughter, if she had not already violated the duties of a wife. Implacable in her enmity, or inconstant in her love, the queen of Italy had stooped from the throne to the arms of a subject; and Helmichis, the king's armour-bearer, was the secret minister of her pleasure and revenge. Against the proposal of the murder, he could no longer urge the scruples of fidelity or gratitude; but Helmichis trembled when he revolved the danger as well as the guilt, when he recollected the matchless strength and intrepidity of a warrior, whom he had so often attended in the field of battle. He pressed, and obtained, that one of the bravest champions of the Lombards should be associated to the enterprise, but no more than a promise of secrecy could be drawn from the gallant Peredeus; the mode of seduction employed by Rosamond betrays her shameless insensibility both to honour and love. She supplied the place of one of her female attendants who was beloved by Peredeus, and contrived some excuse for darkness and silence, till she could inform her companion that he had enjoyed the queen of the Lombards, and that his own death, or the death of Alboin, must be the consequence of such treasonable adultery. In this alternative, he chose rather to be the accomplice, than the victim of Rosamond whose undaunted spirit was incapable of fear or remorse. She expected, and soon found a favourable moment, when the king, oppressed with wine, had retired from the table to his afternoon slumbers. His faithless spouse was anxious for his health and repose: the gates of the palace were shut, the arms removed, the attendants dismissed, and Rosamond, after

Woodcut vignette of *Alboin*, Nuremberg Chronicle, 1493.

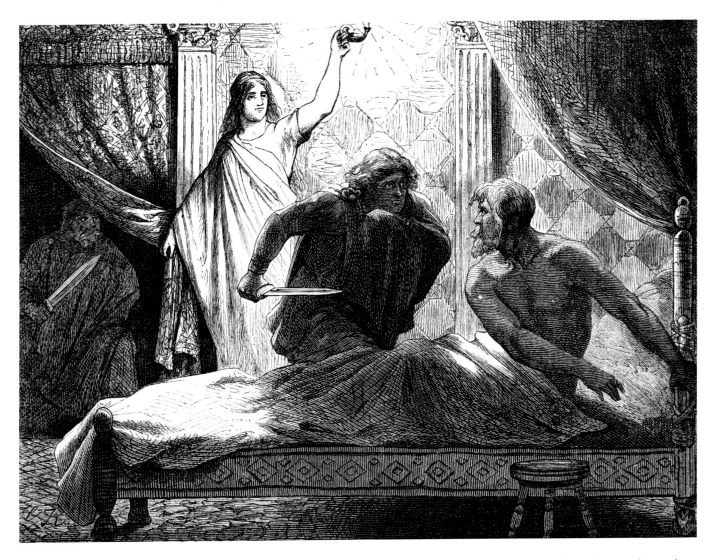

Alboin is murdered on the order of Rosamond, wood engraving, 19th century.

lulling him to rest by her tender caresses, unbolted the chamber-door and urged the reluctant conspirators to the instant execution of the deed. On the first alarm, the warrior started from his couch; his sword, which he attempted to draw, had been fastened to the scabbard by the hand of Rosamond; and a small stool, his only weapon, could not long protect him from the spears of the assassins. The daughter of Cunimund smiled in his fall; his body was buried under the staircase of the palace, and the grateful posterity of the Lombards revered the tomb and the memory of their victorious leader.

The History of the Decline and Fall of the Roman Empire
EDWARD GIBBON (1734–1794)

THE FIRST BLAST OF THE TRUMPET AGAINST THE MONSTROUS REGIMENT OF WOMEN

For John Knox, the teaching of scripture was sufficient to prove that women should not rule over men. In this, his most famous and controversial work, his specific targets are those who were opposed to the Protestant Reformation: Catherine de Medici, Mary of Guise, and Mary Tudor.

> To promote a woman to beare rule, superioritie, dominion or empire aboue any realme, nation, or citie, is repugnant to human nature contumelie to God, a thing most contrarious to his reueled will and approued ordinance, and finallie it is the subuersion of good order, of all equitie and iustice...
>
> For who can denie but it repugneth to nature, that the blind shall be appointed to leade and conduct such as do see? That the weake, the sicke, and impotent persones shall norishe and kepe the hole and strong, and finallie, that the foolishe, madde and phrenetike shal gouerne the discrete, and giue counsel to such as be sober of mind? And such be al women, compared unto man in bearing of authoritie. For their sight in ciuile regiment, is but blindnes: their strength, weaknes: their counsel, foolishenes: and judgement, phrenesie, if it be rightlie considered...
>
> Nature I say, doth paynt them furthe to be weake, fraile, impacient, feble and foolishe: and experience hath declared them to be unconstant, uariable, cruell and lacking the spirit of counsel and regiment.

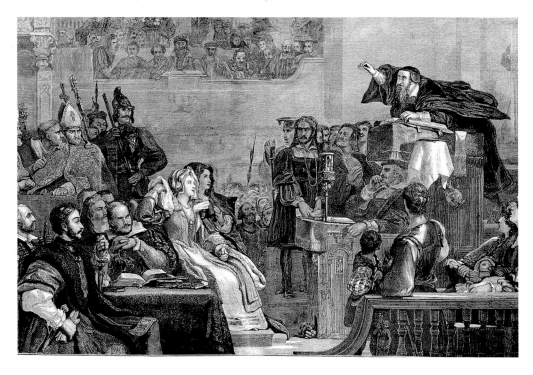

John Knox preaching before the Lords of the Congregation in the Parish Church of St Andrews, 10th June 1559. Print after David Wilkie, 1832.

PERORATION ADDRESSED TO MARY TUDOR

Cursed Iesabel of England, with the pestilent and detestable generation of papistes, make no litle bragge and boast, that they haue triumphed not only against Wyet, but also against all such as haue enterprised any thing against them or their procedinges…

And therfore, let such as assist her, take hede what they do. For assuredlie her empire and reign is a wall without foundation. I meane the same of the authoritie of all women. It hath bene underpropped this blind time that is past, with the foolishnes of people, and with the wicked lawes of ignorant and tyrannous princes. But the fier of Goddes worde is alredie laide to those rotten proppes, (I include the Pope's lawe with the rest), and presentlie they burn, albeit we espie not the flame: when they are consumed, (as shortlie they will be, for stuble and drie timbre can not long indure the fier) that rotten wall, the usurped and uniust empire of women, shall fall by it self in despit of all man, to the destruction of so manie as shall labor to uphold it. And therefore let all man be aduertised, for THE TRUMPET HATH ONES BLOWEN.

JOHN KNOX (1513–1572)
Edited by E. Arber.

COME NOT BETWEEN THE DRAGON AND HIS WRATH

King Lear: …what can you say to draw a third more opulent than your sisters? Speak.
Cordelia: Nothing, my lord.
King Lear: Nothing!
Cordelia: Nothing.
King Lear: Nothing will come of nothing: speak again.
Cordelia: Unhappy that I am, I cannot heave my heart into my mouth:
I love your majesty according to my bond; nor more nor less.
King Lear: How, how, Cordelia! mend your speech a little, lest it may mar your fortunes.
Cordelia: Good my lord, you have begot me, bred me, loved me: I return those duties back as are right fit, obey you, love you, and most honour you. Why have my sisters husbands, if they say they love you all? Haply, when I shall wed, that lord whose hand must take my plight shall carry half my love with him, half my care and duty: Sure, I shall never marry like my sisters, to love my father all.
King Lear: But goes thy heart with this?
Cordelia: Ay, good my lord.
King Lear: So young, and so untender?
Cordelia: So young, my lord, and true.
King Lear: Let it be so; thy truth, then, be thy dower: for, by the sacred radiance of the sun, the mysteries of Hecate, and the night; by all the operation of the orbs from

whom we do exist, and cease to be; here I disclaim all my paternal care, propinquity and property of blood, and as a stranger to my heart and me hold thee, from this, for ever. The barbarous Scythian, or he that makes his generation messes to gorge his appetite, shall to my bosom be as well neighbour'd, pitied, and reliev'd, as thou my sometime daughter.

Kent: Good my liege.

King Lear: Peace, Kent! Come not between the Dragon and his wrath. I loved her most, and thought to set my rest on her kind nursery. Hence, and avoid my sight! So be my grave my peace, as here I give her father's heart from her!

Act 1, Scene 1, *King Lear*, WILLIAM SHAKESPEARE

A loose hand-coloured print of *King Lear*, John & Josiah Boydell, 1792.

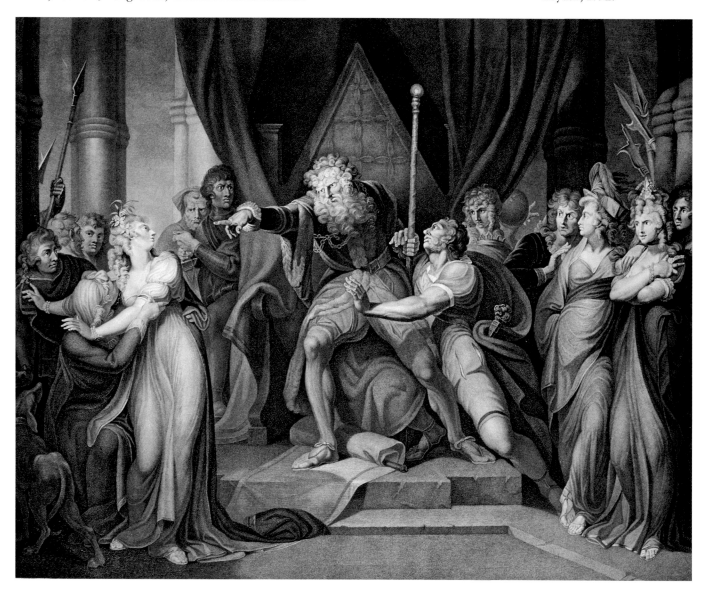

KING LEAR

It may be so, my lord.
Hear, nature, hear, dear goddess, hear!
Suspend thy purpose, if thou didst intend
To make this creature fruitful!
Into her womb convey sterility!
Dry up in her the organs of increase;
And from her derogate body never spring
A babe to honour her! If she must teem,
Create her child of spleen; that it may live,
And be a thwart disnatured torment to her!
Let it stamp wrinkles in her brow of youth;
With cadent tears fret channels in her cheeks;
Turn all her mother's pains and benefits
To laughter and contempt; that she may feel
How sharper than a serpent's tooth it is
To have a thankless child! Away, away!

Act 1, Scene 4, *King Lear*, WILLIAM SHAKESPEARE

Anger (Ira), Jacques Callot, etching and engraving,
after 1621.

SOLILOQUY OF THE SPANISH CLOISTER

Gr-r-r--there go, my heart's abhorrence!
Water your damned flower-pots, do!
If hate killed men, Brother Lawrence,
God's blood, would not mine kill you!
What? your myrtle-bush wants trimming?
Oh, that rose has prior claims –
Needs its leaden vase filled brimming?
Hell dry you up with its flames!

At the meal we sit together;
Salve tibi! I must hear
Wise talk of the kind of weather,
Sort of season, time of year:
Not a plenteous cork crop: scarcely
Dare we hope oak-galls, I doubt;
What's the Latin name for 'parsley'?
What's the Greek name for 'swine's snout'?
…

When he finishes refection,
Knife and fork he never lays
Cross-wise, to my recollection,
As do I, in Jesu's praise.
I the Trinity illustrate,
Drinking watered orange pulp –
In three sips the Arian frustrate;
While he drains his at one gulp!
…

There's a great text in Galatians,
Once you trip on it, entails
Twenty-nine district damnations,
One sure, if another fails;
If I trip him just a-dying,
Sure of heaven as sure can be,
Spin him round and send him flying
Off to hell, a Manichee?
…

Or, there's Satan! – one might venture
Pledge one's soul to him, yet leave
Such a flaw in the indenture
As he'd miss till, past retrieve,
Blasted lay that rose-acacia
We're so proud of! Hy, Zy, Hine...
'St, there's Vespers! Plena gratia
Ave, Virgo! Gr-r-r--you swine!

ROBERT BROWNING

A POISON TREE

I was angry with my friend:
I told my wrath, my wrath did end.
I was angry with my foe:
I told it not, my wrath did grow.

And I watered it in fears,
Night & morning with my tears;
And I sunned it with smiles,
And with soft deceitful wiles.

And it grew both day and night,
Till it bore an apple bright;
And my foe beheld it shine,
And he knew that it was mine,

And into my garden stole,
When the night had veiled the pole:
In the morning glad I see;
My foe outstretched beneath the tree.

WILLIAM BLAKE

A plate from *Songs of
Innocence and Experience*
by William Blake, 1794.

Portrait of William Hazlitt,
William Bewick, 1825.

ON THE PLEASURE OF HATING

The pleasure of hating, like a poisonous mineral, eats into the heart of religion, and turns it to rankling spleen and bigotry; it makes patriotism an excuse for carrying fire, pestilence, and famine into other lands: it leaves to virtue nothing but the spirit of censoriousness, and a narrow, jealous, inquisitorial watchfulness over the actions and motives of others. What have the different sects, creeds, doctrines in religion been but so many pretexts set up for men to wrangle, to quarrel, to tear one another in pieces about, like a target as a mark to shoot at? Does any one suppose that the love of country in an Englishman implies any friendly feeling or disposition to serve another bearing the same name? No, it means only hatred to the French, or the inhabitants of any other country that we happen to be at war with for the time. Does the love of virtue denote any wish to discover or amend our own faults? No, but it atones for an obstinate adherence to our own vices by the most virulent intolerance to human frailties. This principle is of a most universal application. It extends to good as well as evil: if it makes us hate folly, it makes us no less dissatisfied with distinguished merit. If it inclines us to resent the wrongs of others, it impels us to be as impatient of their prosperity. We revenge injuries: we repay benefits with ingratitude. Even our strongest partialities and likings soon take this turn. 'That which was luscious as locusts, anon becomes bitter as coloquintida'; and love and friendship melt in their own fires. We hate old friends: we hate old books: we hate old opinions; and at last we come to hate ourselves.

WILLIAM HAZLITT (1778–1830)

CLERICAL ANGER

Then, the marquis paused, and looked at the dean before he went on speaking. He looked so long that the dean was preparing to take his hat in his hand ready for a start. He showed that he was going to move, and then the marquis went on speaking. 'Sacred! Ah! – and such a child!'

'She is one of whom I am proud as a father, and you should be proud as a sister-in-law.'

'Oh, of course. So I am. The Germains were never so honoured before. As for her birth I care nothing about that. Had she behaved herself, I should have thought nothing of the stable.

'What do you dare to say?' said the dean, jumping from his seat.

The marquis sat leaning back in his armchair, perfectly motionless. There was a smile – almost a pleasant smile on his face. But there was a very devil in

his eye, and the dean, who stood some six feet removed from him, saw the devil plainly. 'I live a solitary life here, Mr Dean,' said the marquis, 'but even I have heard of her.'

'What have you heard?'

'All London have heard of her – this future marchioness, whose ambition is to drive my son from his title and estates. A sacred duty, Mr Dean, to put a coronet on the head of that young – !' – more distinctly, more loudly, more indecisively, than any word which had yet fallen from the man's lips. It was evident that the lord had prepared the word, and had sent for the father that the father might hear the word applied to his own daughter – unless indeed he should first acknowledge himself to have lost his case. So far the interview had been carried out very much in accordance with the preparations as arranged by the marquis; but, as to what followed, the marquis had hardly made his calculations correctly.

...

The dean, as I have said, had been standing about six feet from the easy-chair in which the marquis was lolling when the word was spoken. He had already taken his hat in his hand and had thought of some means of showing his indignation as he left the room. Now his first impulse was to rid himself of his hat, which he did by pitching it along the floor. And then in an instant he was at the lord's throat. The lord had expected it so little that up to the last he made no preparation for defence. The dean had got him by his cravat and shirt collar before he had begun to expect such usage as this. Then he simply gurgled out some ejaculated oath, uttered half in surprise and half in prayer. Prayer certainly was now of no use. Had five hundred feet of rock been there the marquis would have gone down it, though the dean had gone with him. Fire flashed from the clergyman's eyes, and his teeth were set fast, and his very nostrils were almost ablaze. His daughter! The holy spot of his life! The one being in whom he believed with all his heart and with all his strength!

The dean was fifty years of age, but no one had ever taken him for an old man. They who at home at Brotherton would watch his motions, how he walked and how he rode on horseback, how he would vault his gates in the fields, and scamper across the country like a schoolboy, were wont to say that he was unclerical...

The marquis, in spite of what feeble efforts he made, was dragged up out of his chair and made to stand, or rather to totter, on his legs. He made a clutch at the bell-rope, which, to aid his luxurious ease, had been brought close to his hand as he sat, but failed, as the dean shook him hither and thither. Then he was dragged onto the middle of the rug, feeling, by this time that he was going to be throttled. He attempted to throw himself down, and would have done so, but that the dean with his left hand prevented him from falling. He made

one vigorous struggle to free himself, striving as he did so to call for assistance. But the dean, having got his victim's back to the fireplace, and having the poor wretch now fully at his command, threw the man with all his strength into the empty grate. The marquis fell like a heap within the fender, with his back against the top bar and his head driven farther back against the bricks and iron. There for a second or two he lay like a dead mass.

Is He Popenjoy? **ANTHONY TROLLOPE**

In Trollope's story, the Dean of Brotherton's daughter, Mary, has married Sir George Germain, the younger brother and heir to the Marquis of Brotherton. So, this humble cleric's daughter is on the way to becoming a marchioness, but the marquis returns from Italy with a wife and child. In the meeting between the marquis and the dean, the marquis criticises Mary for driving his newly born boy from his title and his estates and uses a derogatory and insulting word to describe Mary's child which Trollope does not dare to mention. The insult is too much for the dean who throws the marquis into the fireplace almost killing him.

Anthony Trollope
Frederick Waddy, 1872.

COLONEL RAWDON CRAWLEY'S RIGHTEOUS ANGER

In Thackeray's *Vanity Fair*, Colonel Rawdon Crawley does not have enough money to sustain the lavish tastes of his wife, Becky Sharp. Debts mount up and one night he is detained in a debtor's gaol from where he writes to Becky begging her to sell her jewellery. Her reply to her husband is that she is ill in bed. A relative bails him out; he returns to his house the following night where he is surprised to find Becky with her elderly and ugly protector, and probably her lover, the Marquis of Steyne. Crawley's outburst of anger at Steyne and his wife is mirrored later in the story by Steyne's cold, calculating fury which ensures that Becky is ostracised from London society and has to scrape by living abroad in very louche company.

Portrait of William Makepeace Thackeray, Samuel Lawrence, *c.* 1850.

Rawdon left her and walked home rapidly. It was nine o'clock at night. He ran across the streets and the great squares of Vanity Fair, and at length came up breathless opposite his own house. He started back and fell against the railings, trembling as he looked up. The drawing-room windows were blazing with light. She had said that she was in bed and ill. He stood there for some time, the light from the rooms on his pale face.

He took out his door-key and let himself into the house. He could hear laughter in the upper rooms. He was in the ball-dress in which he had been captured the night before. He went silently up the stairs, leaning against the banisters at the stair-head. Nobody was stirring in the house besides – all the servants had been sent away. Rawdon heard laughter within – laughter and singing. Becky was singing a snatch of the song of the night before; a hoarse voice shouted 'Brava! Brava!' – it was Lord Steyne's.

Rawdon opened the door and went in. A little table with a dinner was laid out – and wine and plate. Steyne was hanging over the sofa on which Becky sat. The wretched woman was in a brilliant full toilette, her arms and all her fingers sparkling with bracelets and rings, and the brilliants on her breast which Steyne had given her. He had her hand in his, and was bowing over it to kiss it, when Becky started up with a faint scream as she caught sight of Rawdon's white face. At the next instant she tried a smile, a horrid smile, as if to welcome her husband; and Steyne rose up, grinding his teeth, pale, and with fury in his looks.

He, too, attempted a laugh – and came forward holding out his hand. 'What, come back! How d'ye do, Crawley?' he said, the nerves of his mouth twitching as he tried to grin at the intruder.

There was that in Rawdon's face which caused Becky to fling herself before him. 'I am innocent, Rawdon,' she said; 'before God, I am innocent.' She clung hold of his coat, of his hands; her own were all covered with serpents, and rings, and baubles. 'I am innocent. Say I am innocent,' she said to Lord Steyne.

He thought a trap had been laid for him, and was as furious with the wife as with the husband. 'You innocent! Damn you,' he screamed out. 'You innocent! Why every trinket you have on your body is paid for by me. I have given you thousands of pounds, which this fellow has spent and for which he has sold you. Innocent, by – ! You're as innocent as your mother, the ballet-girl, and your husband the bully. Don't think to frighten me as you have done others. Make way, sir, and let me pass'; and Lord Steyne seized up his hat, and, with flame in his eyes, and looking his enemy fiercely in the face, marched upon him, never for a moment doubting that the other would give way.

But Rawdon Crawley springing out, seized him by the neckcloth, until Steyne, almost strangled, writhed and bent under his arm. 'You lie, you dog!' said Rawdon. 'You lie, you coward and villain!' And he struck the Peer twice over the face with his open hand and flung him bleeding to the ground. It was all done before Rebecca could interpose. She stood there trembling before him. She admired her husband, strong, brave, and victorious.

'Come here,' he said. She came up at once.

'Take off those things.' She began, trembling, pulling the jewels from her arms, and the rings from her shaking fingers, and held them all in a heap, quivering and looking up at him. 'Throw them down,' he said, and she dropped them. He tore the diamond ornament out of her breast and flung it at Lord Steyne. It cut him on his bald forehead. Steyne wore the scar to his dying day.

'Come upstairs,' Rawdon said to his wife. 'Don't kill me, Rawdon,' she said. He laughed savagely. 'I want to see if that man lies about the money as he has about me. Has he given you any?'

'No,' said Rebecca, 'that is –'

'Give me your keys,' Rawdon answered, and they went out together.

Rebecca gave him all the keys but one, and she was in hopes that he would not have remarked the absence of that. It belonged to the little desk which Amelia had given her in early days, and which she kept in a secret place. But Rawdon flung open boxes and wardrobes, throwing the multifarious trumpery of their contents here and there, and at last he found the desk. The woman was forced to open it. It contained papers, love-letters many years old – all sorts of small trinkets and woman's memoranda. And it contained a pocket-book with bank-notes. Some of these were dated ten years back, too, and one was quite a fresh one – a note for a thousand pounds which Lord Steyne had given her.

'Did he give you this?' Rawdon said.

'Yes,' Rebecca answered.

'I'll send it to him today,' Rawdon said (for day had dawned again, and many hours had passed in this search), 'and I will pay Briggs, who was kind to the boy, and some of the debts. You will let me know where I shall send the rest to

you. You might have spared me a hundred pounds, Becky, out of all this – I have always shared with you.'

'I am innocent,' said Becky. And he left her without another word.

What were her thoughts when he left her? She remained for hours after he was gone, the sunshine pouring into the room, and Rebecca sitting alone on the bed's edge. The drawers were all opened and their contents scattered about – dresses and feathers, scarfs and trinkets, a heap of tumbled vanities lying in a wreck. Her hair was falling over her shoulders; her gown was torn where Rawdon had wrenched the brilliants out of it. She heard him go downstairs a few minutes after he left her, and the door slamming and closing on him. She knew he would never come back.

Vanity Fair, **WILLIAM MAKEPEACE THACKERAY** (1811–1863)

The Marquis of Steyne,
W.M. Thackeray, 1847.

Maud, Eleanor Fortescue-Brickdale, 1907.

AN ANGRY FATAL BRAWL

Maud (Part 2)

'The fault was mine, the fault was mine' –
Why am I sitting here so stunned and still,
Plucking the harmless wild-flower on the hill? –
It is this guilty hand! –
And there rises ever a passionate cry
From underneath in the darkening land –
What is it, that had been done?
O dawn of Eden bright over earth and sky,
The fires of Hell brake out of thy rising sun,
The fires of Hell and of hate;
For she, sweet soul, had hardly spoken a word,
When her brother ran in his rage to the gate,
He came with the babe-faced lord,
Heaped on her terms of disgrace;
And while she wept, and I strove to be cool,
He fiercely gave me the lie,
Till I with as fierce an anger spoke,
And he struck me, madman, over the face,
Struck me before the languid fool,
Who was gaping and grinning by:
Struck for himself an evil stroke,
Wrought for his house an irredeemable woe.
For front to front in an hour we stood,
And a million horrible bellowing echoes broke
From the red-ribbed hollow behind the wood,
And thundered up into Heaven the Christless code,
That must have life for a blow.
Ever and ever afresh they seemed to grow.
Was it he lay there with a fading eye?
'The fault was mine,' he whispered, 'fly!'
Then glided out of the joyous wood
The ghastly wraith of one that I know;
And there rang on a sudden a passionate cry,
A cry for a brother's blood:
It will ring in my heart and my ears, till I die, till I die.

ALFRED, LORD TENNYSON (1809–1892)

Alfred, Lord Tennyson.

Maud was among Tennyson's first collection of poems after becoming poet laureate in 1850. The narrator of *Maud* falls passionately in love with her begging her 'to come into the garden Maud' where he can successfully woo her. Her brother disapproves of this blossoming relationship and has plans to marry her off to 'a babe-faced lord'. The brother in anger strikes his sister's lover across the face, the lord joins in and in the ensuing brawl the lover delivers a fatal blow to the brother who, dying, accepts the blame and tells him to fly while Maud cries out at seeing what a tragedy her behaviour has caused. A good slice of Victorian melodrama – little wonder that it was met with much hostile criticism which was only abated when 'Come into the garden Maud' became a popular song.

HADRAMAUTI

Who knows the heart of the Christian? How does he
 reason?
What are his measures and balances? Which is his season
For laughter, forbearance or bloodshed, and what devils
 move him
When he arises to smite us? I do not love him.

He invites the derision of strangers – he enters all places.
Booted, bareheaded he enters. With shouts and embraces
He asks of us news of the household whom we reckon
 nameless.
Certainly Allah created him forty-fold shameless.

So it is not in the Desert. One came to me weeping –
The Avenger of Blood on his track – I took him in
 keeping.
Demanding not whom he had slain, I refreshed him, I fed
 him
As he were even a brother. But Eblis had bred him.

He was the son of an ape, ill at ease in his clothing.
He talked with his head, hands and feet. I endured him
 with loathing.
Whatever his spirit conceived his countenance showed it
As a frog shows in a mud-puddle. Yet I abode it!

I fingered my beard and was dumb, in silence confronting
 him.
His soul was too shallow for silence, e'en with Death
 hunting him.
I said: ''Tis his weariness speaks,' but, when he had rested,
He chirped in my face like some sparrow, and, presently,
 jested!

Wherefore slew I that stranger? He brought me
 dishonour.
I saddled my mare, Bijli, I set him upon her.
I gave him rice and goat's flesh. He bared me to laughter.
When he was gone from my tent, swift I followed after,
Taking my sword in my hand. The hot wine had filled
 him.
Under the stars he mocked me – therefore I killed him!

RUDYARD KIPLING

TRUST NO FOX ON GREEN HEATH AND NO JEW ON HIS OATH, 1936

This children's book, written by Elvira Bauer, a Nazi supporter, and published by Julius Streicher, *The Jew Baiter*, sold 100,000 copies, and was used in many German schools. To strengthen its German identity the title is taken from a phrase of Martin Luther's. It is a vile, very nasty piece of propaganda in which caricatures of Jews are depicted as anti-German, deceitful and money-grabbing, compared to young, beautiful Germans. The message is clear – 'Get Out'. Its purpose was to inflame and anger German children at the very presence of Jews in Germany. Hatred was on the curriculum

A PEDAGOGY OF HATRED

In his *Notes on Germany and the War*, Argentinian writer Jorge Luis Borges attacked the publication of Elvira Bauer's children's book.

Displays of hatred are even more obscene and denigrating than exhibitionism. I defy pornographers to show me a picture more vile than any of the twenty-two illustrations that comprise the children's book *Trau keinem Fuchs auf gruener Heid und keinem Jud bei seinem Eid (Don't Trust Any Fox from a Heath and No Jew on his Oath)* whose fourth edition now infests Bavaria. It was first published

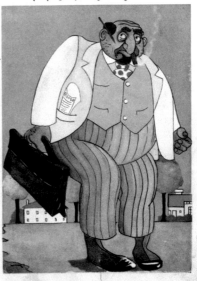

a year ago, in 1936, and has already sold 51,000 copies. Its goal is to instil in the children of the Third Reich a distrust and animosity towards Jews. Verse (we know the mnemonic virtues of rhyme) and color engravings (we know how effective images are) collaborate in this veritable textbook of hatred.

Take any page: for example, page 5. Here I find, not without justifiable bewilderment, this didactic poem – 'The German is a proud man who knows how to work and struggle. Jews detest him because he is so handsome and enterprising' – followed by an equally informative and explicit quatrain: 'Here's the Jew, recognizable to all, the biggest scoundrel in the whole kingdom. He thinks he's wonderful, and he's horrible.' The engravings are more astute: the German is a Scandinavian, eighteen-year-old athlete, plainly portrayed as a worker; the Jew is a dark Turk, obese and middle-aged. Another sophistic feature is that the German is clean-shaven and the Jew, while bald, is very hairy.

… What can one say about such a book? Personally I am outraged, less for Israel's sake than for Germany's, less for the offended community than for the offensive nation. I don't know if the world can do without German civilisation, but I do know that its corruption by the teachings of a hatred is a crime.

Printed in *Sur*, May 1937, **JORGE LUIS BORGES** (1899–1986)
Translated by S.J. Levine.

CHURCHILL – I ABSOLUTELY HATE HIM

Sir John Reith.

Good Friday, 8 April 1955 [the day Churchill resigned as Prime Minister of Britain due to his failing health] I wrote to the wretched Churchill thus:

'Here is someone who worked faithfully and well for you, but whom you broke and whose life you ruined. You were kind enough, some years later, to agree that you had misjudged; you wrote that you were very sorry and that the State was in my debt. I couldn't remind you of this while you had opportunity to put things right; but I can now, and say that I am sorry to feel as I do.'

Of course people would say it was awful to have written such a letter, undignified and all the rest of it. But if I hadn't done it I should be much more bothered than I am likely to be having done it.

SIR JOHN REITH (1889–1971)

Sir John Reith, the first Director General of the BBC, always disliked Winston Churchill. He first crossed Churchill's path in the General Strike in 1926, when Reith insisted that the BBC should not be used as a propaganda tool of the Government. Although Churchill complained that Reith kept him off the air in the 1930s because of his views on India [He was against dominion status for India], when he became Prime Minister in 1940, he did not dismiss Reith from the Cabinet, which he inherited from Neville Chamberlain. He kept Reith on until 1942. During that period, Reith showed scant regard for Churchill, recording in his diary in November 1941, 'The sight of Churchill naturally bothered me. I absolutely hate him.' Reith, impervious to the last, nursed this grievance for the rest of his life, rejoicing at Churchill's defeat in 1945.

Although the BBC mistreated Churchill before the war, he recognised Reith's work on helping to plan D-Day by awarding him the CB (Military) in 1945. After the war, Reith briefly hoped that the new Prime Minister, Clement Atlee, might appoint him to office but Attlee, the Labour Prime Minister from 1945 until 1951, did not do so. But Reith continued to have political influence, as when he wrote this letter in 1955 he was holding the position of Chairman of the Colonial Development Corporation, a significant public body. Between Reith and Churchill there was a clash of incompatible personalities. This letter to Churchill is the splenetic outburst of a man consumed with self-conceit and unable to see the extent to which he is the architect of his own bad luck.

THE END OF THE AFFAIR

'*Oh God, you've done enough*'

Set in London during and just after the Second World War, *The End of the Affair* by Graham Greene, tells of the passionate affair between Sarah Miles, who is married and her lover, Maurice Bendrix. It is an affair which Sarah's husband, Henry, not only knows about but condones because he, too, loves Sarah and wants her to be happy. The story mirrors Greene's own affair with Catherine Walston.

Graham Green.

The affair started in 1939 and lasted until 1944, when Sarah without giving reasons abruptly broke it off. The narrative begins in January 1946 when Bendrix encounters Henry, worried that his wife is having an affair. By hiring a detective, Bendrix is able to read Sarah's diary and discover how much she loved him. He wants to resume the relationship immediately but she is succumbing to a deadly lung infection and dies. Through her diary, Bendrix learns that Sarah thought he had died and had made a promise to God not to see him again if He allowed Bendrix to live again. She says, 'I caught belief like a disease.' Sarah's God is a forgiving and loving God. The story is not just about human love but of Divine love, stunningly described by a miraculous disappearance of a disfiguring strawberry birthmark on the face of a man who had helped Sarah and whom she had kissed. Bendrix, however, finds that God is neither loving nor forgiving. He utters a great paean of hatred against God. This is the passage which ends the book and on which Graham Greene later commented: 'I very much liked the last passages.'

I went up to my room and took the journal out. I tore the covers off. They were tough: the cotton backing came out like fibres; it was like tearing the limbs off a bird, and there the journal lay on the bed, a pad of paper, wingless and wounded. The last page lay upwards and I read again, 'You were there teaching me to squander, so that one day we might have nothing left except this love of You. But You are too good to me. When I ask You for pain, You give me peace. Give it him too. Give him my peace – he needs it more.'

I thought, you've failed there, Sarah. One of your prayers at least has not been answered. I have no peace and I have no love, except for you, you. I said to her, I'm a man of hate. But I didn't feel much hatred; I had called other people hysterical, but my own words were overcharged. I could detect their insincerity. What I chiefly felt was less hate than fear. For if this God exists, I thought, and if even you – with your lusts and your adulteries and the timid lies you used to tell – can change like this, we could all be saints by leaping as you leapt, by shutting the eyes and leaping once and for all: if *you* are a saint, it's not so difficult to be a saint. It's something He can demand of any of us, leap. But I won't leap. I

sat on my bed and said to God: You've taken her, but You haven't got me yet. I know Your cunning. It's You who take us up to a high place and offer us the whole universe. You're a devil, God, tempting us to leap. But I don't want Your peace and I don't want Your love. I wanted something very simple and very easy: I wanted Sarah for a lifetime and You took her away. With Your great schemes You ruin our happiness like a harvester ruins a mouse's nest: I hate You, God, I hate You as though You existed.

I looked at the pad of paper. It was more impersonal than a scrap of hair. You can touch hair with your lips and fingers and I was tired to death of the mind. I had lived for her body and I wanted her body. But the journal was all I had, so I shut it back in the cupboard, for wouldn't that have been one more victory for Him, to destroy it and leave myself more completely without her? I said to Sarah, all right, have it *your* way. I believe you live and that He exists, but it will take more than your prayers to turn this hatred of Him into love. He robbed me and like that king you wrote about I'll rob Him of what he wants in me. Hatred is in my brain, not in my stomach or my skin. It can't be removed like a rash or an ache. Didn't I hate you as well as love you? And don't I hate myself?

I called down to Henry, 'I'm ready,' and we walked side by side over the Common towards the 'Pontefract Arms'; the lights were out, and lovers met where the roads intersected, and on the other side of the grass was the house with the ruined steps where He gave me back this hopeless crippled life.

'I look forward to these evening walks of ours,' Henry said.

'Yes.'

I thought, in the morning I'll ring up a doctor and ask him whether a faith cure is possible. And then I thought, better not; so as long as one doesn't *know*, one can imagine innumerable cures... I put my hand on Henry's arm and held it there; I had to be strong for both of us now, and he wasn't seriously worried yet.

'They are the only things I do look forward to,' Henry said.

I wrote at the start that this was a record of hate, and walking there beside Henry towards the evening glass of beer, I found the one prayer that seemed to serve the winter mood: O God, You've done enough, You've robbed me of enough, I'm too tired and old to learn to love, leave me alone for ever.

GRAHAM GREENE (1904–1991)

The film poster.

THE ANGER OF POLISH SOLDIERS

Military Rape – *Komm Frau* – 'Come Woman'

Throughout history the spoils of war have included looting, pillage, and the rape of the defeated women. Lurid stories are conjured up of mass rape by Asiatic hordes, even Christian Crusaders, the Nazi Army, the Red Army, and the Muslim fanatics of ISIS; their very threat steeled the resolve of the besieged and the threatened to hold out to the last. Although there are no reliable statistical records there are plenty of personal recollections of individual cases of rape.

An interesting dispute has erupted in the last few years over a claim by a German journalist and historian, Miriam Gebhardt, in *Crimes Unspoken* that 860,000 German women and girls were raped by 520,000 Russian soldiers, 190,000 American soldiers and 50,000 French at the end of the Second World War. Gebhardt has also made claims that 45,000 British soldiers raped German women. These figures have been the subject of controversy particularly as they were based on estimates, but these might well be on the low side. In 2002, Anthony Beevor estimated that at least two million German women were raped by allied soldiers during the last six months of World War Two, around 100,000 of them in Berlin.

To the Russian soldiers of the Red Army this was not simply an act of individual lust, but also revenge for the deaths of 926,000 Russian soldiers.

On 12 October 2013, a twenty-six-year-old Polish art student at the Gdansk Fire Arts Academy, Jerzy Bohdan Szumczyk, placed his life-size concrete sculpture called *Komm Frau* (Come Woman), depicting a Red Army soldier raping a pregnant woman

Komm Frau (Come Woman) by Jerzy Bohdan Szumczyk, 2013.

while holding her hair and putting a gun to her head, next to a Communist-era memorial to the Red Army. The statue, which weighed 500 pounds, so appalled the Russian Ambassador that he had the police remove it the next day. The student was arrested but never charged. A Polish journalist estimated that forty per cent of the women living in Gdansk were raped. The student did not apologise and later commented, 'I know that the work is vulgar but such is our history'.

THE ANGER OF RADICAL ISLAM

Hatred is the motive of most religious attacks. Bigots of one faith claim that their beliefs are superior to all others, and their faith is more authentic than others. To deny this truth is an evil that must be eradicated. Such indoctrination allows radical preachers to inflame hatred and urge their followers to acts of violence against unbelievers.

The Christian faiths succumbed to this in the sixteenth century when Roman Catholics and Protestants fought each other to the death for two centuries in fratricidal ideological conflict. In England, Mary Tudor had 300 Protestants burnt at the stake and her sister Elizabeth tortured and burned Jesuits. It was in the eighteenth and nineteenth centuries that Christians came to tolerate each other as the most truly Christian way forward. One of the great gifts that the British Empire gave to the world was that local religions were not persecuted or forbidden, and that all religions were tolerated.

Today, however, the most persecuted religion in the world is Christianity and Christians across the world are attacked by the passionate anger of Talibans, Al-Qaeda, Boko Haram and ISIS. A study produced by the Center for Studies on New Religions found that over 90,000 Christians were murdered in 2016, thirty per cent at the hands

Still from an ISIS recruitment video.

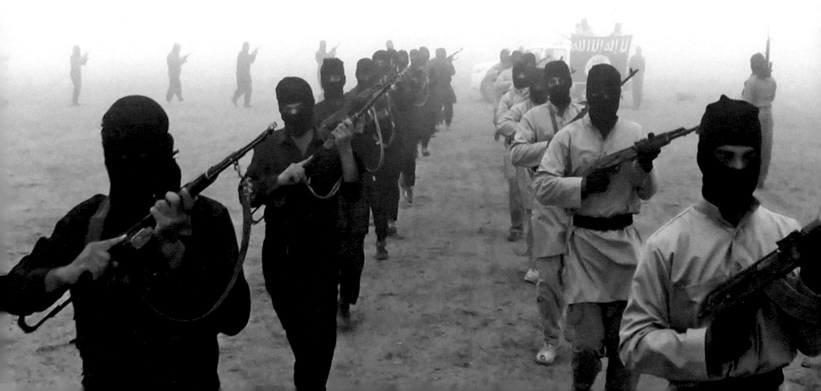

of Islamic terrorists. George Orwell in his essay on 'Lear, Tolstoy and the Fool' in 1947 described so well the course of religious bigotry:

> For if you have embraced a creed which appears to be free from the ordinary dirtiness of politics – a creed from which you yourself cannot expect to draw any material advantage – surely that proves that you are in the right? And the more you are in the right, the more natural that everyone else should be bullied into thinking likewise.

As if bullying was not enough, ISIS has added brute force, rape, torture, beheading, crucifixion and massacre.

NIGERIA

In 2014 all the world knew when 276 Christian schoolgirls were abducted by the fundamentalist Islamic group Boko Haram. Since that time, as the world has all but forgotten the kidnappings, the International Committee of the Red Cross has worked for their release. In October 2016, twenty-one girls were released to their families and in May 2017 a further eighty-two girls. However, many of the girls remain missing.

In 2016 Christian villages in the north of Nigeria were invaded by Muslim Fulani tribes – Christian homes were burnt, churches raised to the ground, old women set alight, young women raped or shot, and babies bashed to death. This slaughter continues with the apparent support of the Nigerian President, Mohammed Bulari, who comes from the Fulani tribes. Among their victims is Audu Gambo, aged twenty-five years. Hurrying back to his village, Godogodo, when he heard gunfire, he found his pregnant wife had been shot dead, disembowelled and then burnt with her unborn child placed on top of her. Unlike the position taken by Abdel Fattah El-Sisi, the Egyptian President and his government towards radical Islam, Nigerian troops seldom intervene against the anger of radical Islamists.

Below left: Two young Fulani men prospecting, 2016.

Below right: Christians protesting at the murder of Shahbaz Bhatti, 2011.

PAKISTAN

Shahbaz Bhatti, a Roman Catholic from the Punjab, was elected to the National Assembly in 2008. Being the only Christian in the Cabinet he was soon appointed the Federal Minister for Minorities. He campaigned vigorously against Pakistan's blasphemy laws which allows non-believers and those who question the Koran to be tried and executed. On 2 March 2011, driving alone after visiting his mother and in full daylight, his car was sprayed by bullets and he was killed. Within minutes the Taliban boasted that they had done it. Some months earlier he had predicted his own death saying, 'I am ready to die for a cause.' On 22 September 2013, Radical Islam, motivated by hatred of the non-believer, brought about a twin suicide bomb attack at the 130-year-old All Saints Church in Peshawar. An estimated 127 Christians were killed and over 250 injured. It was the deadliest attack on Christians in Pakistan's history. Another attack on 15 March 2015 at a Roman Catholic Church and a Protestant Church in Lahore's Youhanabad area killed fifteen Christians, and on 27 March 2016 a suicide bomber, targeting Christians celebrating Easter attacked a playground in Lahore, killing seventy.

ISIS

There have been many occasions when ISIS have tortured and crucified Christians declaring, 'If you love Jesus you will die like Jesus.' On 28 August 2016, twelve Syrian Christian missionaries, including a twelve-year-old boy, were captured near Aleppo. Although their ministry director begged them to leave before their capture, so determined were they to avow and protect their faith they refused to do so. In scenes reminiscent of the Inquisition, ISIS cut off the fingertips of the boy telling his father they would stop the torture only if he denied Christ and returned to Islam. When he and his two colleagues refused, they were also tortured. They and the boy were crucified and left on crosses for two days. Among the other eight Syrian Christians killed by ISIS, the two women were raped before a crowd and then beheaded.

Christian missionaries murdered by ISIS near Aleppo in 2016.

THE EARLY PENALTIES OF ANGER

Æthelberht, King of Kent, 589–616, was the first English king to convert to Christianity and it was in his reign that Augustine came to Canterbury. In 602–603 he issued a set of laws setting out a series of fines for crimes and misdemeanours. Written in Anglo-Saxon it was the earliest legal code and it became the basis for the development of later laws:

If a person… receives a blow from a raised hand, let him who struck the blow pay a shilling. If the bruise that arises from the blow should be black outside the clothing, let him pay 30 sceattas in addition, if it should be inside the clothing, let him pay 20 sceattas in addition, for each bruise.

Æthelberht's code translated by Lisi Oliver, 2001.

For a black eye the offender was fined more than a bruise hidden by a sleeve.

In Æthelberht's day a sceatt was a unit of gold with the weight of a grain of barley, with 20 sceattas per scilling and that one ox was probably valued at one scilling or 'shilling'.

Æthelberht from the *Epitome of Chronicles of Matthew Paris*, 13th century.

Infernal punishment for the Seven Deadly Sins, Nicolas Le Rouge, 1496.

The sin of anger is punished in Hell by impaling.

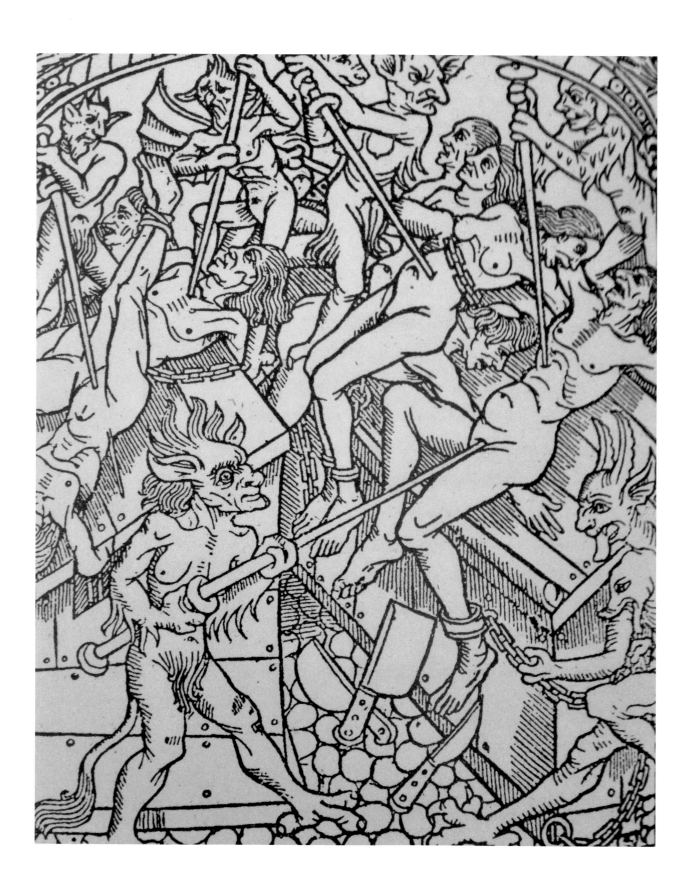

Sloth

Gone Fishing, Ronald Searle, Paris 1961–1975.

It is the sin which believes in nothing, cares for nothing, seeks to know nothing, interferes with nothing, enjoys nothing, loves nothing, hates nothing, finds purpose in nothing, lives for nothing, and only remains alive because there is nothing it would die for.

DOROTHY L. SAYERS

THE INDOLENCE OF THE GAUCHOS OF LA PLATA
At Mercedes I asked two men why they did not work. One gravely said the days were too long; the other that he was too poor.

CHARLES DARWIN (1809–1882)

...ah, why
Should life all labour be?

ALFRED, LORD TENNYSON

Now it is not good for the Christian's health to hustle the Aryan brown,
For the Christian riles, and the Aryan smiles and he weareth the Christian down;
And the end of the fight is a tombstone white with the name of the late deceased,
And the epitaph drear: A Fool lies here who tried to hustle the East.

RUDYARD KIPLING

I must from this enchanting queen break off;
Ten thousand harms, more than the ills I know,
My idleness doth hatch.

Act 1, Scene 2, *Anthony and Cleopatra*, WILLIAM SHAKESPEARE

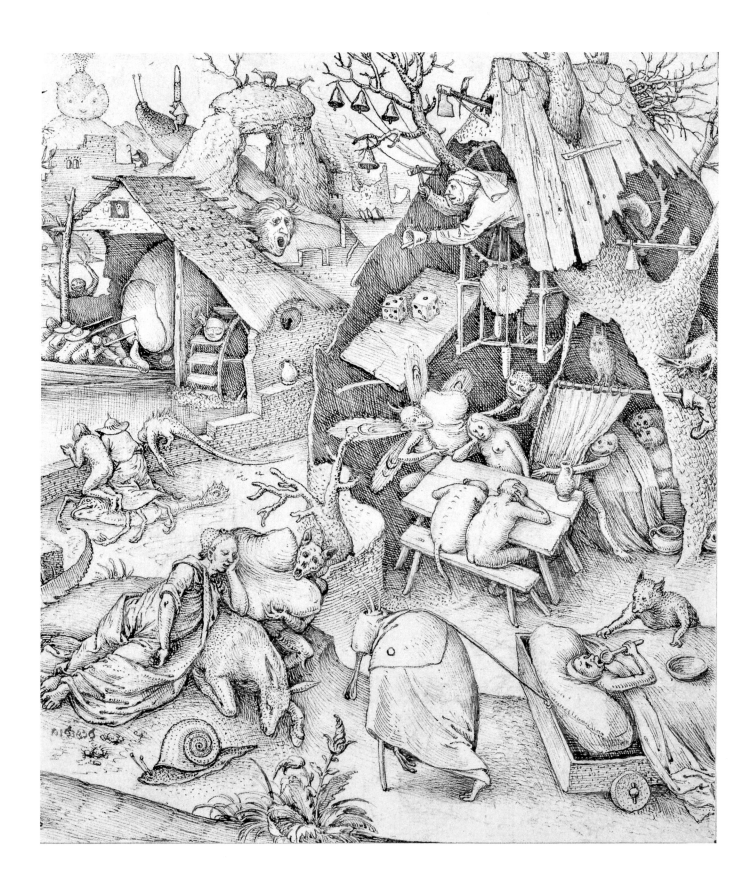

THE WORD SLOTH IS RARELY HEARD TODAY and we have settled instead for laziness. The word chosen by the Desert Fathers in the third century was 'accidia' for which there are several translations, the closest to what they saw as a sin being apathy where the sinner simply couldn't be bothered to follow the word of God. G.K. Chesterton echoed this when he said, 'Tolerance is the virtue of the man with no convictions.' It may be easier to appear tolerant and sit on the fence than to choose sides or have an opinion, but uncritical tolerance and the notion that all truths are equal could lead to a spiritual inertia and a refusal to commit to any belief, cause or country.

Luke:10 shows how 'passing by on the other side' is the way of the non-committed and Proverbs:26 states, 'Interfering in someone else's argument is as foolish as yanking a dog's ears.' Worldly advice is 'Don't get involved.' Interpreted in this light, Pope Gregory in the sixth century warned that sloth would give rise to despair, melancholy, depression and even suicide, and in this guise it qualified as deadly.

Leading to passivity, inertia and sluggishness, can any positive case be made for sloth? Robert A. Heinlein, who was the doyen of American science fiction writers, suggested that 'progress is made by lazy men looking for easier ways to do things.' This observation provides a good one-sentence summary for the causes of social change but it is only partly correct. There have been and will continue to be endless cases where a nation or a society settles for an easier, less ambitious way of life and sinks into torpor. The state of late nineteenth century provincial Russia described by Chekhov illustrates all too clearly how languor and resignation can lead in the end to a revolution.

But sloth has one huge advantage identified by Davina (D.A.) Prince, the winner of a 2012 *Spectator* magazine poetry competition to praise for one of the seven deadly sins:

Death and his scythe will mow us all, so why
waste precious time on toiling? Instead, try
to cultivate Sloth's higher forms: if 'sin'
Is lounging by the poolside, let's begin!
Tell those who question what your idling's for:
No slothful person ever starts a war.

Sloth is regarded today as a vexing misdemeanour but Evelyn Waugh thought it a positive virtue, for 'if politicians and scientists were lazier how much happier we would be.' Procrastination, which is putting off to tomorrow that which should be done today, like writing letters of condolence or congratulation, or not fixing the roof while the sun is shining, does not deserve the punishment of eternal damnation. As sloth is a solitary sin, its punishment is the sadness of loneliness – work and the world works with you, laze and you laze alone.

The elegant defence of sloth is that it allows one to sit coolly observing the way of the world from some quiet corner or sitting beside a trout stream, or abandoning, as

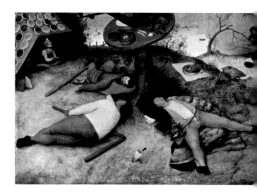

Het Luilekkerland, 'the lazy-luscious-land', known in English as The Land of Cockaigne, Pieter Bruegel the Elder, 1567.

In medieval times, Cockaigne was a mythical land of plenty, but Bruegel's depiction of Cockaigne and its residents is not meant to be a flattering one. He chooses rather a comic illustration of the spiritual emptiness believed to derive from gluttony and sloth, two of the seven deadly sins.

Desidia (Sloth), detail, Pieter Bruegel the Elder, 1557.

eighteenth century aristocrats did, the pleasures and ambitions of the court to 'cultivate their gardens.' In the nineteenth century both Alfred, Lord Tennyson and Robert Louis Stevenson took up the standard for the 'Idler' and in the 1950s, when I was at Oxford, the then Vice-Chancellor published a pamphlet on *The Role of Idleness in Education*. Though few were so optimistic as Bertrand Russell the philosopher and mathematician whose 1932 essay 'In Praise of Idleness' argued that if workers were to work only four hours a day it would promote world peace and harmony. In today's busy and continuously changing world it becomes increasingly difficult to find time for peace and quiet in our lives. Sue Townsend, in *The Woman who Went to Bed for a Year*, describes how Eva Beaver lies in her white bed, in a bare white room slowly withdrawing from her dull, suburban life – good for her, but she also had myriad helpers persuading, cajoling and bullying her along.

Another writer, Thomas Pynchon, in an article in *The New York Review of Books* described sloth's offspring as, 'though bad... not always evil' and a source of inspiration for writers. 'Idle dreaming is often the essence of what we do. We sell our dreams. So real money actually proceeds from sloth, although this transformation is said to be even more amazing elsewhere in the entertainment sector, where idle exercises in poolside loquacity have not infrequently generated tens of millions of dollars in revenue.'

THE INDOLENCE OF THE GERMAN PEOPLE

If we contemplate a savage nation in any part of the globe, a supine indolence and carelessness of futurity will be found to constitute their general character. In a civilised state, every faculty of man is expanded and exercised; and the great chain of mutual dependence connects and embraces the several members of society. The most numerous portion of it is employed in constant and useful labour. The select few, placed by fortune above that necessity, can, however, fill up their time by the pursuits of interest or glory, by the improvement of their estate or of their understanding, by the duties, the pleasures, and even the follies of social life. The Germans were not possessed of these varied resources. The care of the house and family, the management of the land and cattle, were delegated to the old and the infirm, to women and slaves. The lazy warrior, destitute of every art that might employ his leisure hours, consumed his days and nights in the animal gratifications of sleep and food. And yet, by a wonderful diversity of nature, (according to the remark of a writer who had pierced into its darkest recesses), the same barbarians are by turns the most indolent and the most restless of mankind. They delight in sloth, they detest tranquillity. The languid soul, oppressed with its own weight, anxiously required some new and powerful sensation; and war and danger were the only amusements adequate to its fierce temper. The sound that summoned the German to arms was grateful to his ear. It

Sloth (Pigritia)
Jacques Callot, etching and engraving, after 1621.

rouses him from his uncomfortable lethargy, gave him an active pursuit, and, by strong exercise of the body, and violent emotions of the mind, restored him to a more lively sense of his existence. In the dull intervals of peace, these barbarians were immoderately addicted to deep gaming and excessive drinking; both of which, by different means, the one by inflaming their passions, the other by extinguishing their reason, alike relieved them from the pain of thinking.

The History of the Decline and Fall of the Roman Empire, EDWARD GIBBON

YET A LITTLE MORE SLEEP

Simple, Sloth and Presumption.

I saw then in my dream, that he went on thus, even until he came at a bottom, where he saw, a little out of the way, three men fast asleep, with fetters upon their heels. The name of one was Simple, another Sloth, and the third Presumption.

Christian then seeing them lie in this case, went to them, if peradventure he might awake them. And cried, 'You are like them that sleep on the top of a mast, for the Dead Sea is under you, a gulf that hath no bottom. [Prov. 23:34] Awake therefore, and come away; be willing also, and I will help you off with your irons.' He also told them, 'If he that goeth about like a roaring lion comes by, you will certainly become a prey to his teeth.' [1 Pet. 5:8] With that they looked upon him, and began to reply in this sort: Simple said, 'I see no danger'; Sloth said, 'Yet a little more sleep'; and Presumption said, 'Every fat must stand upon its own bottom; what is the answer else that I should give thee?' And so they lay down to sleep again, and Christian went on his way.

Yet was he troubled to think that men in that danger should so little esteem the kindness of him that so freely offered to help them, both by awakening of them, counselling of them, and proffering to help them off with their irons.

The Pilgrim's Progress, JOHN BUNYAN (1628–1688)

The consequence for Simple, Sloth and Presumption of failing to heed Christian's warning is severe. When Mercy revisits the place where they lived she discovers from Great-Heart that all three have been hanged for 'they turned several [pilgrims] out of the way... Slow-pace... Short-wind... No-heart... Sleepy-head...'

T'IS THE VOICE OF THE SLUGGARD

Isaac Watts was an eighteenth century non-conformist priest, scholar and a prolific writer of hymns including 'Oh God Our Help in Ages Past' and 'When I Survey the Wondrous Cross.' He also published *Divine and Moral Songs for Children* in 1715, which became something of a bestseller and was much read in Victorian England. Among the best-known poems in this collection, 'The Sluggard' was so popular that Lewis Carroll parodied it in *Alice in Wonderland* as the *Voice of the Lobster*.

THE SLUGGARD

'Tis the voice of the sluggard; I heard him complain,
'You have waked me too soon, I must slumber again.'
As the door on its hinges, so he on his bed,
Turns his sides and his shoulders and his heavy head.

'A little more sleep, and a little more slumber;'
Thus he wastes half his days, and his hours without number,
And when he gets up, he sits folding his hands,
Or walks about sauntering, or trifling he stands.

I pass'd by his garden, and saw the wild brier,
The thorn and the thistle grow broader and higher;
The clothes that hang on him are turning to rags;
And his money still wastes till he starves or he begs.

SPECIMEN OF MORAL SONGS. 39

SONG I.
The Sluggard.

I made him a visit, still hoping to find
That he took better care for improving his mind:
He told me his dreams, talked of eating and drinking;
But scarce reads his Bible, and never loves thinking.

Said I then to my heart, 'Here's a lesson for me,'
This man's but a picture of what I might be:
But thanks to my friends for their care in my breeding,
Who taught me betimes to love working and reading.

ISAAC WATTS (1674–1748)

THE FATE OF THE IDLE 'PRENTICE, 1747

William Hogarth (1697–1764)

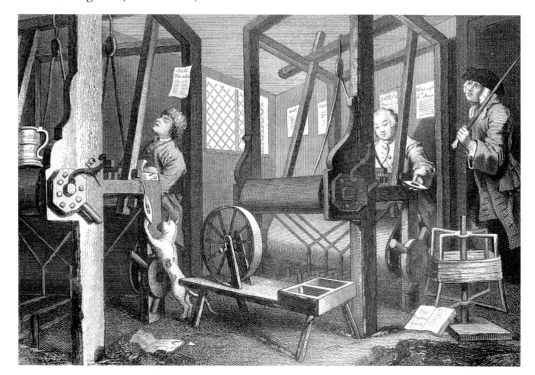

The Idle and The Industrious 'Prentice.

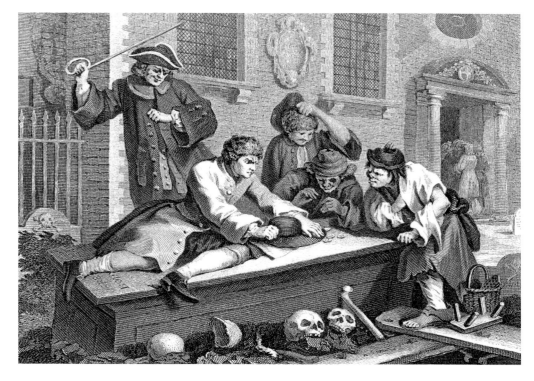

He gambles instead of working.

He is sent off to sea.

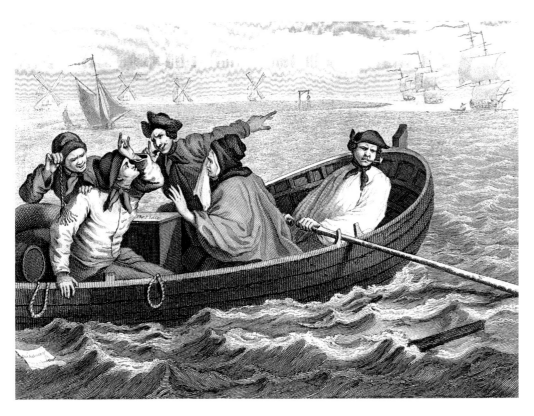

Back home with a common whore.

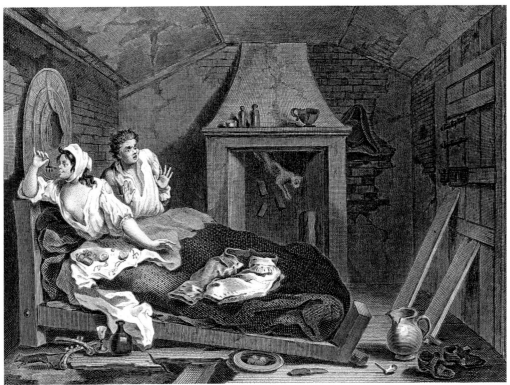

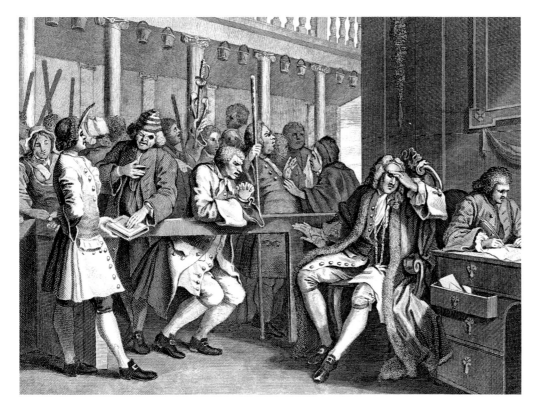

Tried for felony – the Industrious 'Prentice is now a magistrate.

Condemned to hang at Tyburn.

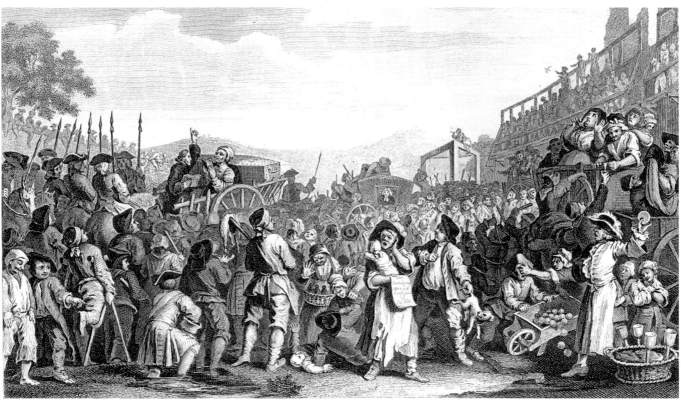

THE LAZY FELLOWS OF MAGDALEN COLLEGE, 1752

I spent fourteen months at Magdalen College; they proved the most idle and unprofitable of my whole life: the reader will pronounce between the school and the scholar; but I cannot affect to believe that nature had disqualified me for all literary pursuits... The fellows or monks of my time were decent easy men, who supinely enjoyed the gifts of the founder; their days were filled by a series of uniform employments; the chapel and the hall, the coffee house and the common room, till they retired, weary and well satisfied, to a long slumber. From the toll of reading, or thinking, or writing, they had absolved their conscience; and the first shoots of learning and ingenuity withered on the ground ... Dr ---- [his own tutor] well remembered that he had a salary to receive, and only forgot that he had a duty to perform.

Memoirs of my Life and Writings, EDWARD GIBBON
Compiled by John Holroyd, Earl of Sheffield.

Portrait of Edward Gibbon,
Henry Walton, 1773.

Magdalen College, Oxford,
M.A. Rocker, line engraving,
1778.

'IT IS WITH THE UTMOST DIFFICULTY THAT I CAN GET UP'

27 March 1764

[Indolence] attacks me especially in the morning. I go to bed at night with the most determined resolutions to get up early. François, my faithful servant, wakes me at half-past-six. But when I open my eyes and see daylight again, a crowd of disagreeable ideas comes into my mind. I think gloomily of the vanity and misery of human life. I think that it is not worth while to do anything. Everything is insipid or everything is dark. Either my feelings will be numbed, or I shall feel pain; and I can only solace myself with a little present ease. Happy is the man who can forget that he exists... The truth is that man is made for action. When he is busy, he fulfils the intention of his Creator, and he is happy. Sleep and amusement serve to refresh his body and his mind and qualify him to continue his course of action. How is it then that I feel so gloomy every morning, and that these convincing arguments have not the least influence on my conduct? I believe the explanation is some physical disorder. My nerves at that time are relaxed, the vapours have risen to my head. If I get up and move about a little, I am happy and brisk. But it is with the utmost difficulty that I can get up. I have thought of having my bed constructed in a curious fashion. I would have it so that when I pulled a cord, the middle of the bed would be immediately raised and me raised with it and gradually set up on the floor. Thus I should be gently forced into what is good for me.

James Boswell, 9th Laird of Auchinleck, Scottish lawyer, diarist, and author. Engraving by S. Freeman from a painting by Sir Joshua Reynolds, 1785.

And must I now heroic lines compose,
I, who fatigu'd with various thinking, doze?
Who, by a kind of lethargy oppress'd,
Maintain that man was only made for rest;
Who lazy blood is stirr'd by no desire,
In whose fat frame there is no spark of fire,
Who the warm chimney-corner would not quit
For all the brilliant charms of lively Wit;
Nor by the voice of Glory or the Fair
Be tempted to forsake an easy-chair.

Boswell in Holland 1763–1764, JAMES BOSWELL (1740–1795)

Mr Skimpole facing arrest by a debt collector seeking a sum of £23 16s 7½d, Phiz (Hablot K. Browne), 1853.

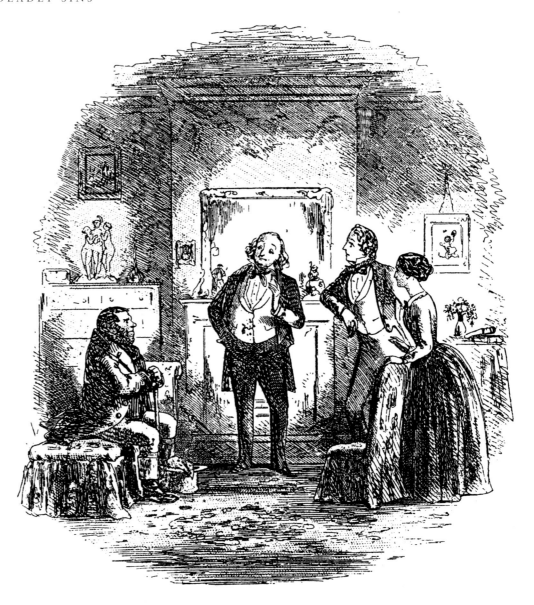

HAROLD SKIMPOLE, AN ENGAGING SPONGER

When we went downstairs, we were presented to Mr Skimpole, who was standing before the fire telling Richard how fond he used to be, in his school-time, of football. He was a little bright creature with a rather large head, but a delicate face and a sweet voice, and there was a perfect charm in him. All he said was so free from effort and spontaneous and was said with such a captivating gaiety that it was fascinating to hear him talk.

…His good friend Jarndyce and some other of his good friends then helped him, in quicker or slower succession, to several openings in life, but to no purpose, for he must confess to two of the oldest infirmities in the world: one was that he had no idea of time, the other that he had no idea of money. In consequence of which he never kept an appointment, never could transact any

business, and never knew the value of anything! Well! So he had got on in life, and here he was! He was very fond of reading the papers, very fond of making fancy-sketches with a pencil, very fond of nature, very fond of art. All he asked of society was to let him live. THAT wasn't much. His wants were few. Give him the papers, conversation, music, mutton, coffee, landscape, fruit in the season, a few sheets of Bristol-board, and a little claret, and he asked no more. He was a mere child in the world, but he didn't cry for the moon. He said to the world, 'Go your several ways in peace! Wear red coats, blue coats, lawn sleeves; put pens behind your ears, wear aprons; go after glory, holiness, commerce, trade, any object you prefer; only – let Harold Skimpole live!'

'I covet nothing,' said Mr. Skimpole in the same light way. 'Possession is nothing to me. Here is my friend Jarndyce's excellent house. I feel obliged to him for possessing it. I can sketch it and alter it. I can set it to music. When I am here, I have sufficient possession of it and have neither trouble, cost, nor responsibility. My steward's name, in short, is Jarndyce, and he can't cheat me... I don't know that it's of any direct use my doing so, but it's all I can do, and I do it thoroughly. Then, for heaven's sake, having Harold Skimpole, a confiding child, petitioning you, the world, an agglomeration of practical people of business habits, to let him live and admire the human family, do it somehow or other, like good souls, and suffer him to ride his rocking-horse!'

It was plain enough that Mr. Jarndyce had not been neglectful of the adjuration. Mr. Skimpole's general position there would have rendered it so without the addition of what he presently said.

'It's only you, the generous creatures, whom I envy,' said Mr. Skimpole, addressing us, his new friends, in an impersonal manner. 'I envy you your power of doing what you do. It is what I should revel in myself. I don't feel any vulgar gratitude to you. I almost feel as if YOU ought to be grateful to ME for giving you the opportunity of enjoying the luxury of generosity. I know you like it. For anything I can tell, I may have come into the world expressly for the purpose of increasing your stock of happiness. I may have been born to be a benefactor to you by sometimes giving you an opportunity of assisting me in my little perplexities. Why should I regret my incapacity for details and worldly affairs when it leads to such pleasant consequences?

Bleak House, CHARLES DICKENS (1812–1870)

The great Victorian values of ambition, application, perseverance, and hard work, meet their direct opposite in Dickens' description. Disengaged, unambitious, and lounging his way through life he sponges off the generosity and goodwill of Mr Jarndyce; but never has a defence for sponging been so delightfully portrayed.

OUR ARTIST.

"If you please, Sir, here's the printer's boy called again!"
"Oh, bother! Say I'm busy."
John Leech, 1846.

VICTORIAN IDLENESS

From ten to eleven, ate breakfast for seven;
From eleven to noon, to begin was too soon;
From twelve to one, asked, 'What's to be done?'
From one to two, found nothing to do;
From two to three, began to foresee
That from three to four would be a damned bore.

A Day at the India Office, THOMAS LOVE PEACOCK (1785–1866)

Recruited in 1819 to the Examiner's Office of the East India Company for his literary ability, Thomas Love Peacock, the novelist, started work dealing with miscellaneous subjects at a starting salary of £600. His literary friend, Charles Lamb, who had been working for the Company as a clerk for three years was paid nothing like as much. The work was undemanding and spasmodic as the mails from India only arrived twice a year. The first line of *A Day at the India Office*, which was sent to Percy Bysshe Shelley, refers to the custom that anyone who turned up before 10 a.m. was given a full breakfast.

Peacock worked for James Mill, who appointed his seventeen-year-old son, John Stuart Mill, as a clerk in 1823. Peacock succeeded James Mill as Chief Examiner in 1836, and when he retired in 1856 he handed over his post to John Stuart Mill – a lovely piece of literary nepotism.

THE SONG OF THE LOTUS-EATERS

'Ah, why should life all labour be?'

CHORIC SONG
I
There is sweet music here that softer falls
Than petals from blown roses on the grass,
Or night-dews on still waters between walls
Of shadowy granite, in a gleaming pass;
Music that gentlier on the spirit lies,
Than tir'd eyelids upon tir'd eyes;
Music that brings sweet sleep down from the blissful skies.
Here are cool mosses deep,
And thro' the moss the ivies creep,
And in the stream the long-leaved flowers weep,
And from the craggy ledge the poppy hangs in sleep."

The Lotus-Eaters
Genie Melisande, 2015.

II

Why are we weigh'd upon with heaviness,
And utterly consumed with sharp distress,
While all things else have rest from weariness?
All things have rest: why should we toil alone,
We only toil, who are the first of things,
And make perpetual moan,
Still from one sorrow to another thrown:
Nor ever fold our wings,
And cease from wanderings,
Nor steep our brows in slumber's holy balm;
Nor harken what the inner spirit sings,
'There is no joy but calm!'
Why should we only toil, the roof and crown of things?

...

IV

Hateful is the dark-blue sky,
Vaulted o'er the dark-blue sea.
Death is the end of life; ah, why
Should life all labour be?
Let us alone. Time driveth onward fast,
And in a little while our lips are dumb.
Let us alone. What is it that will last?
All things are taken from us, and become
Portions and parcels of the dreadful past.
Let us alone. What pleasure can we have
To war with evil? Is there any peace
In ever climbing up the climbing wave?
All things have rest, and ripen toward the grave
In silence; ripen, fall and cease:
Give us long rest or death, dark death, or dreamful ease.

ALFRED, LORD TENNYSON

Robert Louis Stevenson
c. 1887.

AN APOLOGY FOR IDLERS

'...a faculty for idleness implies a catholic appetite and a strong sense of personal identity.'

Extreme *busyness*, whether at school or college, kirk or market, is a symptom of deficient vitality; and a faculty for idleness implies a catholic appetite and a strong sense of personal identity. There is a sort of dead-alive, hackneyed people about, who are scarcely conscious of living except in the exercise of some conventional occupation. Bring these fellows into the country, or set them aboard ship, and you will see how they pine for their desk or their study. They have no curiosity; they cannot give themselves over to random provocations; they do not take pleasure in the exercise of their faculties for its own sake; and unless Necessity lays about them with a stick, they will even stand still. It is no good speaking to such folk: they *cannot* be idle, their nature is not generous enough: and they pass those hours in a sort of coma, which are not dedicated to furious moiling in the gold-mill. When they do not require to go to the office, when they are not hungry and have no mind to drink, the whole breathing world is a blank to them. If they have to wait an hour or so for a train, they fall into a stupid trance with their eyes open. To see them, you would suppose there was nothing to look at and no one to speak with; you would imagine they were paralysed or alienated: and yet very possibly they are hard workers in their own way, and have good eyesight for a flaw in a deed or a turn of the market. They have been to school and college, but all the time they had their eye on the medal; they have gone in the world and mixed with clever people, but all the time they were thinking of their own affairs. As if a man's soul were not too small to begin with, they have dwarfed and narrowed theirs by a life of all work and no play; until here they are at forty, with a listless attention, a mind vacant of all material of amusement, and not one thought to rub against another, while they wait for the train. Before he was breeched, he might have clambered on the boxes; when he was twenty, he would have stared at the girls; but now the pipe is smoked out, the snuff-box empty, and my gentleman sits bolt upright upon a bench, with lamentable eyes. This does not appeal to me as being Success in Life.

ROBERT LOUIS STEVENSON (1850–1894)

UTOPIA, LIMITED

This is the opening chorus from Gilbert and Sullivan's penultimate operetta which premiered on 7 October 1893. It deserves to be more widely known because it is really a satire upon the supposed civilising effect of Britain and her Empire. Utopia is a happy, backward and lazy place which is going to be civilised and modernised by copying Britain. But the imported flowers of progress are soldiers, sailors, company promoters, county councillors and MPs – oh unlucky Utopia.

Programme cover, 1893.

SCENE. *A Utopian Palm Grove in the gardens of King Paramount's Palace, showing a picturesque and luxuriant tropical landscape, with the sea in the distance. Salata, Melene, Phylla, and other Maidens discovered, lying lazily about the stage and thoroughly enjoying themselves in lotus-eating fashion.*

Chorus
In lazy languor – motionless,
We lie and dream of nothingness;
For visions come
From Poppydom
Direct at our command:
Or, delicate alternative,
In open idleness we live,
With lyre and lute
And silver flute,
The life of Lazyland!
In lazy languor – motionless,
We lie and dream of nothingness.

Phylla
The song of birds
In ivied towers;
The rippling play
Of waterway;
The lowing herds;
The breath of flowers;
The languid loves
Of turtle doves –

Chorus.
The song of birds
In ivied towers;
The rippling play
Of waterway.

Phylla.
The lowing herds;
The breath of flowers;
The languid loves
Of turtle doves –

Chorus.
These simple joys are all at hand
Upon thy shores, O Lazyland!
O Lazyland! O Lazyland!
O Lazyland!

Act 1, *Utopia, Limited or the Flowers of Progess*
Music by
SIR ARTHUR S. SULLIVAN (1842–1900)
Libretto by
SIR WILLIAM S. GILBERT (1836–1911)

IN PRAISE OF IDLENESS

Like most of my generation, I was brought up on the saying: 'Satan finds some mischief still for idle hands to do.' Being a highly virtuous child, I believed all that I was told, and acquired a conscience which has kept me working hard down to the present moment. But although my conscience has controlled my *actions*, my *opinions* have undergone a revolution. I think that there is far too much work done in the world, that immense harm is caused by the belief that work is virtuous, and that what needs to be preached in modern industrial countries is quite different from what always has been preached…

I hope that, after reading the following pages, the leaders of the YMCA will start a campaign to induce good young men to do nothing. If so, I shall not have lived in vain.

…

Bertrand Russell in 1957.

When I suggest that working hours should be reduced to four, I am not meaning to imply that all the remaining time should necessarily be spent in pure frivolity. I mean that four hours' work a day should entitle a man to the necessities and elementary comforts of life, and that the rest of his time should be his to use as he might see fit. It is an essential part of any such social system that education should be carried further than it usually is at present, and should aim, in part, at providing tastes which would enable a man to use leisure intelligently. I am not thinking mainly of the sort of things that would be considered 'highbrow'.

…

Above all, there will be happiness and joy of life, instead of frayed nerves, weariness, and dyspepsia. The work exacted will be enough to make leisure delightful, but not enough to produce exhaustion. … Ordinary men and women, having the opportunity of a happy life, will become more kindly and less persecuting and less inclined to view others with suspicion. The taste for war will die out, partly for this reason, and partly because it will involve long and severe work for all. Good nature is, of all moral qualities, the one that the world needs most, and good nature is the result of ease and security, not of a life of arduous struggle. Modern methods of production have given us the possibility of ease and security for all; we have chosen, instead, to have overwork for some and starvation for the others. Hitherto we have continued to be as energetic as we were before there were machines; in this we have been foolish, but there is no reason to go on being foolish forever.

BERTRAND RUSSELL (1872–1970)

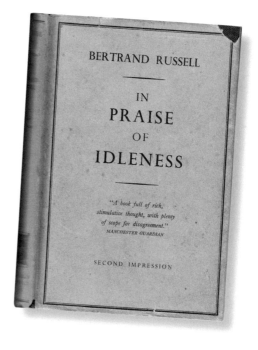

BERTRAND RUSSELL

IN

PRAISE

OF

IDLENESS

"*A book full of rich, stimulative thought, with plenty of scope for disagreement.*"
MANCHESTER GUARDIAN

SECOND IMPRESSION

POVERTY RESULTS FROM BEING IDLE

The Seven Deadly Sins, which Bertolt Brecht and Kurt Weill wrote and composed in 1933 after fleeing Nazi Germany, is a denouncing assault on capitalist morality. The two Annas, represent different personalities of the same girl and journey across America encountering a different sin in each city. Each compassionate impulse of the dancing Anna is labelled as a deadly sin by the rational voice of the singing Anna.

In the first city they, visit the sisters confront a couple in the park. Anna 2 accuses the man of seducing her, and Anna 1 accepts his hush-money. They play this trick several times. But when Anna 1 spots a much wealthier couple her effort is wasted because Anna 2 has fallen asleep on a bench. Anna's family in Louisiana invokes the Lord to watch over her.

The Family

Providence! – grant our child may commence her labour.
Poverty results from being idle!
When she was young she liked her bed but loathed her work.
Poverty results from being idle!
And if we did not drag the blankets off her
That narcoleptic slut slept until midday.

None the less, Anna is undoubtedly a most industrious girl.
Poverty results from being idle!
Good as gold and absolutely loyal to her family.
Poverty results from being idle!
Yes, she is so! Yes, she can be trusted!
Industry will hinder metropolitan temptations.

O, Lord, enlighten our dear Anna!
Find opportunities for her to help herself!
Let her desire to excel lead to affluence!
Then shall we know that our righteous motivation
Makes her prosperous and happy!

The Seven Deadly Sins, BERTOLT BRECHT (1898–1956)
Translated by Christopher Logue.

The Idle Servant,
Nicolaes Maes, 1655.

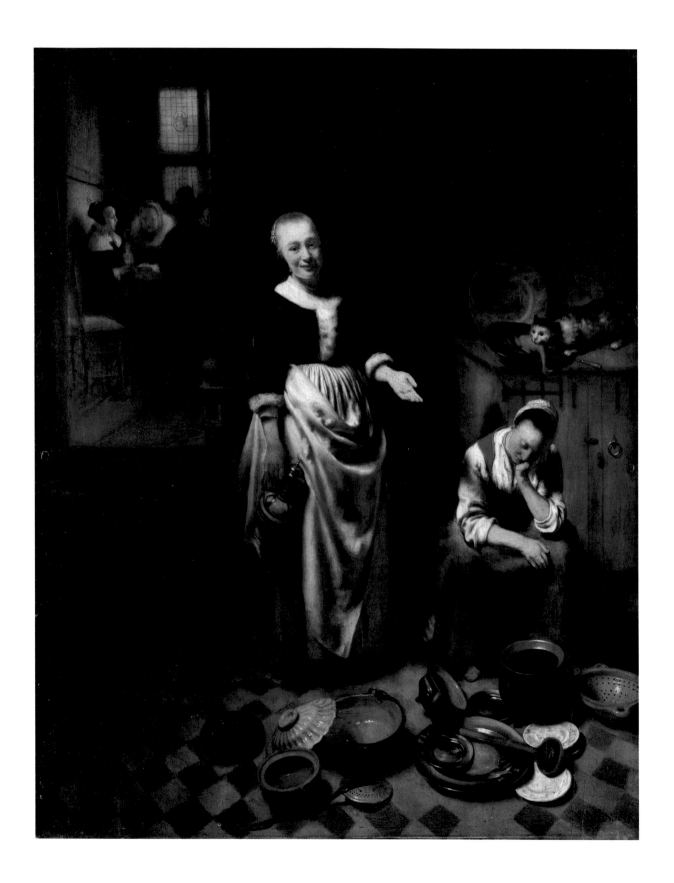

CONTEMPLATIVE IDLENESS

Alic Halford Smith was the Warden of New College from 1944–1958 and the Vice-Chancellor of Oxford from 1954–1957 when I was an undergraduate. He was a philosopher, the epitome of the relaxed, civilised don whose main purpose in life was to buttress the concept of a liberal education. In *Idleness as a Part of Education*, an oration delivered at the London School of Economics and Political Science on 9 December 1949 in an age long before students were preoccupied with computers, cyberspace and the internet, he eloquently defends the role of day-dreaming in education. No Vice-Chancellor today would ever give such advice.

I still need to indicate more clearly if I can, what is the nature of the moods in which imagination begins to operate and how they are induced. When I first referred to such states I used the expressions 'day-dreaming' and 'discursive meditation'. But 'day-dreaming' does not exclude idle preoccupation with ourselves and our own hopes and ambitions; and though 'meditation' is better in this respect it too much suggests conscious thought and its rational processes. Perhaps we shall be nearer the mark if we speak of contemplative idleness. For there is in contemplation a kind of passiveness or surrender to influences which have nothing to do with our day-to-day cares and preoccupations; a surrender to the forms and colours or the sounds of external things which impinge on our senses or, it may be, on that 'inner eye' of which the poet speaks as being 'the bliss of solitude'.

Many who seek the mood of contemplation find that nature, with all that belongs to nature, will help them best. Is it absurd to have the fancy (symbolically at least it is more than a fancy) that when Newton heard the apple drop he was not thinking about mathematics or physics but had abandoned himself to that dreaming state which is induced by the mellow light of autumnal orchards? What is essential is that there should be no hurry nor violence nor noise. When you walk in the quiet country let it sometimes be alone or with a companion with whom it is not necessary to converse. I hope that the advice which I am giving you does not seem to be strange.

Idleness as a Part of Education, A.H. SMITH (1883–1958)

MARLENE DIETRICH

It's not 'cause I wouldn't
It's not 'cause I shouldn't
And you know that it's not 'cause I couldn't
It's simply because I'm the laziest gal in town.

The Laziest Gal in Town, COLE PORTER (1891–1964)

Sung by Marlene Dietrich in Alfred Hitchcock's 1950 film *Stage Fright*.

Evelyn Waugh

EVELYN WAUGH

'One of the most amiable of weaknesses'

The word 'Sloth' is seldom on modern lips. When used, it is a mildly facetious variant of 'indolence', and indolence, surely, so far from being a deadly sin, is one of the most amiable of weaknesses. Most of the world's troubles seem to come from people who are too busy. If only politicians and scientists were lazier, how much happier we should all be. The lazy man is preserved from the commission of almost all the nastier crimes, and many of the motives which make us sacrifice to toil the innocent enjoyment of leisure, are among the most ignoble – pride, avarice, emulation, vainglory and the appetite for power over others. How then has Sloth found a place with its six odious companions as one of the Mortal Sins?

....

It is a fault about which we are particularly liable to self-deception. Almost all the men and women in England proclaim themselves to be busy. They have 'no time' to read or cook or take notice of the ceaseless process of spoliation of their island or even to dress decorously, while in their offices and workshops they do less and less, in quality and quantity, for ever larger wages with which to pay larger taxes for services that diminish in quantity and quality. We have voted for a Welfare State but are everywhere frustrated because we are too lazy to man the services; too few school teachers, too few hospital nurses, too few prison warders. That way lies national disaster; but the subject of this essay is moral, not political. There is something unattractive about those who gaze out of their windows for long periods studying the idleness of the navvies 'at work' outside.

....

It is easy to find explanations of modern laziness. All the 'glittering prizes' of success have lately become tarnished. The company in the room at the top has lost the art of pleasing. But Sloth is not primarily the temptation of the young. Medical science has oppressed us with a new huge burden of longevity. It is in that last undesired decade, when passion is cold, appetites feeble, curiosity dulled and experience has begotten cynicism, that *accidia* lies in wait as the final temptation to destruction. That is the time which is given a man to 'make his soul'. For few of us the hero's and martyr's privilege of a few clear days ending on the scaffold; instead an attenuated, bemused drifting into eternity. Death has not lost its terror in the new clinical arctic twilight. In this state we still have to face the last deadly assault of the devil. It is then, perhaps, that we shall be able to resist only by the spiritual strength we have husbanded in youth.

The Seven Deadly Sins: Sloth, EVELYN WAUGH (1903–1966)

LAZYBONES

Lazybones, sleepin' in the sun,
How you 'spect to get your day's work done?
You'll never get your day's work done
Sleepin' in the noon day sun.

Lazybones, sleepin' in the shade,
How you 'spect to get your cornmeal made?
You'll never get your cornmeal made
Sleepin' in the evenin' shade.

When them taters need sprayin',
I bet you keep prayin'
That the bugs fall off of the vine
And when you go fishin',
I bet you keep wishin'
That the fish won't grab at your line

Lazybones, loafin' through the day,
How you 'spect to make a dime that way?
You'll never make a dime that way –
Never hear a word I say.

JOHNNY MERCER (1909–1976) and HOAGY CARMICHAEL (1899–1981)

This Tin Pan Ally song written in 1933 at the height of the Great Depression was an instant success, selling 350,000 copies in three months. Carmichael claimed that before its release, Tin Pan Alley and its music houses were virtually empty of people, but the success of Lazybones generated new confidence in the music business and within a year, Times Square started to look like itself again. He said it was the song that 'took us out of the depression'.

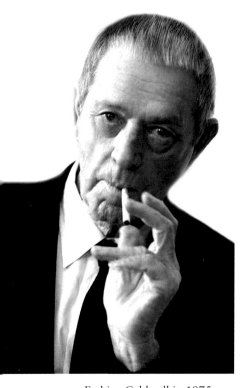

Erskine Caldwell in 1975.

The first edition, 1932.

TOBACCO ROAD

Set in rural Georgia during the worst years of the American Great Depression, *Tobacco Road* tells the story of poor white tenant farmers, the Lesters. This conversation between Jeeter Lester and his wife Ada show up the slothful doings of the likeable old bound-to-the-land Jeeter.

'You're just lazy, that's what's wrong with you. If you wasn't lazy you could haul a load every day, and I'd have me some snuff when I wanted it most.'

'I got to be thinking about farming the land,' Jeeter said. 'I ain't no durn woodchopper. I'm a farmer. Them woodchoppers hauling wood to Augusta ain't got no farming to take up their time, like I has. Why, I expect I'm going to grow near about fifty bales of cotton this year, if I can borrow the mules and get some seed-cotton and guano on credit in Fuller. By God and by Jesus, I'm a farmer. I ain't no durn woodchopper.'

'That's the way you talk every year about this time, but you don't never get started. It's been seven or eight years since you turned a farrow. I been listening to you talk about taking up farming again so long I don't believe nothing you say now. It's a big old whopping lie. All you men is like that. There's a hundred more just like you all around here, too. None of you is going to do nothing, except talk. The rest of them go around begging, but you're so lazy you won't even do that.'

'Now, Ada,' Jeeter said, 'I'm going to start in the morning...'

Tobacco Road, ERSKINE CALDWELL (1903–1987)

The family of a sharecropper, Dorothea Lange, 1939.

The pupil who excelled his master, H.M. Bateman, *c.* 1930.

Envy is the great leveller: if it cannot level things up, it will level them down...
At its best, envy is a climber and a snob; at its worst, it is a destroyer; rather than
have anybody happier than itself, it will see us all miserable together.

DOROTHY L. SAYERS

Whenever a friend succeeds a little, something in me dies.

GORE VIDAL (1925–2012)

He was a man of strong passions, and the green-eyed monster ran up his leg and
bit him to the bone.

Full Moon, P.G. WODEHOUSE (1881–1975)

The dullards' envy of brilliant men is always assuaged by the suspicion that they
will come to a bad end.

Zuleika Dobson, MAX BEERBOHM (1872–1956)

That, of course is why Envy is so unenviable a dominating emotion. All the
seven deadly sins are self-destroying, morbid appetites, but in their early stages
at least lust and gluttony, avarice and sloth know some gratification, while anger
and pride have power, even though that power eventually destroys itself. Envy
is impotent, numbed with fear, yet never ceasing in its appetite; and it knows no
gratification save endless self-torment. It has the ugliness of a trapped rat that has
gnawed its own foot in its effort to escape.

The Seven Deadly Sins, ANGUS WILSON (1913–1991)

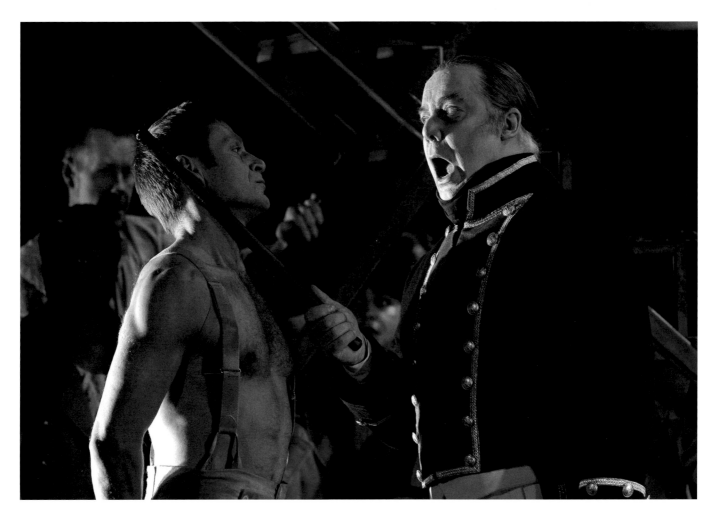

Billy Budd and Claggart from
Benjamin Britten's opera,
ENO, London, 2005.

FOR MANY PEOPLE ENVY IS NO LONGER A SIN. It is the mainstay of the global advertising industry, which looks upon it as a virtue. There are now more advertisements circulated every day than at any time in the history of the world. They offer the prospect and promise of making their customers wealthier, healthier, stronger, more beautiful, more successful, more sexually active, more recognised. They do this with better cars, better homes, better holidays, better pensions, better teeth, better hair, better bodies, better clothes; everything that can make a person better than the Jones's. All sorts of things have become items of desire and status symbols, including trainers for the young, watches for the ambitious alpha male, handbags for the glamorous partygoer. Thorstein Veblen in his classic *The Theory of the Leisure Class* coined the phrase 'conspicuous consumption' for 'the motive that lies at the root of ownership is emulation'.

Whether all of this will lead to a better life is by no means clear or guaranteed. There are, however, measurable benefits: in most developed countries people live longer, are better fed and much of their tedious household work is done by machines rather than

by hand. One result is that people have more time for leisure, wider choices of things to do and more countries to visit, than in previous centuries. Envy has had a hand in all of this progress but there is also a dark side. If what one gets fails to live up to one's expectation, then envy swiftly turns into malice and hatred and becomes deadly. As Lord Halifax observed: 'Malice may be sometimes out of breath, Envy never.'

Shakespeare's Iago is so consumed by envy of Cassio, who is promoted ahead of him, and of Othello, who has a stunningly beautiful white wife, that he schemes to bring them down. Envy also dominates Herman Melville's great story, *Billy Budd*. Claggart, the Master-at-Arms, of the H.M.S. *Bellipotent*, is consumed with envy of the good looks, the purity of innocence, and the large-heartedness of one of his sailors, Billy Budd. He accuses him falsely of wishing to start a mutiny. Budd, afflicted by a stutter, is unable to answer and in his defence, he strikes Claggart a blow to the forehead which proved forceful enough to kill him. The inevitable consequence is that Budd is tried for murder and sentenced to be hanged. No lesser punishment could have been inflicted, as a few months earlier the fleet had had to confront a serious mutiny. Poor wretched Budd is a victim of Claggart's envy which Melville calls 'Natural Depravity'. He says that it is a monomania, for those affected by it 'are madmen, and of the most dangerous sort, for their lunacy is not continuous, but occasional, evoked by some special object; it is protectively secretive, which is as much to say it is self-contained, so that when, moreover, most active it is to the average mind not distinguishable from sanity.'

Envy is a mean-spirited, insidious sin which can be nursed for years until it bursts out into a malicious or even murderous act. When Cain killed his brother Abel, anger was the stimulant but envy the cause. There is no doubt that envy is the most secret of the sins. None of the others can be hidden, they are self-evident, but envy lies concealed, hidden from this world, feeding upon its own bitterness, slowly festering away. Successful, rich and beautiful celebrities with limited talents, shallow education and boundless vanity are the icons of a jealous and envious society. These celebrities are sustained on their pillars by their spiritual leaders, Versace, Gucci, and Armani and by envy's foot soldiers, the gossip column and the glossy magazines. A report by the Marriage Foundation in 2015 found that celebrity fairy-tale weddings are twice as likely to have an unhappy ending than other weddings. Youngsters who crave only to follow celebrities are setting themselves up for disappointment.

If greed can be said to be the sin of capitalism, then envy can be said to be the sin of Marxism. Not all Marxists are envious, but envy has a part in shaping their desire to reduce everyone to a common level and limit personal choice.

The modern British slogan of the politically envious is 'Soak the Rich'. Bertrand Russell, in 1930, observed that, 'Envy is the basis of democracy', yet such thinking differs in other countries. In America, the first impulse of a blue-collar worker, on seeing a rich man in a Cadillac, is not envy, but admiration. He does not want to take away what the rich man has, but to work towards fulfilling the American dream for

himself. In Britain, socialists want to ensure social justice by removing the privilege, status and possessions of the rich and in this envy has an integral part to play.

Envy is also one of the buttresses of increasingly stratospheric executive pay. Since the Greenbury Report of 1995, salaries of senior executives are disclosed in company reports. Their remuneration committees exist to ensure that the salaries of their executives match those of other companies and that they are all in the top quartile. Envy might be concealed but it nonetheless drives the endless pursuit of climbing the ladder faster and higher because it hates to see anyone happy. The American journalist H.L. Menchen, who was keenly aware of pretension, defined contentment in American society, 'as making $10 a month more than your brother-in-law'.

Another aspect of envy is the pleasure evoked when another person has lost their wealth, been humiliated or failed to be recognised. Schaudenfreude, or the delight in the misfortunes of others, is an age-old emotion and it contains an element of justice – how the mighty have fallen. But the pleasure that Clive James exposes in his poem, *The Book of My Enemy has been Remaindered*, cannot really be described as a sin.

Politics of Envy,
Jacky Fleming.

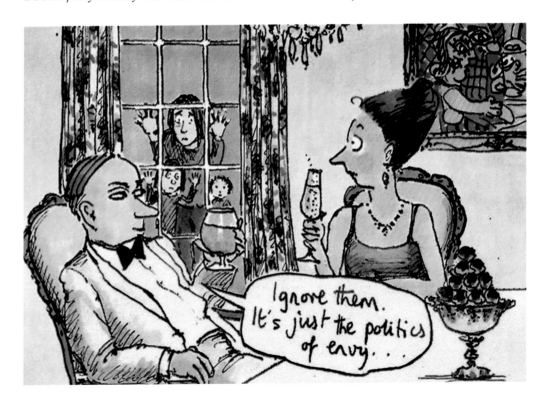

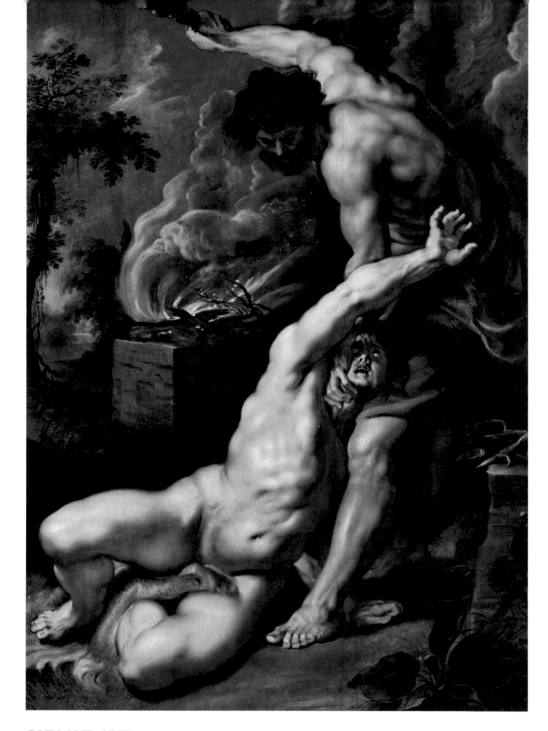

Cain Slaying Abel,
Sir Peter Paul Rubens, 1608.

CAIN AND ABEL

This medieval pageant, also known as the *Ludus Coventriae*, may have been performed in Coventry as the *Corpus Christi* play in the fifteenth century. The scribes who wrote this, developed the story of Cain and Abel from the version in the Book of Genesis, and wove into it some medieval legends. Abel offers to God his best produce (in Genesis it was young sheep) while Cain offers his worst corn. In this version they both present corn and while Abel's flares away, Cain's splutters out. He is envious of his brother's success. One detail, which is new in this version, is that Cain uses a jawbone of an ass to kill his brother. An extra-scriptural tradition first documented in the ninth century in old English literature.

Cain

Hark Abel, brother, what marvel is this?
Thy tithing burns as fire full bright.
It is to me great wonder, iwis.
I trow this is now a strange sight.

Abel

God's will, forsooth, it is
That my tithing with fire is lit.
For of the best were my tithes.
And of the worst thou chose to plight.
A bad thing thou before him spread.
Of the best was my tithing,
Of the worst was thy offering.
Therefore, God almighty, heaven's king
Allowed right not thy deed.

Cain

What, thou stinking wretch, and is it so?
Doth God thee love and hateth me?
Thou shalt be dead, I shall thee slay!
Thy lord, thy God, shalt thou never see,
Tithing more shalt thou never do.
With this jaw bone I shall slay thee.
Thy death is now, thy days are gone
Out of my hands shalt thou not flee.
With this stroke, I thee kill!

Now this boy is slain and dead.
Of him I shall never more have dread.
He shall hereafter never eat bread.
With this grass, I shall him hide.

God

Cain come forth and answer me
Answer my question anon right
Thy brother Abel, where is he now?
Have done now and answer me full straight.

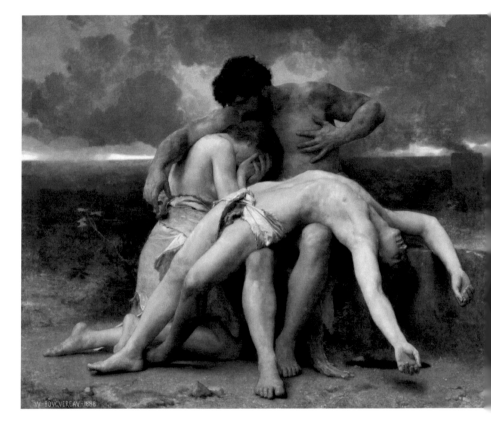

Cain

My brother's keeper, who made me?
Since when was I his keeping knight?
I can not tell where that he be,
To keep him was I never dight;
I know not where he is.

God

Ah cursed Cain, thou art untrue!
And for thy deed thou shalt sore rue.
Thy brother's blood that thou slew
Asks vengeance of this miss.

Thou shalt be cursed on the ground
Unprofitable where so ever thou go
Both vain and empty and nothing sound.
It shall go wrong, whatever thou do.

Cain and Abel, The N-Town Plays, (15th century)

The First Mourning,
William-Adolphe Bouguereau,
1888.

Adam and Eve mourn the death
of their second son.

EPISCOPAL ENVY

The Bishop Orders his Tomb at Saint Praxed's Church, Rome

It is thought that the decorative contrasts between the two tombs in the church of Santa Prassede, were the inspiration for Robert Browning's poem. But there is no tomb there quite like the one which the Bishop desires. This poem was published in 1845 when a controversy was raging in clerical circles over the opulence and paganism that was often revealed in medieval piety.

Below: Tomb of Jacopo di Ranuccio Castelbuono, Bishop of Florence, Arnolfo di Cambio, *c.* 1290.

Vanity, saith the preacher, vanity!
Draw round my bed: is Anselm keeping back?
Nephews – sons mine… ah, God, I know not! Well –
She, men, would have to be your mother once,
Old Gandolf envied me, so fair she was!
What's done is done, and she is dead beside,
Dead long ago, and I am Bishop since,
And as she died so must we die ourselves,
And thence ye may perceive the world's a dream.
Life, how and what is it? As here I lie
In this state-chamber, dying by degrees,
Hours and long hours in the dead night, I ask
'Do I live, am I dead? Peace, peace seems all.

Saint Praxed's ever what the church for peace;
And so, about this tomb of mine. I fought
With tooth and nail to save my niche, ye know:

Old Gandolf cozened me, despite my care;
Shrewd was that snatch from out the corner South
He graced his carrion with, God curse the same!
Yet still my niche is not so cramped but thence
One sees the pulpit o' the epistle-side,
And somewhat of the choir, those silent seats,
And up into the aery dome where live
The angels, and a sunbeam's sure to lurk:
And I shall fill my slab of basalt there,

And 'neath my tabernacle take my rest,
With those nine columns round me, two and two,
The odd one at my feet where Anselm stands:
Peach-blossom marble all, the rare, the ripe
As fresh-poured red wine of a mighty pulse.
Old Gandolf with his paltry onion-stone,
Put me where I may look at him! True peach,
Rosy and flawless: how I earned the prize!

…

That's if ye carve me epitaph aright,
Choice Latin, picked phrase, Tully's every word,
No gaudy ware like Gandolf's second line –
Tully, my masters? Ulpian serves his need!
And then how I shall lie through centuries,
And hear the blessed mutter of the mass,

And see God made and eaten all day long,
And feel the steady candle-flame, and taste
Good strong thick stupefying incense-smoke!
For as I lie here, hours of the dead night,
Dying in state and by such slow degrees,
I fold my arms as if they clasped a crook
And stretch my feet forth straight as stone can point,
And let the bedclothes, for a mortcloth, drop …

…

And leave me in my church, the church for peace,
That I may watch at leisure if he leers –
Old Gandolf, at me, from his onion-stone,
As still he envied me, so fair she was!

ROBERT BROWNING

'AT NEIGHBOURS WEALTH, THAT MADE HIM EUER SAD'

And next to him malicious Enuie rode,
Vpon a rauenous wolfe, and still did chaw
Betweene his cankred teeth a venemous tode,
That all the poison ran about his chaw;
But inwardly he chawed his owne maw
At neighbours wealth, that made him euer sad;
For death it was, when any good he saw,
And wept, that cause of weeping none he had,
But when he heard of harme, he wexed wondrous glad.

...He hated all good workes and vertuous deeds,
And him no lesse, that any like did vse,
And who with gracious bread the hungry feeds,
His almes for want of faith he doth accuse;
So euery good to bad he doth abuse:
And eke the verse of famous Poets witt
He does backebite, and spightfull poison spues
From leprous mouth on all, that euer writt:
Such one vile Enuie was, that fift in row did sitt.

The Faerie Queene, EDMUND SPENSER (1552–1599)

THE FAERIE
QVEENE.

Difpofed into twelue books,
Fashioning
XII. Morall vertues.

LONDON
Printed for William Ponfonbie.
1 5 9 0.

'ENVY IS A GADDING PASSION'

Of Envy

We see likewise the Scripture calleth envy, an *evil eye*; and the astrologers call the evil influences of the stars, *evil aspects*; so that still there seemeth to be acknowledged in the act of envy an ejaculation or irradiation of the eye. Nay, some have been so curious, as to note that the times, when the stroke or percussion of an envious eye doth most hurt, are, when the party envied is beheld in glory or triumph; for that sets an edge upon envy: and, besides, at such times the spirits of the person envied do come forth most into the outward parts, and so meet the blow.

A man that hath no virtue in himself ever envieth virtue in others. For mens minds will either feed upon their own good, or upon others' evil; and who wanteth the one will prey upon the other; and whoso is out of hope to attain to another's virtue will seek to come at evenhand by depressing another's fortune.

A man that is busy and inquisitive is commonly envious: for to know much of other mens matters cannot be because all that ado may concern his own estate; therefore it must needs be that he taketh a kind of play-pleasure in looking upon the fortunes of others. Neither can he that mindeth but his own business find much matter for envy. For envy is a gadding passion, and walketh the streets, and doth not keep home: *Non est curiosus, quin idem sit malevolus.*

Men of noble birth are noted to be envious towards new men when they rise. For the distance is altered, and it is like a deceit of the eye, that when others come on they think themselves go back.

Essays, Civil and Moral,
SIR FRANCIS BACON (1561–1626)

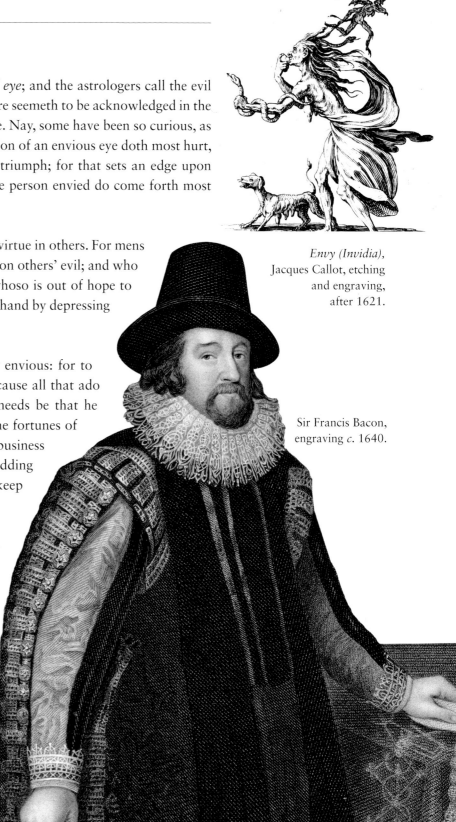

Envy (Invidia),
Jacques Callot, etching and engraving, after 1621.

Sir Francis Bacon, engraving *c.* 1640.

OTHELLO

'I am worth no worse a place'

Roderigo
Thou told'st me thou didst hold him in thy hate.

Iago
Despise me, if I do not. Three great ones of the city,
In personal suit to make me his lieutenant,
Off-capp'd to him; and, by the faith of man,
I know my price, I am worth no worse a place;
But he, as loving his own pride and purposes,
Evades them, with a bombast circumstance
Horribly stuff'd with epithets of war;
And, in conclusion,
Nonsuits my mediators; for, 'Certes,' says he,
'I have already chose my officer.'
And what was he?
Forsooth, a great arithmetician,

One Michael Cassio, a Florentine,
A fellow almost damn'd in a fair wife;
That never set a squadron in the field,
Nor the division of a battle knows
More than a spinster; unless the bookish theoric,
Wherein the toged consuls can propose
As masterly as he: mere prattle, without practice,
Is all his soldiership. But he, sir, had the election;
And I, of whom he eyes had seen the proof
At Rhodes, at Cyprus, and on other grounds
Christian and heathen, must be be-lee'd and calm'd
By debitor and creditor, this counter-caster;
He, in good time, must his lieutenant be,
And I – God bless the mark! – His Moorship's ancient.

Act 1, Scene 1, *Othello*, WILLIAM SHAKESPEARE

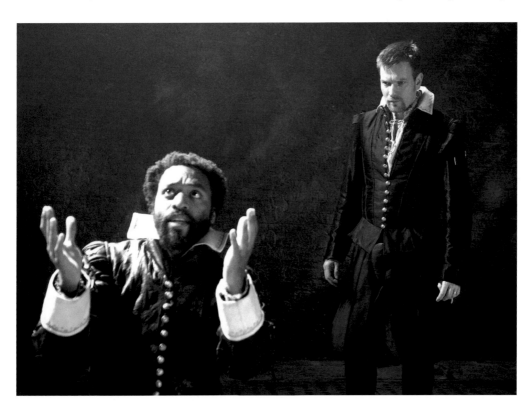

Chiwetel Ejiofor as Othello
and Ewan McGregor as Iago,
Donmar Warehouse, London,
2007.

'CLAGGART'S ENVY STRUCK DEEPER'

That Claggart's figure was not amiss, and his face, save the chin, well moulded, has already been said. Of these favourable points he seemed not insensible, for he was not only neat but careful in his dress. But the form of Billy Budd was heroic; and if his face was without the intellectual look of the pallid Claggart's, not the less was it lit, like his, from within, though from a different source. The bonfire in his heart made luminous the rose-tan in his cheek.

In view of the marked contrast between the persons of the twain, it is more than probable that when the Master-at-arms in the scene last given applied to the sailor the proverb Handsome is as handsome does, he there let escape an ironic inkling, not caught by the young sailors who heard it, as to what it was that had first moved him against Billy, namely, his significant personal beauty.

Now envy and antipathy, passions irreconcilable in reason, nevertheless in fact may spring conjoined like Chang and Eng in one birth. Is envy then such a monster? Well, though many an arraigned mortal has in hopes of mitigated penalty pleaded guilty to horrible actions, did ever anybody seriously confess to envy? Something there is in it universally felt to be more shameful than even felonious crime. And not only does everybody disown it, but the better sort are inclined to incredulity when it is in earnest imputed to an intelligent man. But since its lodgement is in the heart, not the brain, no degree of intellect supplies

Claggart accusing Budd from the 1962 film production.

a guarantee against it. But Claggart's was no vulgar form of the passion. Nor, as directed towards Billy Budd, did it partake of that streak of apprehensive jealously that marred Saul's visage perturbedly brooding on the comely young David. Claggart's envy struck deeper. If askance he eyed the good looks, cheery health, and frank enjoyment of young life in Billy Budd, it was because these happened to go along with a nature that, as Claggart magnetically felt, had in its simplicity never willed malice, or experienced the reactionary bite of that serpent. To him, the spirit lodged within Billy and looking out from his welkin eyes as from windows, that ineffability which made the dimple in his dyed cheek, suppled his joints and dancing in his yellow curls, made him pre-eminently the Handsome Sailor. One person excepted, the Master-at-arms was perhaps the only man in the ship intellectually capable of adequately appreciating the moral phenomenon presented in Billy Budd. And the insight but intensified his passion, which assuming various secret forms within him, at times assumed that of cynic disdain – disdain of innocence. To be nothing more than innocent! Yet in an aesthetic way he saw the charm of it, the courageous free-and-easy temper of it, and fain would have shared it, but he despaired of it.

Billy Budd, HERMAN MELVILLE (1819–1891)

TATTYCORAM

Mr and Mrs Meagles are a kindly couple who befriend Arthur Clenman, the main male character in *Little Dorrit*. They have a daughter called Pet and a girl they call Tattycoram, who they have adopted from the London Foundling Hospital. Tattycoram, beautiful and headstrong is employed as Pet's maid and companion but she is subject to violent outbursts of passion for she envies Pet, and imagines she is belittled and ignored when compared to Pet. She also resents being deprived of the devoted love the Meagles give Pet. Mr Meagles tries to assuage her jealous anger by getting her to count up to twenty-five whenever she is about to have a tantrum but on the occasion described in this passage he fails and Tattycoram runs away.

'Well!' continued Mr Meagles in an apologetic way, 'I admit as a practical man, and I am sure Mother would admit as a practical woman, that we do, in families, magnify our troubles and make mountains of our molehills in a way that is calculated to be rather trying to people who look on – to mere outsiders, you know, Clennam.

Still, Pet's happiness or unhappiness is quite a life or death question with us; and we may be excused, I hope, for making much of it. At all events, it might have been borne by Tattycoram. Now, don't you think so?'

'I do indeed think so,' returned Clennam, in most emphatic recognition of this very moderate expectation.

'No, sir,' said Mr Meagles, shaking his head ruefully. 'She couldn't stand it. The chafing and firing of that girl, the wearing and tearing of that girl within her own breast, has been such that I have softly said to her again and again in passing her, 'Five-and-twenty, Tattycoram, five-and-twenty!" I heartily wish she could have gone on counting five-and-twenty day and night, and then it wouldn't have happened.'

Mr Meagles with a despondent countenance in which the goodness of his heart was even more expressed than in his times of cheerfulness and gaiety, stroked his face down from his forehead to his chin, and shook his head again.

'I said to Mother (not that it was necessary, for she would have thought it all for herself), we are practical people, my dear, and we know her story; we see in this unhappy girl some reflection of what was raging in her mother's heart before ever such a creature as this poor thing was in the world; we'll gloss her temper over, Mother, we won't notice it at present, my dear, we'll take advantage of some better disposition in her another time. So we said nothing. But, do what we would, it seems as if it was to be; she broke out violently one night.'

'How, and why?'

'If you ask me Why,' said Mr Meagles, a little disturbed by the question, for he was far more intent on softening her case than the family's, 'I can only refer you to what I have just repeated as having been pretty near my words to Mother. As to How, we had said Good night to Pet in her presence (very affectionately, I must allow), and she had attended Pet

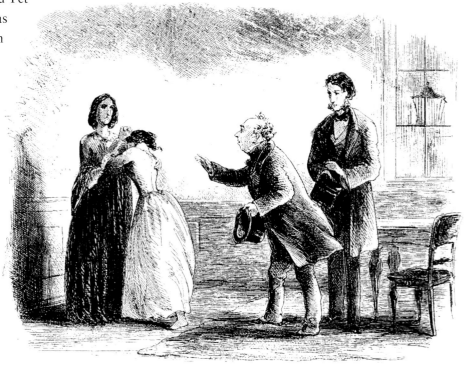

Five-and-Twenty, by Phiz (Hablot K. Browne), 1856.

up-stairs – you remember she was her maid. Perhaps Pet, having been out of sorts, may have been a little more inconsiderate than usual in requiring services of her: but I don't know that I have any right to say so; she was always thoughtful and gentle.'

'The gentlest mistress in the world.'

'Thank you, Clennam,' said Mr Meagles, shaking him by the hand; 'you have often seen them together. Well! We presently heard this unfortunate Tattycoram loud and angry, and before we could ask what was the matter, Pet

came back in a tremble, saying she was frightened of her. Close after her came Tattycoram in a flaming rage. "I hate you all three," says she, stamping her foot at us. "I am bursting with hate of the whole house."'

'Upon which you –?'

'I?' said Mr Meagles, with a plain good faith that might have commanded the belief of Mrs Gowan herself. 'I said, count five-and-twenty, Tattycoram.'

Mr Meagles again stroked his face and shook his head, with an air of profound regret.

'She was so used to do it, Clennam, that even then, such a picture of passion as you never saw, she stopped short, looked me full in the face, and counted (as I made out) to eight. But she couldn't control herself to go any further. There she broke down, poor thing, and gave the other seventeen to the four winds. Then it all burst out. She detested us, she was miserable with us, she couldn't bear it, she wouldn't bear it, she was determined to go away. She was younger than her young mistress, and would she remain to see her always held up as the only creature who was young and interesting, and to be cherished and loved? No. She wouldn't, she wouldn't, she wouldn't! What did we think she, Tattycoram, might have been if she had been caressed and cared for in her childhood, like her young mistress? As good as her? Ah! Perhaps fifty times as good. When we pretended to be so fond of one another, we exulted over her; that was what we did; we exulted over her and shamed her. And all in the house did the same. They talked about their fathers and mothers, and brothers and sisters; they liked to drag them up before her face. There was Mrs Tickit, only yesterday, when her little grandchild was with her, had been amused by the child's trying to call her (Tattycoram) by the wretched name we gave her; and had laughed at the name. Why, who didn't; and who were we that we should have a right to name her like a dog or a cat? But she didn't care. She would take no more benefits from us; she would fling us her name back again, and she would go. She would leave us that minute, nobody should stop her, and we should never hear of her again.'

Mr Meagles had recited all this with such a vivid remembrance of his original, that he was almost as flushed and hot by this time as he described her to have been.

'Ah, well!' he said, wiping his face. 'It was of no use trying reason then, with that vehement panting creature (Heaven knows what her mother's story must have been); so I quietly told her that she should not go at that late hour of night, and I gave her my hand and took her to her room, and locked the house doors. But she was gone this morning.'

Little Dorrit, CHARLES DICKENS

MY RIVAL

I go to concert, party, ball –
　　What profit is in these?
I sit alone against the wall
　　And strive to look at ease.
The incense that is mine by right
　　They burn before Her shrine;
And that's because I'm seventeen
　　And she is forty-nine.

I cannot check my girlish blush,
　　My colour comes and goes.
I redden to my finger-tips,
　　And sometimes to my nose.
But she is white where white should be,
　　And red where red should shine.
The blush that flies at seventeen
　　Is fixed at forty-nine.

I wish I had her constant cheek:
　　I wish that I could sing
All sorts of funny little songs,
　　Not quite the proper thing.
I'm very gauche and very shy,
　　Her jokes aren't in my line;
And, worst of all, I'm seventeen
　　While She is forty-nine.

The young men come, the young men go,
　　Each pink and white and neat,
She's older than their mothers, but
　　They grovel at Her feet
They walk beside Her rickshaw-wheels –
　　None ever walk by mine;
And that's because I'm seventeen
　　And she is forty-nine.

She rides with half a dozen men
　　(She calls them 'boys' and 'mashes')
I trot along the Mall alone;
　　My prettiest frocks and sashes
Don't help to fill my programme-card,
　　And vainly I repine
From ten to two A.M. Ah me!
　　Would I were forty-nine.

She calls me 'darling,' 'pet,' and 'dear,'
　　And 'sweet retiring maid.'
I'm always at the back, I know –
　　She puts me in the shade.
She introduces me to men –
　　'Cast' lovers, I opine;
For sixty takes to seventeen,
　　Nineteen to forty-nine.

But even She must older grow
　　And end Her dancing days,
She can't go on for ever so
　　At concerts, balls, and plays.
One ray of priceless hope I see
　　Before my footsteps shine;
Just think, that She'll be eighty-one
　　When I am forty-nine!

RUDYARD KIPLING

From *Under the Deodars*,
Rudyard Kipling, 1888.

'MIRROR, MIRROR ON THE WALL
WHO IS THE FAIREST OF THEM ALL?'

The beautiful and wicked queen, who is riddled by envy, asks her mirror everyday this question. When one day she receives the reply, 'Snow White', she decides to destroy her. Disguised as an old woman, she offers a poisoned apple to Snow White, who falls into a deep sleep. Although she is meant to die she is awakened by the kiss of a prince.

Snow White and the Evil Queen, Walt Disney, 1937.

ENVY LEADING TO VICIOUS ANTI-SEMITISM

The blackest consequence of envy is succinctly put by Arthur Schopenhauer, when he reminds us that, 'hatred always accompanies envy'. I am indebted to Joseph Epstein's essay, 'Our Good Friends, the Jews', for pinning down envy as the source of anti-Semitism:

> Consider these rough statistics from the Vienna of 1936, a city that was 90% Catholic and 9% Jewish: Jews accounted for 60% of the city's lawyers, more than half its physicians, more than 90% of its advertising executives, and 123 of its 174 newspaper editors. And this is not to mention the prominent places Jews held in banking, retailing, and intellectual and artistic life. The numbers four or five years earlier for Berlin are said to have been roughly similar.

Jews were thought of as a separate elite, living closely together, united by dietary requirements, circumcision, religious rituals, an innate flair for making money, and their ability to survive centuries of persecution. This resulted in the book burning in the Opernplatz in Berlin in May 1933 when Goebbels made his fire speech:

> The era of extreme Jewish intellectualism has come to an end... During the past fourteen years while you, students, had to suffer in silent shame the humiliations of the November Weimar Republic your libraries were inundated with the trash and filth of Jewish sidewalk literature... Therefore, you are doing the right thing as you, at this midnight hour, surrender to the flames the evil spirit of the past... We join together in the vow that we previously so often promised to the nightly sky: 'Illuminated by many flames let it be an oath! The Reich and the nation and our Führer Adolf Hitler – Heil.

Völkischer Beobachter, May 1933, Translated by Dr Roland Richter.

Joseph Goebbels, Hitler's minister of propaganda and public information. 'The Fire Speech', 10 May 1933.

Tilly Losch and Lotte Lenya
as Anna-Anna in Paris, 1933.

'I SAW THAT ENVY CRUSHED HER SOUL'

First performed in the *Théâtre des Champs-Élysées*, Paris, in 1933, Bertold Brecht's
and Kurt Weill's, *Seven Deadly Sins*, tells the story of two Annas. Anna 1, who sings,
and Anna 2, who dances, are in fact two facets of one personality. At the bidding
of her family, they travel to six American cities to make enough money to build a
little house on the banks of the Mississippi. In each city, the two Annas encounter a
different deadly sin, and Anna 1 (the practical one) rebukes Anna 2 (the artistic one)
for engaging in sinful behaviour.

In San Francisco, Anna 2 realises she is surrounded by other people who are enjoying
the pleasures of the world that she has denied herself. Overcome with envy, she despairs.
Anna 1, denounces these pleasures as evil and holds her sister to their purpose.

Anna 1

The final city we tasted was San Francisco.
All went quite well until Anna's
Sense of purpose was transformed into envy:
 Of those who live their days in idleness,
 Of those too proud to be bought,
 Of those whose anger hits successful injustice,
 Of those who are happy by nature,
 Of those who know no love but true love,
 Of those who will not bargain and who seek no return.
So I said to my despairing sister
When I saw that envy crushed her soul:

'Do not forget that Creation is evil
And none except the good enter the Kingdom of Light.
Denigrate the actions of each sin-sickened weevil!
Wrong is their right. Wrong is their right.
Wrong is their right – and shall be lost in the night!

Upright, my sister! Walk upright! We scorn them!
The scum of the earth in their bad paradise.
Nothing can help them. No angel shall mourn them.
When they are lashed, when they are lashed,
When they are lashed we shall spurn their cries!'

The Seven Deadly Sins, BERTOLD BRECHT
Translated by Christopher Logue.

HOW TO SPEND IT, *FINANCIAL TIMES*, 2017

The 2005 Economic and Social Research Council's report on the Seven Deadly Sins showed that envy plays a significant part in the spiralling stock of personal debt in Britain. Among those aged sixteen to fifty-nine, one in four people admitted being envious of others. Of that group eighteen per cent had arrears, and twenty-three per cent used informal kinds of borrowing.

Magazines like *how to spend it* and *The Times* 'Rich List' are compulsive reading material for the envious, intent on having the distinctive paraphernalia of the rich, the assured and the polished. These might be cufflinks for £3,470, a watch for £24,200, a chair for £7,300 or Blondie shoes for £582. As the market in vanity capital grows so superficiality reigns and envy wins.

'THE BOOK OF MY ENEMY HAS BEEN REMAINDERED'

The book of my enemy has been remaindered
And I am pleased.
In vast quantities it has been remaindered
Like a van-load of counterfeit that has been seized
And sits in piles in a police warehouse,
My enemy's much-prized effort sits in piles
In the kind of bookshop where remaindering occurs.
Great, square stacks of rejected books and, between
 them, aisles
One passes down reflecting on life's vanities,
Pausing to remember all those thoughtful reviews
Lavished to no avail upon one's enemy's book –
For behold, here is that book
Among these ranks and banks of duds,
These ponderous and seemingly irreducible cairns
Of complete stiffs.

The book of my enemy has been remaindered
And I rejoice.
It has gone with bowed head like a defeated legion
Beneath the yoke.
What avail him now his awards and prizes,
The praise expended upon his meticulous technique,
His individual new voice?
Knocked into the middle of next week
His brainchild now consorts with the bad buys
The sinker, clinkers, dogs and dregs,
The Edsels of the world of moveable type,

The bummers that no amount of hype could shift,
The unbudgeable turkeys.

Yea, his slim volume with its understated wrapper
Bathes in the blare of the brightly jacketed *Hitler's
 War Machine*,
His unmistakably individual new voice
Shares the same scrapyard with a forlorn skyscraper
Of *The Kung-Fu Cookbook*,
His honesty, proclaimed by himself and believed by
 others,
His renowned abhorrence of all posturing and
 pretence,
Is there with *Pertwee's Promenades and Pierrots-
One Hundred Years of Seaside Entertainment*,
And (oh, this above all) his sensibility,
His sensibility and its hair-like filaments,
His delicate, quivering sensibility is now as one
With *Barbara Windsor's Book of Boobs*,
A volume graced by the descriptive rubric
'My boobs will give everyone hours of fun'.

Soon now a book of mine could be remaindered also,
Though not to the monumental extent
In which the chastisement of remaindering has been
 meted out
To the book of my enemy,
Since in the case of my own book it will be due
To a miscalculated print run, a marketing error –
Nothing to do with merit.
But just supposing that such an event should hold
Some slight element of sadness, it will be offset
By the memory of this sweet moment.
Chill the champagne and polish the crystal goblets!
The book of my enemy has been remaindered
And I am glad.

CLIVE JAMES (*b.* 1939)

SOWERS OF SCANDAL AND SCHISM

This is the punishment for sowers of scandal and sowers of schism.

> Truly I saw – it seems to me I can
> See still – I saw a headless trunk that sped
> Running towards me as the others ran;
>
> And by the hair it held the severed head
> Swung, as one swings a lantern, in its hand;
> And that caught sight of us: 'Ay me!' it said.

The Divine Comedy: The Inferno, Canto XXVIII. DANTE ALIGHIERI
Translated by Dorothy L. Sayers.

The Schismatics and Sowers of Discord: Mosca de' Lamberti and Bertrand de Born, William Blake, 1824–27.

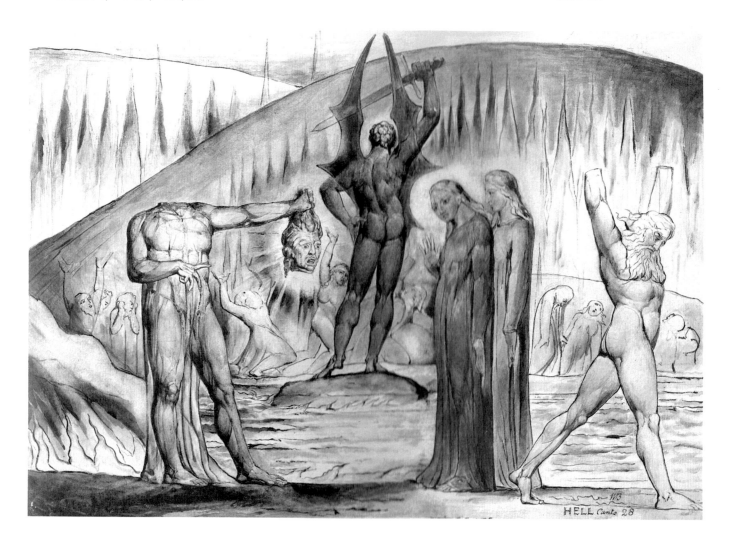

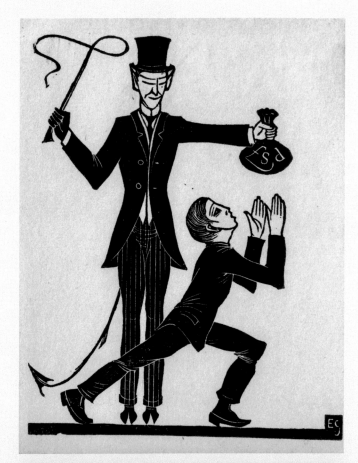

The Money Bag, Eric Gill, 1915.

Radix omnium malorum avaritia
For the love of money is the root of all evil

1 TIMOTHY 6:10

To be clever enough to get all that money,
one must be stupid enough to want it.

G.K. CHESTERTON (1874–1936)

Oh Lord, won't you buy me a Mercedes Benz?
My friends all drive Porsches, I must make amends.
Worked hard all my lifetime, no help from my friends,
So Lord, won't you buy me a Mercedes Benz?

JANIS JOPLIN (1943–1970)
This was the last song recorded by this great blues singer
before her sudden death on 4 October 1970.

Desire! Desire! I have too dearly bought,
With price of mangled mind, thy worthless ware;

SIR PHILIP SIDNEY (1554–1586)

Get place and wealth if possible with grace;
If not, by any means get wealth and place.

ALEXANDER POPE (1688–1744)

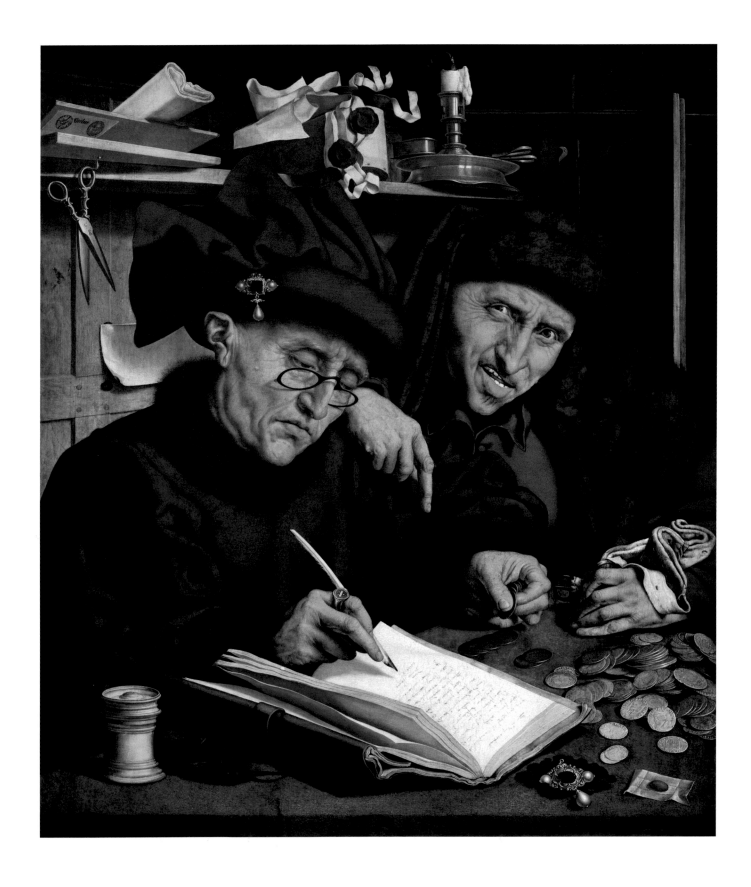

Thomas Aquinas regarded greed as 'a sin against God', since sinners placed those qualities that would lead to an eternal life below the acquisition of material things – the very things that would die with them. For centuries Christianity condemned selfishness and congregations were reminded of Christ's words about the camel and the eye of the needle. The attitude to avarice changed in the 18th century when philosophers, thinkers and economists did not castigate avarice recognising that the Industrial Revolution had created opportunities for a mass of individuals to become rich by their own inventiveness and their energy. Their self-interest not only enriched them but also enriched society as Adam Smith recognised:

> It is not from the benevolence of the butcher, the brewer, or the baker that we expect our dinner, but from their regard to their own interest.

'We all seem to be about aggression and greed. It's a massive pressure that affects us all.' Eric Cantona, 2009.

Up to that time wealth had depended very largely upon the inheritance of large landed estates, but huge fortunes were soon made in the industrial towns in the north of England. Politicians sought to contain such unbridled success with the introduction in Britain in the 1840s of Income Tax and in the 1890s Estate Duty. This not only reduced the income and capital of the wealthy, it provided the much needed money for the growing public expenditure of the State. So Bernard Mandeville was right (see page 16).

Avarice only really begins to take root when a person has all the necessities in life needed to support his family. There is a borderline between the things that people really need and the things they would really like to have: it is a constantly moving borderline since very often what was regarded at one time as a luxury becomes a commonplace necessity. Step beyond the borderline and the passion to own something special becomes compulsive. Today you can buy a wristwatch for a few pounds but one was featured in the December 2016 *Financial Times* supplement, *how to spend it*, designed by Richard Mille costing £808,500. A greedy customer has an appetite that demands it is fed.

In today's world there is a billionaire bonanza. An OXFAM report in January 2016 calculated that just sixty-two individuals had the combined wealth of the poorest half of the global population. Their net worth was $1.76 trillion, much of it held in offshore accounts. In 2010 it had taken 388 men and women to match the collective income levels of the world's poorest half, so in five years the wealth of this circle of billionaires had risen by forty-four per cent while the wealth of the poorest had fallen by forty-one per cent. As Alexander Pope commented:

> But Satan now is wiser than of yore,
> And tempts by making rich, not making poor.

The Tax Collectors,
Quentin Massys, 1520s.

The Sunday Times
Rich List in 2017 identified
134 Billionaires in the UK.

1916	First billionaire	John D. Rockefeller
2009	793 billionaires	Combined wealth of USD 2.4 trillion
2016	1,810 billionaires	Combined wealth of USD 6.48 trillion

Source: Forbes Billionaires

In the past such huge disparities in wealth have usually led to the rattle of the tumbrils over the cobblestones.

The financial collapse of banks in 2008, which affected the whole of the world, was due to avarice; the uncontrolled, relentless, aggressive, self-centred greed of bankers, brokers, property speculators, and fund managers who were only concerned with the level of their bonuses. They were all engaged in sinning on a grand scale, and even the largest and hitherto most reputable banks were heavily implicated in illegal acts of rigging interest and exchange rates. On 16 July 2002, before a committee on Financial Services, Alan Greenspan, a former Chairman of the US Federal Reserve, spoke of an 'infectious greed that seemed to grip so much of our business community', but he did nothing to kill the virus. 'Our historical guardians of financial information were overwhelmed.'

Sixty-seven years before Greenspan's testimony, Franklin D. Roosevelt, on the eve of the US 1936 national election, set out his achievements as president over the previous four years and the backdrop to the Great Depression, for he knew where the blame lay:

We had to struggle with the old enemies of peace – business and financial monopoly, speculation, reckless banking, class antagonism, sectionalism, war profiteering. They had begun to consider the Government of the United States as a mere appendage to their own affairs. We know now that Government by organised money is just as dangerous as Government by organised mob.

FRANKLIN D. ROOSEVELT (1882–1945)
Address at Madison Square Garden, New York City, October 1936.

ST AMBROSE OF MILAN

Money is never quiet; it moves on as though dashed upon a rock; thus it strikes the breast of the debtor and straightway slips back thence whence it came. It comes with a murmur, with a moan it recedes. Yet often the sea rests quiet by favour of the winds; always the wave of interest is in motion. It overwhelms the shipwrecked, casts out the naked, despoils the clothed, abandons the unburied. For you seek money and you incur shipwreck.

ST AMBROSE OF MILAN (340–397)

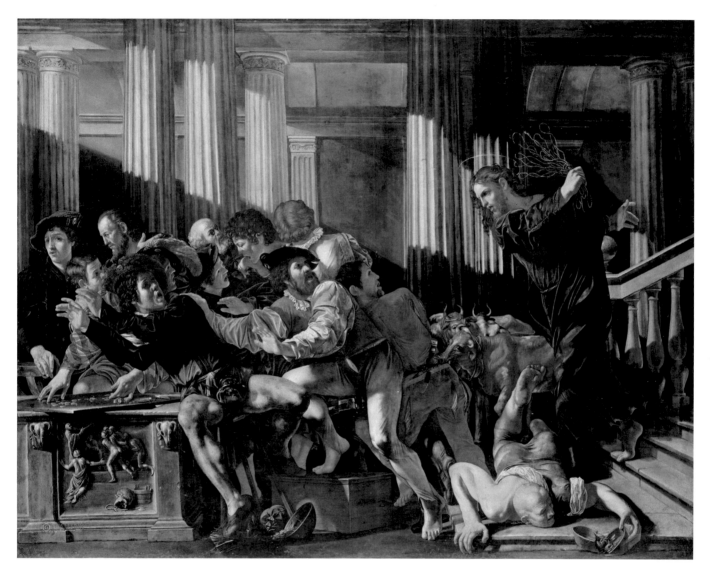

Long before St Ambrose noted the connection between the 'waves of interest' and human misery, Christ had destroyed the prevailing notion that anyone can earn eternal life. 'It is easier for a camel to go through the eye of a needle, than for a rich man to enter the Kingdom of God.' Heaven was the great equaliser, as in that place the poor and worthy were comforted to know that they would not have to meet those people who had lorded it over them in this world. The Third Lateran Council of 1179 denied Christian burial to merchants, bankers and other usurers. Usury was considered the same as robbery and violence. But Christians were not the first people to be worried about being very rich. In ancient mythology King Midas, celebrated by Ovid in *Metamorphoses*, is ruined by his gift of turning everything he touches into gold.

Christ Driving the Moneylenders out of the Temple, Cecco del Caravaggio, 1610.

MIDAS

Bacchus was so grateful
He offered to grant Midas any wish –
Whatever the King wanted, it would be granted.
Midas was overjoyed
To hear this first approach, so promising,
Of his peculiar horrible doom.
He did not have to rack his brains.
A certain fantasy
Hovered in his head perpetually,
Wistfully fondled all his thoughts by day,
Manipulated all his dreams by night.
Now it saw its chance and seized his tongue.
It shoved aside
The billion – infinite – opportunities
For Midas
To secure a happiness, guaranteed,
Within the human range
Of what is possible to a god.
It grasped, with a king's inane greed,
The fate I shall describe.

Midas said: 'Here is my wish.
Let whatever I touch become gold.
Yes, gold, the finest, the purest, the brightest.'
Bacchus gazed at the King and sighed gently.
He felt pity –
Yet his curiosity was intrigued
To see how such stupidity would be punished.
So he granted his wish, then stood back to watch.
…

Almost in terror now
He reached for the goblet of wine –
Taking his time, he poured in water,
Swirled the mix in what had been translucent
Rhinoceros horn
But was already common and commoner metal.
He set his lips to the cold rim
And others, dumbfounded
By what they had already seen, were aghast
When they saw the wet gold shine on his lips,
And as he lowered the cup
Saw him mouthing gold, spitting gold mush –
That had solidified, like gold cinders.
He got up, reeling
From his golden chair, as if poisoned.
He fell on his bed, face down, eyes closed
From the golden heavy fold of his pillow.
He prayed
To the god who had given him the gift
To take it back, 'I have been a fool.
Forgive me, Bacchus. Forgive the greed
That made me so stupid.
Forgive me for a dream
That had not touched the world
Where gold is truly gold and nothing but.
Save me from my own shallowness,
Where I shall drown in gold
And be buried in gold.
Nothing can live, I see, in a world of gold.'

TED HUGHES (1930–1998)

The King's Wine Turns into Gold
English School,
20th century.

Ted Hughes was attracted by Ovid's *Metamorphoses* which was written shortly after the birth of Christ and by the Middle Ages was one of the most popular books in print. It was Chaucer's favourite book and an inspiration for Shakespeare. All the tales describe how bodies are magically changed by the powers of the gods into other bodies. Bacchus, the god of wine, gives Midas the gift of turning anything he touches into gold. When this completely ruins his life he has to be saved by Bacchus. What Ted Hughes identified in Ovid's poem was 'what passion feels like to the one possessed by it. Not just ordinary passion either, but human passion *in extremis* – passion when it combusts, or levitates, or mutates into an experience of the supernatural.'

VOLPONE; OR, THE FOX

A room in Volpone's house (his chamber)
[*Enter*] **Mosca** [*and discovers*] **Volpone** [*in his bed*].

Volpone [*Rising.*]
Good morning to the day; and next, my gold:
Open the shrine that I may see my Saint.
[*Mosca draws a curtain to disclose Volpone's treasure.*]
Hail, the world's soul, and mine! More glad than is
The teeming earth to see the long'd-for sun
Peep through the horns of the celestial Ram,
Am I, to view they splendour, darkening his;
That, lying here amongst my other hoards,
Shew'st like a flame by night; or like the day
Struck out of chaos, when all darkness fled
Unto the centre. O thou son of Sol,
But brighter than thy father, let me kiss,
With adoration, thee, and every relick

Of sacred treasure in this blessed room.
Well did wise poets, by thy glorious name,
Title that age which they would have the best;
Thou being the best of things: and far transcending
All style of joy, in children, parents, friends,
Or any other waking dream on earth:
Thy looks when they to Venus did ascribe,
They should have given her twenty thousand Cupids;
Such are thy beauties and our loves! Dear saint,
Riches, the dumb God that giv'st all men tongues;
That canst do nought and yet mak'st men do all things;
The price of souls; even hell, with thee to boot,
Is made worth heaven. Thou art virtue, fame,
Honour, and all things else. Who can get thee,
He shall be noble, valiant, honest, wise –

Act 1, Scene 1, *Volpone*, BEN JONSON (1572–1637)

Volpone, the Fox, is a miserly merchant in Venice, who having no children dupes a series of legacy hunters into giving him valuable gifts in the expectation of them becoming his heir. The elaborate stings are organised by his cynical servant Mosca, the fly, who feeds his vanity. Greed is right at the centre of the play. Volpone starts each day by worshipping his wealth, itself an act of blasphemy according to the Pythagorean belief accepted at that time that one should only reflect upon the highest ideals. Volpone also worships the sun, which in alchemy is the symbol of gold. The play is less about the exposure of avaricious criminal corruption and more about the mockery of gullible fools. In such a context the predators themselves are preyed upon. Volpone is like the fox in the fable feigning death in order to catch some birds. Jonson drew very deeply from the classical authors Horace, Petronius and Juvenal who so well described the legacy hunters of ancient Rome – nothing changes.

Volpone, Aubrey Beardsley, 1898.

The Money Changer and His Wife, Quentin Massys, 1514.

GOLD

...What is here?
Gold? yellow, glittering, precious gold? No, gods,
I am no idle votarist: roots, you clear heavens!
Thus much of this will make black white, foul fair,
Wrong right, base noble, old young, coward valiant.
Ha, you gods! Why this? What this, you gods? Why, this
Will lug your priests and servants from your sides,
Pluck stout men's pillows from below their heads:
This yellow slave
Will knit and break religions, bless the accursed;
Make the hoar leprosy adored, place thieves,
And give them title, knee and approbation
With senators on the bench: this is it
That makes the wappen'd widow wed again;
She, whom the spital-house and ulcerous sores
Would cast the gorge at, this embalms and spices
To the April day again. Come, damned earth,
Thou common whore of mankind, that puts odds
Among the rout of nations; I will make thee
Do thy right nature.

Act 4, Scene 3, *Timon of Athens*, WILLIAM SHAKESPEARE

Tulip price index 1636-37

The Tulipomania was
thought to be the first
speculative bubble.

TULIPOMANIA, 1636–1637

In the 1630s the United Dutch Provinces [the Netherlands] was the most prosperous
country in Europe. The profits of the Dutch East India Company flowed into the country
increasing the wealth of the merchant classes who spent some of their money on houses,
developing gardens and growing tulips, which were exotic plants from the East and
quite different from every other flower known to Europe. The newly rich indulged in
conspicuous consumption by buying ever rarer bulbs to display their wealth.

There were two categories of buyers: the owners of the gardens eager to show
off the latest tulips and the professional growers who were eager to have something
different, exquisite and special. Buyers were willing to pay higher and higher prices. As
a result of the demand for tulips, speculators entered the market and a type of formal
futures market was established where contracts to buy bulbs at the end of the growing
season were bought and sold. The buyers were a relatively small, closely-knit social
group of well-to-do merchants. The trade was called *windhandel* (wind trade) because
no physical bulbs were changing hands.

The rapid rise in prices started on 12 November 1636, sky-rocketing such that
some bulbs were changing hands ten times a day. But the bubble burst in Haarlem in
February 1637 when the bulb buyers refused to appear at an auction due possibly to
an outbreak of bubonic plague in the city.

A Satire on Tulipomania
(detail), Jan Brueghel the
Younger, *c.* 1640.

Speculators are depicted
as brainless monkeys in
contemporary upper-class dress.

THE SOUTH SEA BUBBLE, 1711–1720

The first golden age of dodgy financial dealings

An early trade label of the South Sea Company, for export of finest English serge cloth. The letters in the seal below read SS&FC, for *South Sea and Fishery Company*.

In 1720 the whole of England was swamped by a huge wave of speculative frenzy through the activities of the South Sea Company. This company had been formed a few years earlier with a monopoly to trade with the Spanish colonies in South America. However, owing to Spain's sovereignty over its new world colonies, the company was left with few options. Potential for a South Sea fortune was further diminished when after 1718 the fragile relationship between Spain and Britain worsened. Its principal activity, however, was the consolidation of government debt raised by the war of Spanish succession (1701–1714), which it promised to pay off over a number of years. In return for surrendering their government debt into the South Sea Company, the company would issue the debt holders with shares to the same value. As a guarantee, the British government offered to pay the company an annual sum of money which would be distributed as a dividend to shareholders. But to make this a really attractive proposition the price of the shares had to rise.

The directors of the company, led by its chairman, John Blunt, a great bully and son of a shoemaker, set about talking their shares up. So successful was he that on 17 June 1720 he received a baronetcy for his labours. Blunt and his promoters, which included politicians and bankers, were helped by the Chancellor of the Exchequer John Aislabie, who announced to Parliament on 22 January a plan for a scheme to take over most of the unconsolidated national debt of Britain in exchange for South Sea Company shares. Crucially the directors of the company had complete freedom as to the terms they could offer to the debt-holders.

The shares, which had stood at £128 at the beginning of 1720, rose in February to £175. In March they were at £330. Aislabie and several other ministers bought stock and he, together with King George I and his two mistresses, received stock that had not been issued, a deal which was akin to modern day options. Everybody was getting in on the act: Alexander Pope instructed his stockbroker to buy in February, and Isaac Newton bought heavily and shrewdly got out, but later in the year he went back in at the top of the market and lost £20,000. As he observed, 'I can calculate the movement of the stars, but not the madness of the people.'

Stock was issued in June at the price of £1,000 per share. Its success caused a feeding frenzy. Masses of other bubble companies were floated and naked avarice captured the nation. In August, the company issued its last stock at the same price but shrewd foreign investors were already selling and banks were running out of money to lend. Blunt could do nothing more to prop up the price and by the end of September the price was down to £150, a drop of seventy-five per cent in four weeks. Banks failed, many people were bankrupted, the company secretary fled, 462 members of the House

of Commons and 112 peers were involved in the crash. After a Parliamentary Inquiry in 1721, Aislabie and four MP directors were expelled from the House and sent to the Tower. The Bubble had burst.

THE BUBBLE

A South Sea Bubble card of 1720 from *Extraordinary Popular Delusions and the Madness of Crowds*, Charles Mackay, 1841.

Ye wise Philosophers explain
What Magick makes our Money rise,
When dropt into the Southern Main;
Or do these Juglers cheat our Eyes?

Put in your Money fairly told;
Presto be gone – 'Tis here agen:
Ladies, and Gentlemen, behold,
Here's ev'ry Piece as big as Ten.

Thus in a Basin drop a Shilling,
Then fill the Vessel to the Brim;
You shall observe, as you are filling,
The Pond'rous Metal seems to swim:

It rises both in Bulk and Height,
Behold it mounting to the Top;
The liquid Medium cheats your Sight,
Behold it swelling like a Sop.

In Stock Three Hundred Thousand Pounds;
I have in view a Lord's Estate:
My Mannors all contiguous round;
A Coach and Six, and serv'd in Plate.

Thus the deluded Bankrupt raves,
Puts all upon a desp'rate Bett;
Then plunges in the Southern Waves,
Dipt over Head and Ears – in Debt.
…
One Fool may from another win,
And then get off with Money stor'd;
But if a Sharper once comes in,
He throws at all, and sweeps the Board.

As Fishes on each other prey,
The Great Ones swallowing up the
 Small;
So fares it in the Southern Sea:
But Whale Directors eat up all.

When Stock is high, they come between,
Making by second-hand their Offers;
Then cunningly retire unseen,
With each a Million in his Coffers.

JONATHAN SWIFT (1667–1745)

Hogarth's 1721 *South Sea Scheme* is a caricature of the financial speculation and credulity that caused the South Sea Bubble. The London Guildhall is shown on the left and the base of the Monument is on the right signifying the power and wealth of the City of London dwarfing the dome of St Paul's. The people on the financial wheel of fortune or a merry-go-round, are the investors including, a whore, a clergyman on the left, a bootblack boy, a hag and a Scottish nobleman. Blindfolded Fortune is hung by her hair from the balcony of the Guildhall while a winged Devil chops off lumps of her flesh; Honesty is broken on the wheel by Self-interest, observed by an Anglican priest; and Honour is flogged by Villainy.

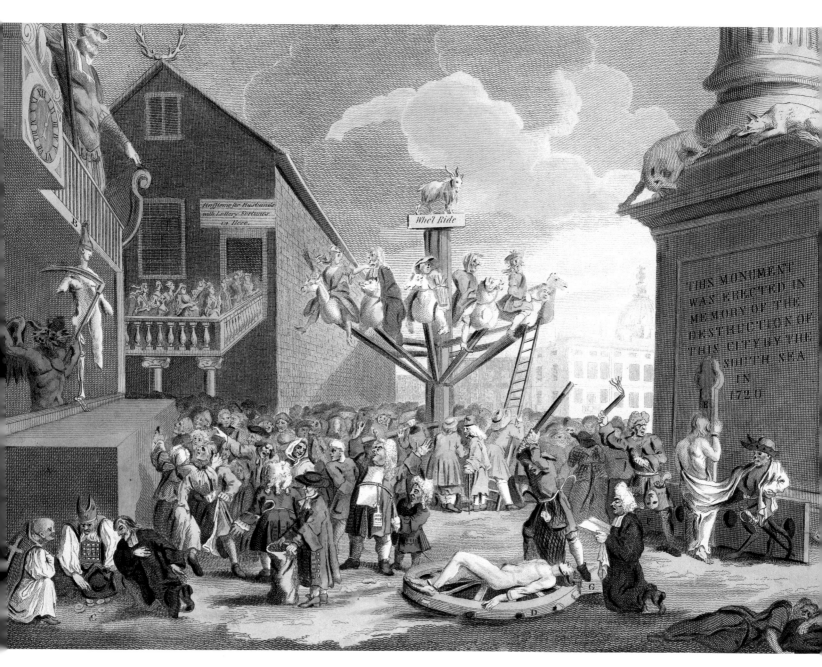

Emblematical print of the
South Sea Scheme, illustration
by William Hogarth and
re-engraved by Thomas
Cook, 1812.

London Stock Exchange
at Capel Court, engraving
by unknown artist from
The Penny Magazine, 1844.

SHARES

As is well-known to the wise of their generation, traffic in shares is the one thing to have
to do with in this world. Have no antecedents, no established character, no cultivation,
no ideas, no manners; have shares. Have shares enough to be on Boards of Direction
in capital letters, oscillate on mysterious business between London and Paris, and be
great. Where does he come from? Shares. Where is he going to? Shares. What are his
tastes? Shares. Has he any principles? Shares. What squeezes him into Parliament?
Shares. Perhaps he never of himself achieved success in anything, never originated
anything, never produced anything! Sufficient answer to all; Shares. O mighty shares!
To set those blaring images so high and to cause us smaller vermin, as though under
the influence of henbane or opium, to cry out, night and day, 'Relieve us of our money,
scatter it for us, buy us and sell us, ruin us, only we beseech ye take rank among the
powers of the earth, and fatten on us'!

Our Mutual Friend, CHARLES DICKENS

Speculation, at first a sentiment, or if you please, a taste, passes next into a habit, then
it grows into a passion, a master passion, which like Aaron's serpent, swallows up and
strengthens itself with other passions. It becomes at last more fierce than anger, more
gnawing than jealousy, more greedy than avarice, more absorbing than love. The stock-
market may be likened to a withered old harridan enamelled, painted, and decked in the
latest mode, which leers on the speculator, and points to golden prizes, that like the desert
mirage, fades away and leaves him to his ruin.

Ten Years on Wall Street, WILLIAM WORTHINGTON FOWLER (1833–1881)

SCROOGE, 'A COVETOUS, OLD SINNER'

In *A Christmas Carol*, published in December 1843, Charles Dickens added a word to the English language – 'Scrooge'.

Oh! But he was a tight-fisted hand at the grindstone, Scrooge! a squeezing, wrenching, grasping, scraping, clutching, covetous old sinner! Hard and sharp as flint, from which no steel had ever struck out generous fire; secret, and self-contained, and solitary as an oyster. The cold within him froze his old features, nipped his pointed nose, shrivelled his cheek, stiffened his gait; made his eyes red, his thin lips blue; and spoke out shrewdly in his grating voice. A frosty rime was on his head, and on his eyebrows, and his wiry chin. He carried his own low temperature always about with him; he iced his office in the dog-days; and didn't thaw it one degree at Christmas.

External heat and cold had little influence on Scrooge. No warmth could warm, nor wintry weather chill him. No wind that blew was bitterer than he, no falling snow was more intent upon its purpose, no pelting rain less open to entreaty. Foul weather didn't know where to have him. The heaviest rain, and snow, and hail, and sleet, could boast of the advantage over him in only one respect. They often 'came down' handsomely, and Scrooge never did.

Ignorance and Want, John Leech, 1843.

Ebenezer Scrooge devoted his life to, 'Avarice, hard dealing, griping cares', but the Spirit of Christmas Present drew to his attention two children:

They were a boy and a girl. Yellow, meagre, ragged, scowling, wolfish; but prostrate, too, in their humility. Where graceful youth should have filled their features out, and touched them with its freshest tints, a stale and shrivelled hand, like that of age, had pinched, and twisted them, and pulled them into shreds. Where angels might have sat enthroned, devils lurked, and glared out menacing. No change, no degradation, no perversion of humanity, in any grade, through all the mysteries of wonderful creation, has monsters half so horrible and dread.

Scrooge started back, appalled. Having them shown to him in this way, he tried to say they were fine children, but the words choked themselves, rather than be parties to a lie of such enormous magnitude.

'Spirit. are they yours?' Scrooge could say no more.

'They are Man's,' said the Spirit, looking down upon them. 'And they cling to me, appealing from their fathers. This boy is Ignorance. This girl is Want. Beware them both, and all of their degree, but most of all beware this boy, for on his brow I see that written which is Doom, unless the writing be erased. Deny it,' cried the Spirit, stretching out its hand towards the city. 'Slander those who tell it ye. Admit it for your factious purposes, and make it worse. And abide the end.'

A Christmas Carol, CHARLES DICKENS

THE CONSEQUENCES OF UNABATED AVARICE

'Mr Merdle, a borrower'

Numbers of men in every profession and trade would be blighted by his insolvency; old people who had been in easy circumstances all their lives would have no place of repentance for their trust in him but the workhouse; legions of women and children would have their whole future desolated by the hand of this mighty scoundrel. Every partaker of his magnificent feasts would be seen to have been a sharer in the plunder of innumerable homes; every servile worshipper of riches who had helped to set him on his pedestal, would have done better to worship the Devil point-blank. So, the talk, lashed louder and higher by confirmation on confirmation, and by edition after edition of the evening papers, swelled into such a roar when night came, as might have brought one to believe that a solitary watcher on the gallery above the Dome of Saint Paul's would have perceived the night air to be laden with a heavy muttering of the name of Merdle, coupled with every form of execration.

For by that time it was known that the late Mr. Merdle's complaint had been, simply, Forgery and Robbery. He, the uncouth object of such wide-spread adulation, the sitter at great men's feasts, the roc's egg of great ladies' assemblies, the subduer of exclusiveness, the leveller of pride, the patron of patrons, the bargain-driver with a Minister for Lordships of the Circumlocution Office, the recipient of more acknowledgment within some ten or fifteen years, at most, than had been bestowed in England upon all peaceful public benefactors, and upon all the leaders of all the Arts and Sciences, with all their works to testify for them, during two centuries at least – he, the shining wonder, the new constellation to be followed by the wise men bringing gifts, until it stopped over certain carrion at the bottom of a bath and disappeared – was simply the greatest Forger and the greatest Thief that ever cheated the gallows.

Little Dorrit, CHARLES DICKENS

In *Little Dorrit*, Mr Merdle, the great banker, inventor, entrepreneur and patron flattered and worshipped, beloved by the Press, courted by Ministers, is simply a crook. In the evening of a long day Mr Merdle called surprisingly upon a newly married couple, Edmund and Fanny Sparkler, and asks them if he can borrow a penknife. Fanny, looking through her recent wedding presents, offers him a pearl-handled one but he says, 'I would prefer one with a darkened tortoiseshell handle.' She finds one and gives it to him saying, 'Don't get ink on it.' Later that night in a room in a public bathhouse, a man's body is found with its jugular vein cut and beside it is a tortoiseshell-handled penknife which is stained, but not with ink.

Mr Merdle becomes a borrower, Phiz (Hablot K. Browne), 1857.

THE RICH SHOPKEEPER

Anton Chekhov wrote his first play, *Platonov*, in 1878, when he was twenty years old, but it was never performed in his lifetime, as it would have taken five hours to stage and was rejected by Maria Yermolova, a rising actress for whom the play was specifically written. It was not published until 1923 in Moscow. It depicts a town in provincial Russia rotten with drink, hypocrisy, laziness and money. The lead character Mikhail Platonov, an embittered school teacher, has squandered his inheritance as a local lothario and holds many of his neighbours in contempt, particularly the wealthy merchant Pavel Shcherbuk. In this excerpt, prompted by a thief Osip, Platonov launches into a devastating tirade against capitalism which was just then emerging in Russia.

Sir Philip Green, 2016.

Anna:	Please!
Osip:	You think I'm the only one?
Platonov:	No.
Osip:	You think I'm the only thief here?
Paltonov:	Not at all.
Osip:	If we're talking about thieves: Pavel Shcherbuk.
Platonov:	Ah well...
Shcherbuk:	Leave me out of it.
Osip:	Why? You're no different from me.
Platonov:	On the contrary. He's quite a lot different. He holds parties. People go to them. He gives money to charity. He buys up everything he can lay his hands on. He doesn't want one shop, he wants fifty shops. He wants a chain of shops. And a chain of bars. And a chain of hotels. His tentacles reaching out across the country. And for that people respect him. Shcherbuk has grasped the governing principle of Russian life. Crooks die in the forest but they prosper in the drawing room!
Anna:	Please, Platonov, you must stop!
Platonov:	Make enough money and no one will say a word against you.

Platonov, ANTON CHEKHOV (1860–1904)

Shcherbuk does not forget Platonov's insolent outburst and later in the play he tells Osip, 'I don't want him [Platonov] killed. Maim him. Can you do that? He's a good-looking man. Cripple but not kill him.' Osip replies that he can do that and Shcherbuk inquires, 'How much will that cost?'

THE SPOILS OF POYNTON

In this 1896 novel, first published under the title *The Old Things*, Henry James describes the overpowering sense of ownership felt by Mrs Gereth for her collection of antique furniture, tapestries and porcelain which she and her husband have assiduously collected during their lives. She is determined not to let it pass to the woman whom her weak son wants to marry as she cannot be trusted to cherish it: only Mrs Gereth's companion Fleda Vetch can give it the love which she herself has lavished upon it. She will not surrender it, and eventually this priceless collection destroys her family and is itself destroyed in a great fire at Poynton.

Henry James, John Singer Sargent, 1913.

'I could give up everything without a pang, I think, to a person I could trust, I could respect.' The girl heard her voice tremble under the effort to show nothing but what she wanted to show, and felt the sincerity of her implication that the piety most real to her was to be on one's knees before one's high standard. 'The best things here, as you know, are the things your father and I collected, things all that we worked for and waited for and suffered for. Yes,' cried Mrs Gereth, with a fine freedom of fancy, 'there are things in the house that we almost starved for! They were our religion, they were our life, they were *us*! And now they're only *me* – except that they're also *you*, thank God, a little, you dear!' she continued, suddenly inflicting on Fleda a kiss apparently intended to knock her into position. 'There isn't one of them I don't know and love – yes, as one remembers and cherishes the happiest moments of one's life. Blindfold, in the dark, with the brush of a finger, I could tell one from another. They're living things to me; they know me, they return the touch of my hand. But I could let them all go, since I have to, so strangely, to another affection, another conscience. There's a care they want, there's a sympathy that draws out their beauty. Rather than make them over to a woman ignorant and vulgar, I think I'd deface them with my own hands. Can't you see me, Fleda, and wouldn't you do it yourself?' – she appealed to her companion with glittering eyes. 'I couldn't bear the thought of such a woman here – I *couldn't*...'

...

'*You* would replace me, *you* would watch over them, *you* would keep the place right,' she austerely pursued, 'and with you here – yes, with you, I believe I might rest, at last, in my grave!' She threw herself on Fleda's neck, and before Fleda, horribly shamed, could shake her off, had burst into tears which couldn't have been explained, but which might perhaps have been understood.

...

'I'll give up the house if they'll let me take what I require!' That, on the morrow, was what Mrs Gereth's stifled night had qualified her to say, with a tragic face,

Panorama (Down with Liebknecht),
George Grosz, 1919.

at breakfast. Fleda reflected that what she 'required' was simply every object that surrounded them... The girl's dread of a scandal, of spectators and critics, diminished the more she saw how little vulgar avidity had to do with this rigor. It was not the crude love of possession; it was the need to be faithful to a trust and loyal to an idea. The idea was surely noble: it was that of the beauty Mrs Gereth had so patiently and consummately wrought. Pale but radiant, with her back to the wall, she rose there like a heroine guarding a treasure. To give up the ship was to flinch from her duty; there was something in her eyes that declared she would die at her post.

The Spoils of Poynton, Henry James (1843–1916)

PANORAMA (DOWN WITH LIEBKNECHT)

In 1919 Karl Liebknecht and Rosa Luxembourg published a magazine, *The Red Flag*, to promote a Marxist revolution in Germany. It never attracted mass support and the government, with what was left of the Imperial Grand Army, ruthlessly suppressed it and shot both of them. George Grosz in this cartoon focuses upon the whiskered profiteers and fat-faced industrialists who had managed to do well out of the First World War and depicts a common prostitute as a symbol of their festering rot of society which emerged from the defeat.

THE CRAVING FOR PORCELAIN IS LIKE A CRAVING FOR ORANGES

Augustus II the Strong of Saxony (1670–1733)

Kaspar Utz, a Sudeten German with a Jewish background lives in Communist Prague and has devoted his life since he left school to amassing a superb collection of over a thousand pieces of Meissen porcelain. He has a compulsive urge, a craving to seek out, to acquire, and to keep the most beautiful pieces. Utz is an insight into the obsession and drive which dominates the life of a collector. For Kaspar Utz his collection is a refuge from the horrors of the twentieth century which he has witnessed. As Utz's life nears its end, he destroys his collection and after his death when representatives from the communist state museum and an art dealer search his two-bedroom flat they find empty rooms and no evidence that a collection ever existed. Passionate collectors will give their soul and pay over the odds for an object whether it be a piece of porcelain, a stamp, a bronze, a rare edition in a pristine book jacket which would complete their collection.

Utz was the owner of a spectacular collection of Meissen porcelain which, through his adroit manoeuvres, had survived the Second World War and the years of Stalinism in Czechoslovakia. By 1967 it numbered over a thousand pieces – all crammed into the tiny two-roomed flat on Široká Street.

...

It was at Céske Krížove that this precocious child, standing on tiptoe before a vitrine of antique porcelain, found himself bewitched by a figurine of Harlequin that had been modelled by the greatest of Meissen modellers, J.J. Kändler.

The Harlequin sat on a tree trunk. His taut frame was sheathed in a costume of multi-coloured chevrons. In one hand he waved an oxidised silver tankard; in the other a floppy yellow hat. Over his face there was a leering orange mask.

'I want him,' said Kaspar.

The grandmother blanched. Her impulse was to give him everything he asked for. But this time she said, 'No! One day perhaps. Not now.'

Four years later, to console him for the death of his father, the Harlequin arrived in Dresden in a specially made leather box, in time for a dismal Christmas celebration. Kaspar pivoted the figurine in the flickering candlelight and ran his pudgy fingers, lovingly, over the glaze and the brilliant enamels. He had found his vocation: he would devote his life to collecting – 'rescuing' as he came to call it – the porcelains of the Meissen factory.

He neglected his schoolroom studies, yet studied the history of porcelain manufacture, from its origins in China to its rediscovery in Saxony in the reign of Augustus the Strong. He bought new pieces. He sold off those which were inferior, or cracked. By the age of nineteen he had published in the journal *Nunc* a lively defence of the Rococo style in porcelain – an art of playful curves from an age when men adored women – against the slur of the pederast Winckelmann: 'Porcelain is almost always made into idiotic puppets.'

...

'An object in a museum case', he wrote, 'must suffer the de-natured existence of an animal in the zoo. In any museum the object dies – of suffocation and the public gaze – whereas private ownership confers on the owner the right and the need to touch. As a young child will reach out to handle the thing it names, so the passionate collector, his eye in harmony with his hand, restores to the object the life-giving touch of its maker. The collector's enemy is the museum curator. Ideally, museums should be looted every fifty years, and their collection returned to circulation ...'

'What', Utz's mother asked the family physician, 'is this mania of Kaspar's for porcelain?'

'A perversion,' he answered. 'Same as any other.'

Utz, BRUCE CHATWIN (1940–1989)

Harlequin
J. J. Kändler, *c.* 1740.

This Harlequin, of around 1740, was created by Johann Joachim Kändler, the greatest Meissen porcelain modeller of the eighteenth century. His figures were initially made to replace wax and sugar sculptures used at grand dinners, but his Harlequin was not a table decoration, rather a cabinet piece for connoisseurs.

BANANAS

1945

On one occasion, just after the war, the first consignment of bananas reached Britain. Neither I, my sister Teresa nor my sister Margaret had ever eaten a banana throughout the war, when they were unprocurable, but we had heard all about them as the most delicious taste in the world.

When this first consignment arrived, the socialist government decided that every child in the country should be allowed one banana. An army of civil servants issued a library of special banana coupons, and the great day arrived when my mother came home with three bananas. All three were put on my father's plate, and before the anguished eyes of his children, he poured on cream, which was almost unprocurable, and sugar, which was heavily rationed, and ate all three.

A child's sense of justice may be defective in many respects, and egocentric at the best of times, but it is no less intense for either. By any standards, he had done wrong. It would be absurd to say that I never forgave him, but he was permanently marked down in my estimation from that moment, in ways which no amount of sexual transgression would have achieved.

It had, perhaps, the effect of my estimation of him that the Lavery and Great Débâcles combined had on him of me.

From that moment, I never treated anything he had to say on faith or morals very seriously.

Will This Do? AUBERON WAUGH (1939–2001)

Evelyn Waugh with his wife
and six children including
Auberon Waugh standing
behind him, 1959.

'THERE MUST BE MORE MONEY'

In this still from the 1949 film *The Rocking Horse Winner*, adapted from a 1926 short-story by D.H. Lawrence, Paul is played by John Howard Davis who had made his name aged nine in David Lean's 1948 *Oliver Twist*.

The story describes Paul's troubled family. His weak father cannot make enough money for his high spending wife and anxiety pervades the household. Sensing the unease, the three children, Paul and his two sisters, claim the house whispers, 'there must be more money'. Paul's cold and aloof mother tells him the only thing that matters in life is luck; she is unlucky, but 'If you are lucky you will always get more money.'

Wishing to get his mother's love and approval Paul decides to find luck thinking that will be a way to make money for his mother. Given a rocking horse for Christmas he believes that if he rides it long enough, the horse will tell him where he can find luck. Riding with frenzied vigour he implores, 'Now take me to where there is luck, now take me.' From riding the rocking horse he finds that he can predict what horse is going to win a horse race. It is only after a long ride that the name of a racehorse is divulged to him and confiding this to one of his uncles he mentions the name which his uncle, Oscar Creswell, recognises as a winner at Ascot. Paul then asks the horse to tell him who is going to win the Lincoln and he gets the name 'Daffodil'. By this time Paul has been regularly betting with Bassett, the family gardener, and they agree to put £300 on Daffodil. Their winnings mount up and Paul gives £5,000 to his uncle to give to his mother without revealing the source to meet some of the writs she was receiving.

However, Paul only gets to hear a winner's name after an exhaustive, frenzied ride, pushing himself to the very limit of his endurance to satisfy his mother's lust for more money.

By now the rocking horse has been moved to Paul's room in the attic where he can indulge his obsession alone.

Paul and the gardener decide to try and get the winner's name of the Derby and so the night before the race he has a long and completely exhausting ride until dawn in his attic room. When his mother enters she hears him scream, 'It is Malabar!,' as he falls from the horse and collapses. The gardener realising this is incredibly valuable information places all their winnings on Malabar at 14/1 and wins £80,000. He whispers the good news to Paul who is barely conscious, but Paul does manage to say to his mother, 'Malabar! Malabar! Did I say Malabar! Do you think I am lucky Mother? I knew Malabar didn't I? Over £80,000 and I call that lucky. Don't you Mother? If I can ride my horse and get there then I am absolutely sure! Mother did I ever tell you? I am lucky.' At his moment of victory he falls into unconsciousness and dies, a victim to his mother's avarice.

A still from the film *The Rocking Horse Winner*.

FUTURES SONG

Out you cunt, out in oh fuck it
I've dealt the gelt below the belt and I'm jacking up the ackers
My front's gone short, fuck off old sport, you're standing on my knackers
I've spilt my guts, long gilt's gone nuts and I think I'm going crackers
So full of poo I couldn't screw, I fucked it with my backers
I fucked it with my backers
I fucked it with my backers
Backups: Out! Buy buy buy! Leave it!
No! Yes! Cunt!
4! 5! Sell!
Quick! Prick! Yes! No! Cunt!

How hard I dredge to earn my wedge, I'm sharper than a knife
Don't fucking cry get out and buy, Chicago's going rife
You're back to front come on you cunt don't give me any strife
You in or out? Don't hang about, you're on the floor of Liffe!
They call me a tart who can hardly fart when it's bedlam in the pit
I'm the local tootsie playing footsie but I don't mind a bit
Cos my future trusts my money lusts as far as it can spit
And my sterling works on mouthy jerks whose bids are full of shit
...
Money-making money-making money-making money-making
Money-making money-making money-making caper
Do the fucking business do the fucking business do the fucking business
And bang it down on paper.
So L.I.F.F.E. is the life for me and I'll burn out when I'm dead
And this fair exchange is like a rifle range what's the price of flying lead?
When you soil your jeans on soya beans shove some cocoa up your head
You can never hide if your spread's too wide, you'll just fuck yourself instead.

Serious Money, CARYL CHURCHILL (B. 1938)
Song Lyrics, IAN DURY (1942–2000)

Caryl Churchill's play *Serious Money* was first performed at the Royal Court Theatre in London in March 1987. It is a witty and blunt assault on the malpractices in the City of London that came to light in the Guinness affair and other financial scandals in the mid 1980s. It pokes fun at insider trading, concert parties, junk bonds, leveraged buyouts, option and future trading on LIFFE, the London International Finance and

Future Exchange, and commodity trading in which the only commodity was money. In the London financial market of the 1980s a clear division existed between the 'educated class' and the 'barrow boys'. The move from 'gentlemanly capitalism' to the 'Big Bang' suited streetwise dealers of working class backgrounds. The typical trader was known as 'Essex Man' – a lightly educated, lager-drinking womaniser – who made a fortune by ranting and raving to clinch his deals, but was burnt out by the age of thirty.

GREED IS GOOD … GREED WORKS

Greed is all right by the way: I want you to know that. I think greed is healthy. You can be greedy and still feel good about yourself.

IVAN BOESKY speaking at University of California, Berkeley, May 1986

Boesky's words inspired the 1987 film *Wall Street* with the famous speech of Gordon Gekko, played by Michael Douglas: 'Greed, for lack of a better word, is good. Greed is

Michael Douglas playing Gordon Gekko in the film *Wall Street*, 1987.

right, greed works. Greed clarifies, cuts through, and captures the essence of evolutionary spirit. Greed, in all its forms; greed for life, for money, for love, knowledge has marked the upward surge of mankind.'

Ivan Boesky, the son of a Detroit bar owner, set up his financial trading company in 1975. He operated in the Junk Bond market, which was pioneered by Michael Milken, who operated from Century City in Los Angeles, principally through holding huge seminars which he addressed, and which were dubbed 'Predator's Balls'.

These high-yield bonds were used extensively in facilitating leveraged buyouts in the early 1980s and precipitated a Wall Street boom. When Boesky uttered these famous words on 18 May 1986 at the commencement ceremony of the School of Business Administration at the University of California, Berkeley, his time as Wall Street arbitrageur was fast running out. Six days earlier his chief informant, Dennis Levine, had been arrested by federal officials on charges of insider trading in New York.

On 14 November 1986, the Securities and Exchange Commission announced that Boesky had confessed to insider trading and that he had agreed to pay $100 million and was helping the government in investigating other offenders. Milken was implicated and in November 1990 was given a ten-year prison sentence. The Junk Bond market collapsed in 1989 and there were spectacular bankruptcies. This episode lived up to Marx's famous dictum that capitalism was based upon 'the astonishing belief that the nastiest motives of the nastiest men somehow or other work for the best results in the best of all possible worlds'.

TOADS OF PROPERTY, 1921

George Grosz was the leading caricaturist of the Weimar Republic. In this work drawn in pen and ink on paper two years after the end of the First World War, the viewer can see a factory scene with many distraught and dishevelled figures. In the foreground sit bankers and war profiteers clutching money they have amassed. They are brutish and indifferent to the suffering of those around them, including the unemployed, the old widow, the barefoot little girl and the boy on crutches who has one leg. Although the industrialists express no outward concern for the workers, they cannot survive without the armed soldiers in the background protecting their factories.

Toads of Property,
George Grosz, 1921.

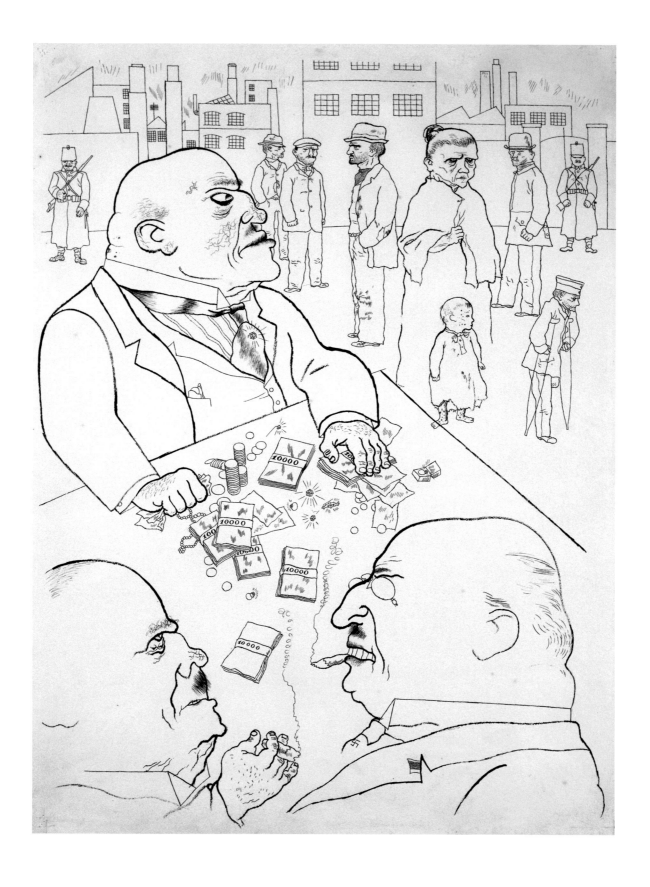

TRUTH AT LAST

The Rich Man

The rich man has his motor-car,
His country and his town estate.
He smokes a fifty-cent cigar
And jeers at Fate.
He frivols through the livelong day,
He knows not Poverty, her pinch.
His lot seems light, his heart seems gay;
He has a cinch.
Yet though my lamp burns low and dim,
Though I must slave for livelihood –
Think you that I would change with him?
You bet I would!

FRANKLIN PIERCE ADAMS (1881–1960)

Franklin Pierce Adams was a popular American journalist of the 1940s and 1950s, best known for his witty and satirical column, *The Conning Tower*.

FOR THE GIT WHO HAS EVERYTHING

I tried it in Chinese the other night and drew some characters. It looked good and Victoria was impressed but I copied it off a Chinese menu so I probably had 'fried rice, salt and pepper ribs, and hot and sour soup' on my arm instead of 'Victoria'!

I've wanted a new tattoo for ages, but we agreed it would look a bit tacky if I just had 'Victoria' in English.

So I've finally gone for Arabic because it's quite arty and I wanted something different.

That is what I do when I'm bored – new tattoos, new cars, new watches – I sound a right sad git.'

David Beckham (b. 1975) from *Beckham – The Future* by Gwen Russell, 2014.

David Beckham had the name 'Victoria' tattooed in Hindi on his forearm. Unfortunately, it was spelt incorrectly and an 'H' was added to 'Vihctoria'.

David Beckham's Tattoos, 2015.

GUSTAVE DORÉ'S ILLUSTRATION OF DANTE ALIGHIERI'S, INFERNO, 'HOARDERS AND WASTERS'

The sinners here are relentlessly pushing up all the money they have hoarded, never enjoying it, always striving to no end.

> For all the gold that is beneath the moon,
> Or ever has been, of these weary souls
> Could never make a single one repose.

The Hoarders and Wasters,
Gustave Doré, 1857.

The Divine Comedy, The Inferno, Canto VII, DANTE ALIGHIERI
Translated by Henry Wadsworth Longfellow.

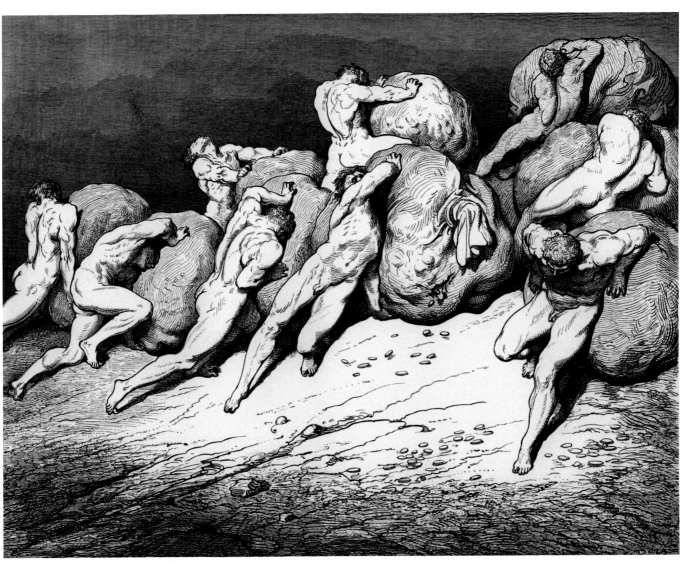

WINDING SHEETS HAVE NO POCKETS

'Here lyes a knave', 1606

Thou Politick Bankrupt, poore rich man, thou ill-painted foole, when thou art to lye in thy last Inne (thy loathsome graue) how heauy a loade will thy wealth bee to thy weake corrupted Conscience! Those heapes of Siluer, in telling of which thou hast worne out thy fingers ends, will be a passing bell, tolling in thine eare, and calling thee to a fearefull Audit. Thou canst not dispose of thy riches, but the naming of euery parcel will strike to thy heart, worse then the pangs of thy departure: thy last will, at the last day, will be an Inditement to cast thee; for thou art guilty of offending those two lawes (enacted in the vupper House of heauen) which directly forbid thee to steale, or to couet thy neighbors goods.

But this is not all neither; for thou lyest on thy bed of death, and art not carde for: thou goest out of the world, and art not lamented: thou art put into the last linnen that euer thou shalt weare, (thy winding-sheete) with reproch, and art sent into thy Graue with curses: he that makes thy Funerall Sermon, dares not speake well of thee, because he is asham'd to belye the dead: and vpon so hatefull a fyle doest thou hang the records of thy life, that euen when the wormes haue pickt thee to the bare bones, those that goe ouer thee, will set vpon thee no Epitaph but this, Here lyes a knaue.

The Seven Deadly Sins of London, THOMAS DEKKER (1572–1632)

 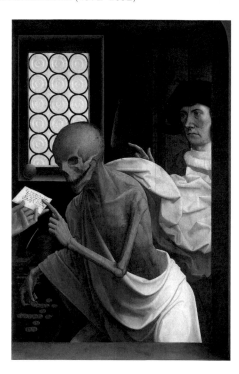

A Miser Settling His Final Account, Jan Provost, 16th century.

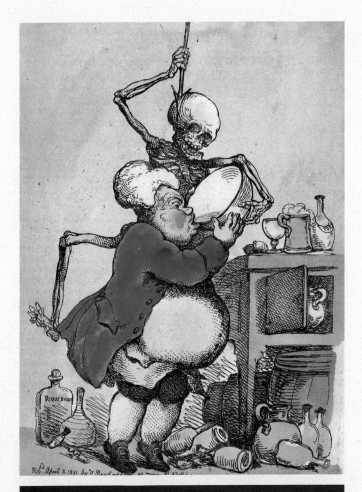

Gluttony

The Last Drop, Thomas Rowlandson, 1811.

For the drunkard and the glutton shall come to poverty.

PROVERBS 23:21

My idea of Heaven is eating pâtés de foie gras to the sound of trumpets.

SYDNEY SMITH (1771–1845)

But I'm not so think as you drunk I am.

J.C. SQUIRE (1882–1958)

Gut eates all day, and lechers all the night,
So all his meate he tasteth over, twise:
And, striving so to double his delight,
He makes himselfe a thorough-fare of vice.
Thus, in his belly, can he change a sin
Lust it comes out, that gluttony went in.

BEN JONSON

'Oh, pity the poor glutton
Whose troubles all begin
In struggling on and on
* to turn*
What's out into what's in.'
Walter de la Mare

TODAY GLUTTONY IS NOT CONDEMNED FROM THE PULPIT – it is no longer a sin, it is an ailment and a sinner is not punished for his or her sin but by sin itself. The glutton's punishment is in this world, not the next, for it is obesity which elicits the disgust of friends and strangers alike. The pot-belly puff ball flesh, sagging breasts, ballooning thighs, a thickening neck and flaccid skin are accompanied by belching, farting and vomiting as the glutton eats and drinks him or herself to an early death. Their God is their gut and their minds are turned off by articles on slimming, dietary apps and health clubs.

Gluttony was identified as a sin in the fourth century. John Cassain, known as John the Ascetic (360–435), established a monastic settlement near Marseilles in the South of France, which recognised that 'the first conflict we must enter upon is that against gluttony.' It was then believed that there were three steps towards mysticism – Purgatio, Illuminatio and Unitio. During the first level, Purgatio, young monks fought by means of prayer and denial to overcome the pleasures of the flesh. This was achieved by purging themselves of gluttony, lust and the desire for possessions. Cassain stressed, 'Do not pity the body bitterly complaining of weakness, nor fatten it up with extravagant food… A body deprived of food is an obedient horse, and it will never throw off its rider.'

St John Chrysostom (349–407) started his religious life as a hermit before he became a popular preacher and later the Archbishop of Constantinople. He believed that there was little more shameful or worse than gluttony and in his teaching he gave it the prime place: 'Gluttony turned Adam out of Paradise, Gluttony it was that drew down the deluge at the time of Noah.' He also added, 'the increase in luxury is nothing but the increase in excrement.' Among other Christian theologians St. Paul (*c.* 5 – *c.* 67) condemned gluttony and Thomas à Kempis (*c.* 1380–1471) in his *Imitation of Christ* observed, 'When the belly is full to bursting with food and drink, debauchery knocks at the door.'

With the onset of the printing press secular writers took up the charge – Chaucer's Pardoner, in *The Canterbury Tales*, tells of three drunkards who met death through their indulgence, 'O womb, O belly, O stinking cod! [bag] Fulfilled of dung and of corruption. At either end of thee foul is the sound.' Dante consigned gluttons to the third circle of Hell which was a lower region than lust and there they dwelt naked in a cold, filthy, freezing bog for all eternity.

The fourteenth-century poem *Piers Plowman* portrays an alcohol-ravaged England, in which ale serves to reveal the bestial nature of the people.

There was laughing and lowering and 'Let go the cup!'
They sat so till evensong singing now and then,
Till Glutton had gulped down a gallon and a gill.
His guts 'gan to grumble like two greedy sows;
He pissed a pot-full in a paternoster-while;
And blew with the bugle at his backbone's end,
That all hearing that horn held their nose after
And wished it were stopped up with a wisp of furze.

Piers Plowman, WILLIAM LANGLAND

Gluttony is pure self-indulgence and generally no-one else is involved, indeed any other presence is an unnecessary intrusion into the totally self-absorbed process of a glutton stuffing food into his or her mouth. In the 1929 grainy, black and white, silent film

Gluttony (Gula), Jacques Callot, etching and engraving, after 1621.

Piccadilly, Charles Laughton makes his film debut as a diner, in full evening dress, seated on the edge of a dance floor, with his napkin tucked into his collar, and so totally preoccupied with his lavish meal that he doesn't spare a glance for the provocative artiste dancing in front of him. In a slightly different setting, Terry Jones, as Mr Creosote, in Monty Python's 1983 film *The Meaning of Life*, acts a morbidly obese middle-aged man. Sitting in a restaurant, surrounded by other well dressed customers, he is served a vast amount of food and drink while vomiting repeatedly until he eventually explodes. Although Creosote orders the highlights off the restaurant's evening menu, to a glutton the food itself is not very important, just as a drunkard is happy to get intoxicated with any combination of alcoholic drink; it is the sheer compelling necessity to eat. Sir John Suckling (1609–1641) put it neatly:

Terry Jones and John Cleese
in Monty Python's
The Meaning of Life, 1983.

*'Just a wafer-thin mint
monsieur...'*

'Tis not the meat, but 'tis the appetite
Makes eating a delight.'

Illustrations from the
Tacuinum Sanitatis, a
medieval handbook on
health, 14th century.

Gluttons have little or no appreciation of beauty or delicacy, they just want to eat more and more, and that makes them a bore. There is no intellectual stimulation, no communal enjoyment, no reflective epilogue, just a belch – gluttons may have companions, but they have no friends.

Gluttony can be a forechamber to lust, except that nowadays the Friday and Saturday night binge-drinkers, and the party-going hedonists in Ibiza and other such places, are usually so drunk that they are incapable of any sexual activity.

Over-eating is one of the curses of the modern world for it is easier to do it today than at any time in the history of the human race. Britain is now one of the 'fattest' countries in Europe – a quarter of the adult population is statistically obese. Over-eating now kills more people than drugs, and the media encourages and pampers the greedy. Books on cooking lead the non-fiction bestseller lists, chefs have become celebrities, and TV baking competitions are watched by millions. However, just as people are compulsively interested in food, they are also interested in wanting to lose weight. The food industry and media relentlessly exploit this paradox. A vast market of slimming diets are published every month and their diet plans are today's papal indulgences to pardon the sin of gluttony. They do not try to save you from eternal damnation; their targets are rather simpler and more temporal. They help one to cope with a neighbour's contempt, a friend's hilarity or a lover's repugnance.

Man's preoccupation with gastronomy and cooking was formalised in the fifteenth century with the publication in Venice of the 1475 book, *De honesta voluptate et valetudine* translated as 'On Honourable Pleasure and Health'. It was written by an Italian Renaissance humanist, Bartolomeo Platina, who had come to know a renowned chef Maestro Martino of Como. It contains over 200 recipes and was the first printed cookbook.

GLUTTONS TURNED INTO SWINE

The goddess, rising, asks her guests to stay,
Who blindly follow where she leads the way.
Eurylochus alone, of all the band,
Suspecting fraud, more prudently remained.
On thrones around with downy coverings graced,
With semblance fair, the unhappy men she placed.
Milk newly pressed, the sacred flour of wheat,
And honey fresh, and Pramnian wines the treat:
But venomed was the bread, and mixed the bowl,
With drugs of force to darken all the soul:
Soon in the luscious feast themselves they lost,
And drank oblivion of their native coast.
Instant her circling wand the goddess waves,

To hogs transforms them, and the sty receives.
No more was seen the human form divine;
Head, face, and members, bristle into swine:
Still cursed with sense, their minds remain alone,
And their own voice affrights them when they groan.
Meanwhile the goddess in disdain bestows
The mast and acorn, brutal food! and strows
The fruits of cornel, as their feast, around;
Now prone and grovelling on unsavoury ground.

The Odyssey, Book X, HOMER
Translated by Alexander Pope.

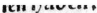

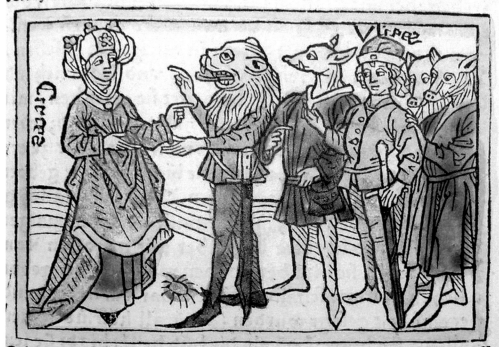

A German medieval
woodcut from a translation
by Heinrich Steinhowel of
*Boccaccio's de Mulieribus
Claris*, 1474.

On his journey home Odysseus lands in Aeaea, home of the beautiful witch goddess Circe, who is protected by lions and wolves. She provides a luxurious feast, including a pottage of cheese and wheat sweetened with honey and laced with wine, for his entire crew. It drugs them and then she turns them into swine. Hermes tells Odysseus that he can overcome Circe by eating a herb called Moly which will protect them from her spells. Later, when Odysseus has disarmed her, they become lovers and he spends a happy year with her.

A marginal grotesque
of drunkenness, Luttrell
Psalter, *c.* 1330.

MEDIEVAL DRUNKENNESS – LUTTRELL PSALTER

Lincolnshire, Around 1320–1340

Wine is a lecherous thing and drunkenness
A squalor of contention and distress.
O drunkard, how disfigured is thy face,
How foul they breath, how filthy thy embrace!
And through thy drunken noise a stertorous snort
Like *'samson-samson'* – something of the sort.
Yet Samson never was a man to swig.
You totter, lurch and fall like a stuck pig,
Your manhood's lost, your tongue is in a burr.
Drunkenness is the very sepulchre

Of human judgement and articulation.
He that is subject to the domination
Of drink can keep no secrets, be it said.
Keep clear of wine, I tell you, white or red,
Especially Spanish wines which they provide
And have on sale in Fish Street and Cheapside.

'The Pardoner's Tale', *The Canterbury Tales,*
GEOFFREY CHAUCER

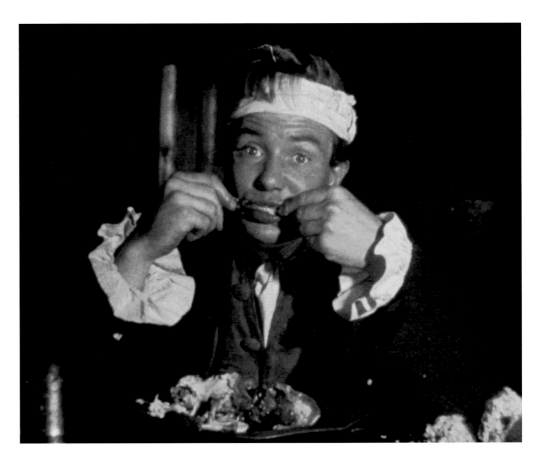

Albert Finney in the film
Tom Jones, 1963.

IN DEFENCE OF GLUTTONY

In Henry Fielding's novel, *The History of Tom Jones*, Tom is kind-hearted but he has a weakness for the fairer sex and happily beds three different women none of whom are his true love. His randy nature leads him into all kinds of misadventures. In this passage Tom arrives at a country inn but before he can enjoy the delights of the beautiful, buxom redhead Mrs Waters, he tucks in to a huge dinner eating three pounds of beef, putting food before fornication.

An apology for all heroes who have good stomachs, with a description of a battle of the amorous kind.

Now after this short preface, we think it no disparagement to our heroe to mention the immoderate ardour with which he laid about him at this season. Indeed, it may be doubted, whether Ulysses, who by the way seems to have had the best stomach of all the heroes in that eating poem of *The Odyssey*, ever made a better meal. Three pounds at least of that flesh which formerly had contributed to the composition of an ox, was now honoured with becoming part of the individual Mr Jones.

This particular we thought ourselves obliged to mention, as it may account for our heroe's temporary neglect of his fair companion; who eat but very little, and was indeed employed in considerations of a very different nature, which passed unobserved by Jones, till he had entirely satisfied that appetite which a fast of twenty-four hours had procured him; but his dinner was no sooner ended, than his attention to other matters revived...

The History of Tom Jones, Chapter V, HENRY FIELDING (1707–1754)

A PARSON'S PLEASURE

January 28 1780

We had for dinner a Calf's Head, boiled Fowl and Tongue, a Saddle of Mutton rosted on the Side Table, and a fine Swan rosted with Currant Jelly Sauce for the First Course. The Second Course a couple of Wild Fowl called Dun Fowls, Larks, Blamange, Tarts, etc., etc. and a good Desert of Fruit after amongst which was a Damson Cheese. I never eat a bit of Swan before, and I think it good eating with a sweet sauce. The Swan was killed 3 weeks before it was eat and yet not the lest bad taste in it.

July 18 1786

Purging and vomiting almost the whole day. I believe I made too freely yesterday with Currant Tarts and Cream.

The Diary of a Country Parson, James Woodforde (1740–1803)

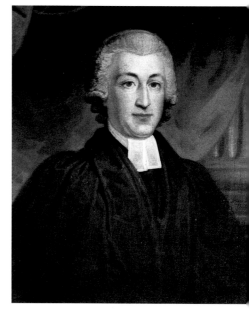

James Woodforde, painted by his nephew, Samuel Woodforde, 18th century.

A VOLUPTUARY UNDER THE HORRORS OF DIGESTION

The brilliant, cruel, 1792 portrait (overleaf) by James Gillray of George, the Prince of Wales, later the Regent and George IV, draws its strength from not being a caricature, but being a picture of a thirty-two-year-old man ruining himself by selfish indulgence. He has eaten most of a leg of ham, his plate is completely clean, the bottles are empty, the chamber pot stands ready on top of unpaid bills and he is picking his teeth in a vulgar way. On the table behind him stand cures for stinking breath, piles and venereal disease, whilst on the floor are his gambling debts. The waistcoat is held by just one button and his swelling paunch is bursting his breeches. The Brighton Museum has a pair of his breeches dating from 1827 which measure fifty-five inches around the waist. George's favourite tipple was cherry brandy which he drank throughout the day and he enjoyed giving lavish banquets in the Brighton Pavilion where he persuaded the famous French chef Carême to join him in 1816. In 1817 he prepared a banquet for the Grand Duke Nicholas of Russia which included thirty-six main dishes and thirty-two side dishes.

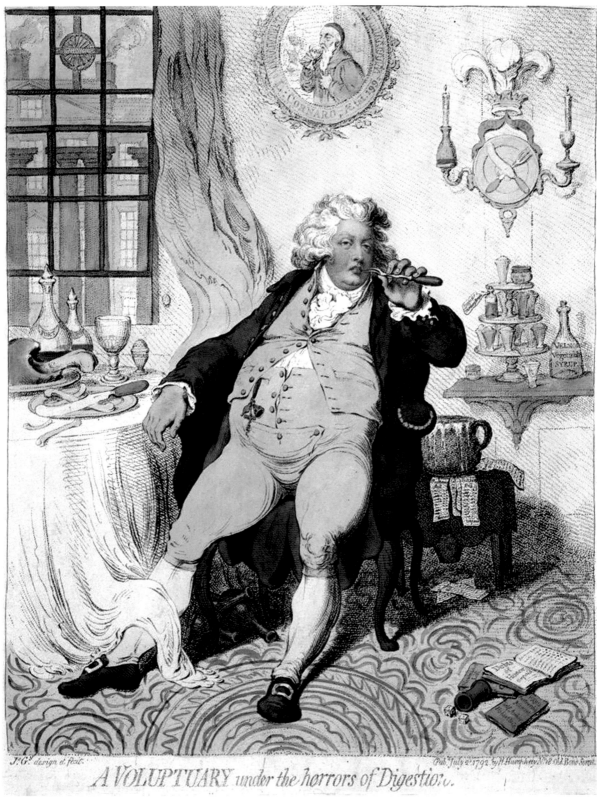

A VOLUPTUARY under the horrors of Digestion.

A Voluptuary under the horrors of Digestion,
James Gillray, 2 July 1792.

GERMANS EATING SOUR-KROUT

The plates and massive tankards are inscribed Weyler Castle Street which was an eating-house run by a Viennese called Weyler, in Castle Street, east of Leicester Square, London, known for its sausages and sauerkraut.

The Germans are the worst, for sheer bulk. What miles of liver sausage, what oceans of beer and the quagmires of those colossal bellies! How appalling they look from behind; the terrible creases of fat three deep across solid and shaven napes! Necks wreathed in smiles, the stigmata of damnation; and delusive smiles, for when they turn round there is nothing but a blank stare and a jigsaw of fencing scars. If you are ever losing an argument with such a one you can always win by telling him to wipe those smiles off the back of his neck...

Germans eating sour-krout,
James Gillray, 1803.

The Seven Deadly Sins: Gluttony, PATRICK LEIGH FERMOR (1915–2011)

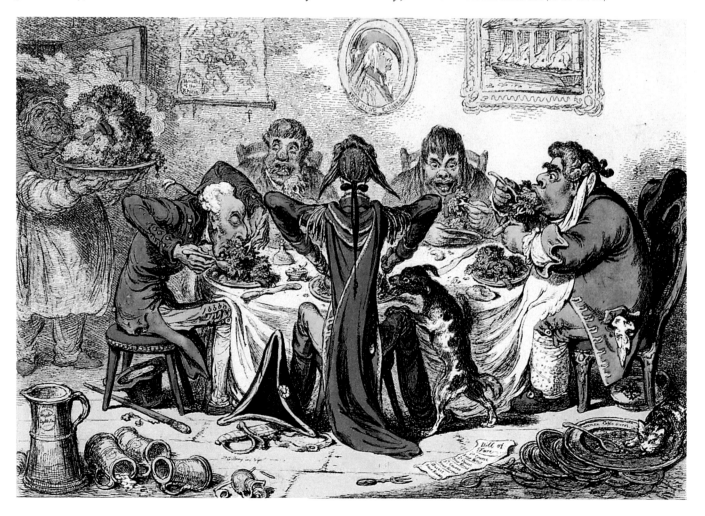

CIVIC PRIDE, 1750

Before the twentieth century men who were grossly fat were not castigated by government, nor derided by their friends and neighbours, but treated as minor celebrities. This print records a bet about the size of the waistcoat worn by a recently deceased shopkeeper, Mr Edward Bright. His friends were rather proud of him and his grossness was considered almost a virtue.

Soon after Bright's death in 1750, aged twenty-nine years old and weighing over forty-seven stone, a bet was made between Mr Codd and Mr Hance [a gambler] that seven hundred men could fit inside Bright's waistcoat. Mr Codd won his bet when seven men from the Dengie 'Hundred' [a parcel of land] were buttoned in.

The Surpriseing Bett Decided, British 18th century.

A view of decideing [*sic*] the Wager between a Mr Codd and a Mr Hance of Maldon in the County of Essex which was that 7 Men where actually with great ease on the first day of December 1750 in the House of the Widow Day, the Black Bull of Maldon aforesaid, button'd within the Waistcoat of Mr Bright deceas'd late Shop Keeper of the same Town.

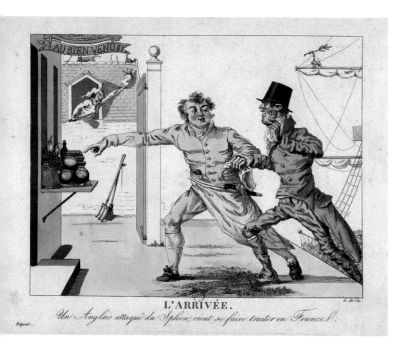

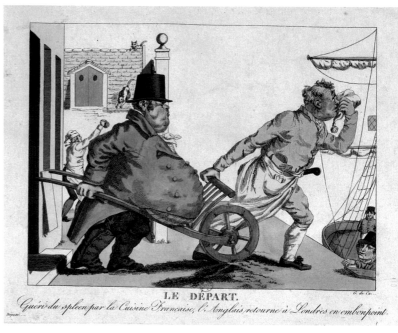

ENGLISH GLUTTONY

1815

After the victory of Waterloo in 1815, many English people took the opportunity to visit France again. Here is a traveller shown arriving lean and leaving grossly fat where he was supposed to take a cure for his spleen. As soon as he arrives he is led to a restaurant where the chef is killing some cats in preparation for a stew. On his return the traveller's spleen seems to have been cured by *la cuisine française*, but at some cost.

L'Arrivée, Godissart de Cari, 1815.

Le Départ, Godissart de Cari, c. 1815.

HOCK AND SODA-WINE

Don Juan

CLXXVIII
And the small ripple spilt upon the beach
Scarcely o'erpass'd the cream of your champagne,
When o'er this brim the sparkling bumpers reach,
That spring-dew of the spirit! The heart's rain!
Few things surpass old wine: and they may preach
Who please, – the more because they preach in vain,
Let us have wine and woman, mirth and laughter,
Sermons and soda-water the day after.

CLXXIX
Man, being reasonable, must get drunk;
The best of life is but intoxication:
Glory, the grape, love, gold, in these are sunk
The hopes of all men, and of every nation;

Without their sap, how branchless were the trunk
Of life's strange tree, so fruitful on occasion:
But to return, – get very drunk; and when
You wake with head ache, you shall see what then.

CLXXX
Ring for your valet – bid him quickly bring
Some hock and soda-water, then you'll know
A pleasure worthy Xerxes the great king;
For not the bless'd sherbet, sublimed with snow,
Nor the first sparkle of the desert-spring,
Nor Burgundy in all its sunset glow,
After long travel, ennui, love, or slaughter,
Vie with that draught of hock and soda-water.

Don Juan, LORD BYRON (1788–1824)

Byron as Don Juan, with Haidee, Alexandre-Marie Colin, 1831.

The Drunkard's Home,
George Cruikshank,
c. 1842.

THE DRUNKARD'S HOME, GEORGE CRUIKSHANK

'So be it! "Behold the man!" Excuse me, young man, can you... No, to put it more strongly and more distinctly; not *can* you but *dare* you, looking upon me, assert that I am not a pig?'

The young man did not answer a word.

'Well,' the orator began again stolidly and with even increased dignity, after waiting for the laughter in the room to subside. 'Well, so be it, I am a pig, but she is a lady! I have the semblance of a beast, but Katerina Ivanovna, my spouse, is a person of education and an officer's daughter. Granted, granted, I am a scoundrel, but she is a woman of a noble heart, full of sentiments, refined by education.'

...

'Such is my fate! Do you know, sir, do you know, I have sold her very stockings for drink? Not her shoes – that would be more or less in the order of things, but her stockings, her stockings I have sold for drink! Her mohair shawl I sold for drink, a present to her long ago, her own property, not mine; and we live in a cold room and she caught cold this winter and has begun coughing and spitting blood too. We have three little children and Katerina Ivanovna is at work from morning till night; she is scrubbing and cleaning and washing the children, for she's been used to cleanliness from a child. But her chest is weak and she has a tendency to consumption and I feel it! Do you suppose I don't feel it? And the more I drink the more I feel it. That's why I drink too. I try to find sympathy and feeling in drink… I drink so that I may suffer twice as much!' And as though in despair he laid his head down on the table.

Crime and Punishment, FYODOR DOSTOEVSKY (1821–1881)
Translated by Constance Garnett

The Effects of Intemperance,
Jan Steen, *c.* 1664.

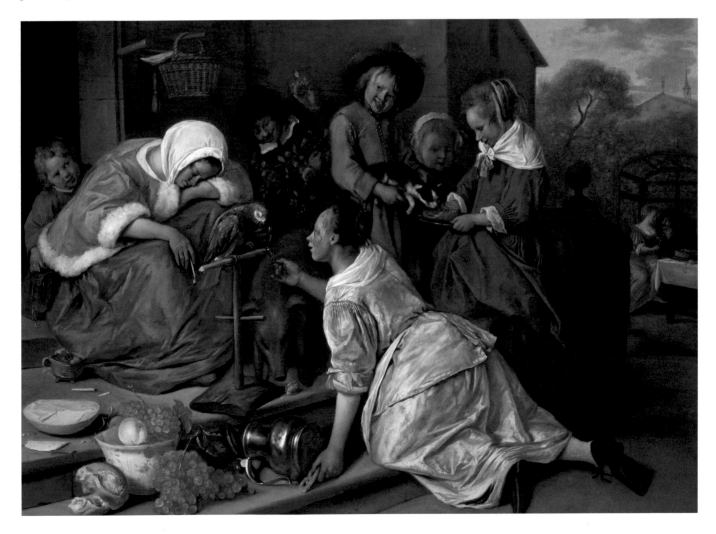

THE BOOK OF DEMONS

Up A Height And Raining

It is dawn and soon I will have a fit,
a seizure, a gagthroat convulsion,
a demon convention with furtongue
pressed hard against the roof of my mouth.

Mouth an estuary for the love of drink,
and I know I stink of it darling
and no amount of mints or garlic can hide it
from the houndsniff now that's built into your mind.

There will be blood, dearest, and horrid venom,
and black demon matter we'll never clean off.
I won't go again onto the drip. Not to the hospital
or the lock-away ward with its tightly kept key.
I'm going solo with capsules and the strength of
 your love.

Yes, love, they come: shiny shoes oddly enough,
the very nature of poetry erased from their report books,
tight black leather gloves to grip the bottles. Those
ugly gloved hands which search your soul.
You must guzzle aloud and let them do it
for every demon has to have its day.

No stopping them and no stopping me
parallel to the horizon: my licence laws very strict –
I go from glass to glass, bottle to offy and back.
There's one thing you can say: I never slack
from TV cornflake zone until Big Ben's a post epilogue
 memory.

Except I can't remember it or anything
unless the mind-piranhas begin to swarm
and I know I am not Cromwell or Milton
but I am Protestant heretic,
a Leveller lunatic, filled and felled by wine,
whose failed allotment is a museum of weeds,
whose rainy medallions are mare's tail and crowsfoot
 trefoil.

I do remember a blue light turning, and turning
to you and trying to speak and couldn't. Just
the bleeps on the machine trying to keep me alive.

And after X-ray escaping the wheelchair, vodka-legged,
felled face down by the drink in the street.
Nervous pedestrians leaning over
and a discerning passer-by: leave him he's pissed.

The Book of Demons, BARRY MACSWEENEY (1948–2000)

Barry MacSweeney was acclaimed as a young poet in the 1960s, but as he admitted himself, he was an alcoholic by the age of sixteen. In 1995 he was almost killed, in his words, by 'his solitary hard drinking, and after a series of life-threatening fits and convulsions which ended with him on a life support machine, he underwent rehabilitation through detoxification in several hospitals and in an addiction clinic.' Optimistically he wrote in 1997, 'He has now fully recovered.' Sadly, it was not to be and the craving returned. In May 2000, alone in his room, he choked to death among the empties. This end of life he probably foresaw when he wrote, 'One day choke on it, tongue / jammed backwards down / throat's clogged highway.'

Barry MacSweeney.

In 1997 Bloodaxe Books published *The Book of Demons* which describes his journey from 'angel boyhood to scarred bottledom', through the craving, joy, humiliation, torment and delirium of a life devoted to the demon drink. This tragic masterpiece is the brilliant, brutal, eloquent and moving epitaph of a gifted poet.

DRINK PROVOKES THE DESIRE BUT IT TAKES AWAY THE PERFORMANCE

(*Knocking within*)
Porter: Anon, Anon! I pray you remember the porter.
(*He opens the gate*)
(*Enter MacDuff and Lennox.*)

MacDuff: Was it so late, friend, ere you went to bed
That you do lie so late?
Porter: Faith, sir, we were carousing till the second cock, and drink, sir, is a great provoker of three things.
MacDuff: What three things does drink especially provoke?
Porter: Marry, sir, nose-painting, sleep, and urine. Lechery, sir, it provokes and unprovokes; it provokes the desire but it takes away the performance: therefore, much drink may be said to be an equivocator with lechery: it makes him and mars him; it sets him on and it takes him off; it persuades him and disheartens him, makes him stand to and not stand to: in conclusion, equivocates him in a sleep, and, giving him the lie, leaves him.

The drunken porter speaks with MacDuff and Lennox after Macbeth has murdered Duncan, Henry Courtney Selous, 19th century.

MacDuff: I believe drink gave thee the lie last night.
Porter: That it did, sir, i' the very throat on me: but I required him for his lie; and, I think, being too strong for him, though he took up my legs sometime, yet I made a shift to cast him.

Act 2, Scene 3, *The Tragedy of Macbeth*,
WILLIAM SHAKESPEARE

UNDER THE VOLCANO

Albert Finney as Geoffrey
Firmin in the film *Under the
Volcano*, 1984.

In *Under the Volcano*, the English writer Malcolm Lowry describes the last day in
the life of Geoffrey Firmin, the British Consul in the Mexican town of Quauhnahuac
[Cuernavaca], which is situated between the twin volcanoes of Popocatepetl and
Iztaccihuatl. In the second chapter the reader finds Firmin, sitting at a hotel bar,
drinking himself to death at 7 a.m. on 2 November 1938, Mexico's Day of the Dead.

Rejecting both duty and love, as his wife had just returned to him, he descends
through a growing crowd of hallucinations to his own Inferno. Indeed one critic
has described this book as the drunken *Divine Comedy*. Bent on self destruction he
drinks steadily all day, all the while having a strange clairvoyance, conscious of what
is happening to him, but incapable of stopping it. Some critics see in Firmin a symbol
for the state of Europe towards the end of the 1930s, and the ravine into which his
dead body is tossed as analogous to the abyss into which Europe was fast falling. It is
a tragic story but Firmin has an element of the heroic within him.

The Consul dropped his eyes at last. How many bottles since then? In how many
glasses, how many bottles had he hidden himself, since then alone? Suddenly he
saw them, the bottles of aguardiente, of anís, of jerez, of Highland Queen, the

Malcolm Lowry in 1946.

glasses, a babel of glasses – towering, like the smoke from the train that day – built to the sky, then falling, the glasses toppling and crashing, falling downhill from the Generalife Gardens, the bottles breaking, bottles of Oporto, tinto, bianco, bottles of Pernod, Oxygénée, absinthe, bottles smashing, bottles cast aside, falling with a thud on the ground in parks, under benches, beds, cinema seats, hidden in drawers at Consulates, bottles of Calvados dropped and broken, or bursting into smithereens, tossed into garbage heaps, flung into the sea, the Mediterranean, the Caspian, the Caribbean, bottles floating in the ocean, dead Scotchmen on the Atlantic highlands – and now he saw them, smelt them, all, from the very beginning bottles, bottles, bottles, and glasses, glasses, glasses, of bitter, of Dubonnet, of Falstaff, Rye, Johnny Walker, Vieux Whisky, *blanc* Canadien, the apéritifs, the digestifs, the demis, the dobles, the *noch ein* Herr Obers, the *et glas* Araks, the *tusen taks*, the bottles, the bottles, the beautiful bottles of tequila, and the gourds, gourds, gourds, the millions of gourds of beautiful mescal… The Consul sat very still. His conscience sounded muffled with the roar of water. It whacked and whined round the wooden frame house with the spasmodic breeze, massed, with the thunderclouds over the trees, seen through the windows, its factions. How indeed could he hope to find himself, to begin again when, somewhere, perhaps, in one of those lost or broken bottles, in one of those glasses, lay, forever, the solitary clue to his identity? How could he go back and look now, scrabble among the broken glass, under the eternal bars, under the oceans?

Under the Volcano, MALCOLM LOWRY (1909–1957)

It is a tragic story of restlessness and guilt reflecting Lowry's own life as an alcoholic succumbing to the same doomed life as the Consul. His death in 1957 in the village of Ripe was almost unnoticed but his cottage is visited by his devoted readers.

VODKA'S VICTORY

Front cover, and inside page,
Vladimir Shinkarev, 1980.

When Pyotr opened his eyes, it felt like he was reopening a half-healed wound.

'Are you going to work?' Maxim repeated.

'No,' answered Pyotr, and pulled the coat up over his head.

Under the coat it was close and cosy, there was a smell of coarse tobacco, there was something spinning around in there. There seemed to be little creatures sitting in his fist and crawling in and out of it. They crawled as quick as they could, in case someone big, the size of a pig, came crawling through. Funny… why was everything so out of balance – his mouth was dry, on fire, but his feet were just the opposite, freezing cold? Because the head was more important? Or just closer? Or…

'Want some beer?' asked Maxim.

'No.'

Several of the little people crawled into his fist at the same time. No, forget about work. Or… Ah, it was beer he was asking about: do I want some beer? Right, then!

He flung the coat aside and sat up.

'I've poured you some,' said Maxim. 'Go on, it'll steady you a bit.'

It was a hazy morning; not in the sense that the room was filled with smoke, not that. In the slanting rays of the early light the bottles glinted like an aquarium, and everything white seemed hazy mother-of-pearly. Wasn't that wonderful – morning existed too. Pearly mother-of-morning. It wasn't beer he should be drinking, but coffee, as much as possible – and then set off walking and wondering.

Pyotr stood up, picked up his padded jacket off the floor then, not knowing where to put it and not capable of thinking the problem through, he dropped it again.

He put the glass to his lips and his teeth chattered against it.

There were so many things going on at every moment, his senses had become excessively heightened. Pyotr picked up his jacket again and was about to launch into God-knows-what far-reaching line of action, but he couldn't do it, he broke down and dropped it again.

He tried his beer again, too, gazing into the turbid depths of the sludge in a desperate search for hope, then groaning as he raised it to his lips and pressed them against it in a kiss. The beer seemed very thick, as though it wasn't even liquid. Drinking it immediately made him tired.

'The water's over there in the jar,' said Maxim.

Pyotr staggered across, took a drink of water and staggered back.

'Listen, Maxim, I think I've got to go to the army office! Mobilisation registration certificate… registrificate!'

'Go on then, off you go.'

Pyotr promptly swung round and tumbled out on to the street.

'Maxim and Fyodor': A Novel and Two Short Stories: Young Russians Search for the Meaning of Life, VLADIMIR SHINKAREV (*b.* 1954)
Translated by Andrew Bromfield.

'... a drink in the morning and you are free all day.'

This book, *Maxim and Fyodor*, originally produced on flimsy, well-thumbed, blurry papers, was passed hand-to-hand in Russia in the 1970s amongst the artistic and literary circles. In the 1980s in the heady first years of Gorbachev's perestroika, when the censorship world of old Marxism and Leninism was cracking up, it still circulated as a *samizdat* [a clandestine publishing system within the Soviet Union by which forbidden literature was reproduced and circulated privately]. The two heroes of the story are 'alconauts' living in a small communal flat in Leningrad during the 1970s. They spend their lives searching for and consuming port, vermouth, beer and 'the snout-twister' vodka. They are dismissed by Russian society as slobs and by their own disciple, Pyotr, as 'pretty stupid'.

The book was conceived as a massive protest about the stifling officialdom of Brezhnev's bureaucracy and social realism. It was a cry from the streets for freedom from conformity, and liberty to express nonsense – 'a drink in the morning and you are free all day'. In the 1990s it became a bestseller, a showcase of fine writing, with such gems as, 'there may be clever people about but it makes no difference'.

JEEVES TO THE RESCUE

P.G. Wodehouse's great creation, Bertie Wooster, is often 'stewed to the gills' and 'tanked to the uvula,' and being an expert in this area he confides to his friend Claude Cattermole (Catsmeat) Potter-Pirbright that 'there are six varieties of hangover – the Broken Compass, the Sewing Machine, the Comet, the Atomic, the Cement-Mixer and the Gremlin Boogie'.

Fortunately for Bertie he has Jeeves. In Wodehouse's 1925 *Jeeves Takes Charge*, Jeeves is hired as Bertie's valet. Their meeting and subsequent partnership is cemented for all time by one of Jeeves' first acts by providing 'a glass and tray' to help 'a morning head'.

Stephen Fry as Jeeves in the 1990 Granada Television production of *Jeeves and Wooster*.

I swallowed the stuff. For a moment I felt as if somebody had touched off a bomb inside the old bean and was strolling down my throat with a lighted torch, and then everything seemed suddenly to get all right. The sun shone in through the window; birds twittered in the tree-tops; and, generally speaking, hope dawned once more.

'You're engaged!' I said, as soon as I could say anything.

I perceived clearly that this cove was one of the world's wonders, the sort no home should be without.

'Thank you, sir. My name is Jeeves.'

Jeeves Takes Charge, P.G. WODEHOUSE

Attending to Bertie Wooster's raging hangover Jeeves remarks, it is 'a little preparation of my own invention. It is the Worcester Sauce that gives it its colour. The raw egg makes it nutritious. The red pepper gives it its bite. Gentlemen have told me that they have found it extremely invigorating after a late evening.' As many people have since commented, Jeeves' recipe is very similar to the 'Prairie Oyster' tonic popularised by Christopher Isherwood's Sally Bowles in the 1939 book, *Goodbye to Berlin*.

THE PENALTY OF PORT

As a result of the 1703 Methuen Treaty, wines from Portugal came into England with little or no duty. The aristocracy were quick to take up the habit of drinking port, but discovered it was detrimental to those suffering from arthritic conditions. King George IV's daily consumption of port and brandy was so excessive that it led to his suffering from gout at an early age. Gout stools were designed to give the sufferer some relief from the agonizing pain and by 1826 the King's bed had no fewer than 'eleven gouty pillows'.

The Gout, James Gillray, 1799

THE CAPITALIST DINNER BY DIEGO RIVERA

Diego Rivera (1886–1957) expressed his Marxist beliefs through his paintings. These were usually murals, painted in prominent places and visible to many thousands of people. *The Capitalist's Dinner,* in the hall of Agrarian Revolution in the Ministry of Education building in Mexico City, shows a widespread human truth of social inequality. Rich and poor are shown together. A rich family is about to have a splendid dinner. They are rich enough to be gluttons. But what a dismal greedy gathering. The faces of the family are turned inward, a spoilt child is crying and the father has his eyes closed as if in prayer but more probably to shut out the reality of his situation. In the background farm workers with no material wealth are shown as young and vigorous, but they also carry guns and a threatening belt of bullets.

The Capitalist's Dinner, from *Ballad of the Proletarian Revolution, 1928–1929,* Diego Rivera.

THE PUNISHMENT FOR GLUTTONY

In the third circle of Hell Dante comes across the Gluttons led by Ciacco. He introduces himself to Dante:

> Ciacco you citizens nicknamed me – alack!
> Damnable gluttony was my soul's disease;
> See how I waste for it now in the rain's wrack.

The Divine Comedy, The Inferno, Canto VI, DANTE ALIGHIERI
Translated by Dorothy L. Sayers.

The identity of Ciacco is unclear but the word is derogatory and usually refers to a 'pig'. In the third circle of Hell each gluttonous soul grovels in slimy, black mud with heavy, steady rain. As gluttony in the real world lives a warm and cosy life, the landscape of the third circle is filled with freezing water, and sodden, filthy earth.

The Drawings for Dante's Divine Comedy, Sandro Botticelli, *c.* 1485.

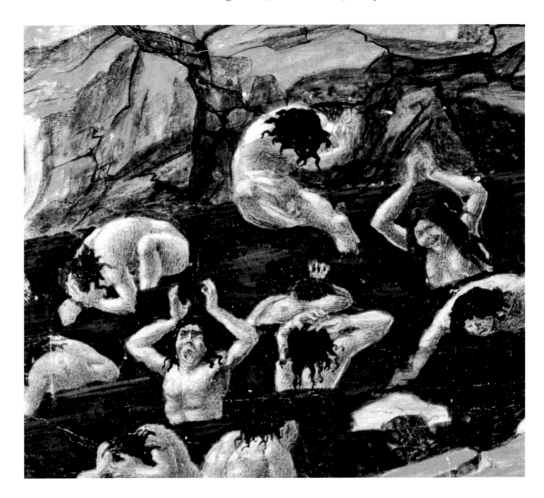

THE VENGEANCE OF GLUTTONY

'In a way, gluttony is an athletic feat, a stretching exercise.'
John Updike, 1990.

'It is the only sin which turns us into monsters'

Its vengeance is far more convincing than Dante's penalty for gluttons – permanent hounding by Cerberus in a non-stop hailstorm. Spiritual sins may rack the conscience, fill us with misery, lay the soul waste, and turn our hearts to stone. Alas, they do! But at least they don't ruin our blood pressure or hobnail our livers. What are snarling and hailstones compared with the pangs of indigestion, palpitations, much-sweats, heart-burn, bilious attacks, d.t.s, real alcoholism, nicotine poisoning? The Fathers didn't reckon with this.' Mr Vortigern flourished his cigar. 'What torments match the agony of a chainsmoker short of tobacco? Surely those earthly pains and humiliations should shorten our sentences later on? And what about obesity, bottle-noses, bleary-eyes, grog-blossoms and breath like a blowlamp? It is the only sin which turns us into monsters. I have got off lightly so far.' Mr Vortigern glanced with satisfaction at his reflection in a gunsmith's window. 'At least *girth*-control invites no anathema, if we can but practice it. Always remember that outside every thin man lurks a fat man trying to climb in.

The Seven Deadly Sins: Gluttony, PATRICK LEIGH FERMOR

Lust

Contemplating Ruin, Ferdinand von Reznicek, *c.* 1908.

...I've got the pox! At last! The real thing! not the contemptible clap... no, no, the great pox, the one which Francis I died of. The majestic pox... and I'm proud of it, by thunder.

An exalted GUY DE MAUPASSANT (1850–1893)

Like Francis I, Maupassant was afflicted by syphilis for much of his life. He died from the disease in a private asylum at Passy in Paris.

...Die: die for adultery! No:
The wren goes to 't, and the small gilded fly
Does lecher in my sight.
Let copulation thrive;

Act 4, Scene 6, King Lear, WILLIAM SHAKESPEARE

For the sin they do by two and two, they must pay for one by one.

RUDYARD KIPLING

Doing, a filthy pleasure is, and short;
And done, we straight repent us of the sport:
Let us not then rush blindly on unto it,
Like lustful beasts, that only know to do it:
For lust will languish, and that heat decay.
But thus, thus, keeping endless holiday,
Let us together closely lie and kiss,
There is no labour, nor no shame in this;
This hath pleased, doth please, and long will please; never
Can this decay, but is beginning ever.

GAIUS PETRONIUS (27–66)
Translated by Ben Jonson.

ONE CAN LUST FOR MANY THINGS – POWER, FAME, FOOD AND GOLD – but the deadly sin is the lust for sexual activity. The obsession of lust is furtive, secretive, devious and deceitful, driven by a determination to possess and triumph, and its burning passion, which demands immediate gratification usually secured by force. It has nothing to do with love.

It has never been better described than by William Shakespeare in Sonnet 129:

The expense of spirit in a waste of shame
Is lust in action; and till action, lust
Is perjur'd, murderous, bloody, full of blame,
Savage, extreme, rude, cruel, not to trust;
Enjoy'd no sooner but despised straight;
Past reason hunted, and no sooner had,
Past reason hated, as a swallow'd bait,
On purpose laid to make the taker mad:
Mad in pursuit and in possession so;
Had, having, and in quest to have, extreme;
A bliss in proof, and prov'd, a very woe;
Before, a joy propos'd; behind, a dream.
All this the world well knows; yet none knows well
To shun the heaven that leads men to this hell.

This fresco, thought to be of Sappho, was found at Pompeii.

Sexual passion was central to Classical Greek and Roman cultures, and the gods were as much subject to its spell as ordinary humans. It has been a favourite subject for artists often explicitly depicting this primal behaviour in their art.

In the seventh century BC, Helen, the daughter of Zeus, was married to the King of Sparta, Menelaus, and was thought to be the most beautiful woman in the world. Paris, the Prince of Troy, fell passionately in love with her and abducted her to Troy. Menelaus was not prepared to let this violent act go unpunished and he marshalled a fleet and an army and launched history's most famous war. The cause of which was memorably described centuries later in *Doctor Faustus* by Christopher Marlowe (1564–1593):

Was this the face that launch'd a thousand ships
And burnt the topless towers of Ilium.

In the sixth century BC, Sappho (630–580 BC) wrote the earliest poems in western literature about the passion one person can feel for another.

The Loves of Helen and Paris (detail), Jacques-Louis David, 1788.

Two Satyrs about to rape a sleeping Maenad, Attic red-figure hydria *c.* 500 BC.

Rape of Persephone, Gian Lorenzo Bellini, 1622.

…whenever I catch
sight of you, even if for a moment,
then my voice deserts me

and my tongue is struck silent.

At that time it was very common for gods and goddesses to succumb to lust. Hades, the brother of Zeus, was given the underworld to run and he raped and abducted Persephone, the daughter of Zeus and Demeter, and made her, his Queen of the Underworld.

There are many explicit paintings and drawings from classical antiquity like this image from around 500 BC depicted upon a Greek black figure water jug of two sexually aroused satyrs about to rape a sleeping maenad.

The Desert Fathers in the third century raged against the carnal desires of men. St Jerome (347–420) bewailed the temptation of the flesh:

Yet I was often surrounded by dancing girls… and my mind was hot with desire… When my flesh rebelled, I subdued it by weeks of fasting.

St Augustine identified sexual activity as being a deadly sin. On his conversion to Christianity he repudiated the woman he had been living with and who had borne him a son. Famously, writing in his *Confessions*:

As a youth I had been woefully at fault, particularly in early adolescence. I had prayed to you for chastity and said, 'Give me chastity and continence but not yet.'

For Christians, the penalty for lust was eternal damnation and throughout the Middle Ages congregations throughout Europe were told by their priests of the horrors that awaited the sinful in the afterlife. However, there were also punishments in this world for many libertines caught syphilis and gonorrhoea. Those who tried the only known cure of mercury usually lost their noses – many eighteenth century prints feature harlots and lecherous soldiers with black noses.

Adultery has become a misdemeanour rather than a sin. In 2002 a Canadian entrepreneur, Noel Biderman, launched a website called Ashley Madison to encourage married people to commit adultery. Lust was the driver and it was very successful, for by 2015 it had attracted over thirty-seven and a half million customers, including just over one million in the UK. When, in July 2015, it was hacked and personal details, including names, telephone numbers and in some cases nude photographs, sexual fantasies and customers' liaisons, became public the effect was deadly. Extortion and embarrassment following this breach of privacy resulted in reports of suicide and divorce.

As for the adulterers Kipling got it right:

For the sins they do by two and two
They must pay for one by one.

Many people, some very young, can become addicted to lust from pornographic films which are so easily available over the internet. According to *The Economist* in 2015 the web boasted an estimated 700m–800m individual pornography pages, three-fifths in America. PornHub, claims to have had nearly eighty billion video viewings in 2014, and more than eighteen billion visits. Mindgeek who own and operate all the websites in the PornHub Network is now one of the world's biggest online operators in any industry serving more than one hundred million visitors a day. With or without web-based pornography people are increasingly treated to a barrage of media images focused on sensuality and sex which puts physical immediate gratification above emotional intimacy.

The End of Lust, Siné.

FAUSTUS AND HELEN

In Greek Mythology, Paris, the son of Priam, the King of Troy, seduces Helen, the Queen of Sparta and wife of Menelaus, and abducts her to Troy. Menelaus and Agamemnon, his brother, unable to accept the shame that their family suffered raise a thousand ships and launch Greece's war on Troy. In Christopher Marlowe's 1592 play of *Doctor Faustus*, Faustus addresses the summoned shade of Helen of Troy.

Re-enter **HELEN**

FAUSTUS: Was this the face that launch'd a thousand ships,
And burnt the topless towers of Ilium?
Sweet Helen, make me immortal with a kiss – [*Kisses her.*]
Her lips suck forth my soul: see where it flies!
Come, Helen, come, give me my soul again.
Here will I dwell, for heaven is in these lips,
And all is dross that is not Helena.
I will be Paris, and for love of thee,
Instead of Troy, shall Wertenberg be sack'd;
And I will combat with weak Menelaus,
And wear thy colours on my plumed crest;
Yes, I will wound Achilles in the heel,
And then return to Helen for a kiss.
O, thou art fairer than the evening air
Clad in the beauty of a thousand stars;
Brighter art thou than flaming Jupiter
When he appear'd to hapless Semele;
More lovely than the monarch of the sky
In wanton Arethusa's azur'd arms;
And none but thou shalt be my paramour!

Doctor Faustus, CHRISTOPHER MARLOWE (1564–1593)

Christopher Marlowe, Anonymous, 1585.

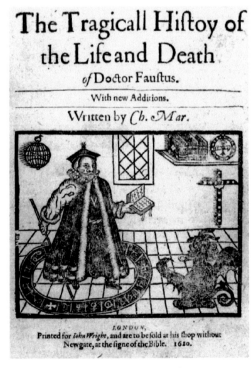

Frontispiece to a 1620 printing of *Doctor Faustus* showing Faustus conjuring Mephistopheles.

A WOMAN'S EROTIC DESIRE

To me it seems that man has the fortune
of gods, whoever sits beside you
and close, who listens to you
sweetly speaking

and laughing temptingly. My heart
flutters in my breast whenever
I quickly glance at you –
I can say nothing,

my tongue is broken. A delicate fire
runs under my skin, my eyes
see nothing, my ears roar,
cold sweat

rushes down me, trembling seizes me,
I am greener than grass.
To myself I seem
needing but little to die.

Yet all must be endured, since...

Poem 31, SAPPHO
Translated by Diane J. Raynor.

Sappho,
Charles Mengin, 1877.

Sappho was one of the first lyric poets and her poetry was well-known and much admired by many succeeding generations in classical Greek and Roman periods. But only a small proportion of what she wrote has survived; 650 lines from an output that may have been as high as 10,000. In the third century BC the great Library of Alexandria had nine books of songs attributed to Sappho, but they were all destroyed in the great fire. As her poems were written on papyrus made from the stems of the aquatic flowering plant of the same name growing in Egypt – many have simply disappeared over time leaving only a few fragments. A book was a length of papyrus extended for several metres, wound round sticks at both ends. It was read by unrolling the papyrus from one stick to the other.

It was the custom to recycle papyrus scrolls into cartonnage, a material that resembles papier mâché and to use it to make mummy cases. Egyptian rubbish is sometimes a treasure trove for lost Greek poems. Some of Sappho's works on papyrus were found in

a rubbish mound in the Ancient Egyptian town of Oxyrhynchus [the city of the Sharp-Nosed Fish – modern Egyptian Arabic *El Bahnasa*] at the beginning of the twentieth century and others turn up from time-to-time, the latest discovery turning up in a collection bequeathed to the University of Mississippi and sold at Christies in 2011. In all there are 192 fragments, including twelve poems of between fifteen to twenty lines; short passages of four, five and six lines; couplets and single words.

Many of Sappho's poems, unknown to modern day scholars, were read in antiquity mainly for their erotic content. Statements from the Classical Greek and Roman period speak of her female homoeroticism and her relationships with young women. Little is known about Sappho's life on the island of Lesbos. She had two brothers, may also have been married and may have had a daughter, but it is assumed that her poems were semi-autobiographical. Some were dedicated to Aphrodite, the Goddess of Passionate Love, as opposed to Hera, the Goddess of Marital Love, and some mention the names of several women; fragment 31 is quite clearly an expression of erotic desire for a woman. She is a striking gay icon from Ancient Greece who has given the word 'Lesbian' to the world.

ARISTOTLE AND PHYLLIS, 320 BC

The story of Aristotle and Phyllis originated as a medieval legend. In his conquest of Asia, Alexander the Great (356–323 BC) took as his paramour a beautiful Indian, Phyllis. He was so infatuated with her that he neglected affairs of state and Aristotle was chosen to persuade him to do more governing and less fornicating. His success with Alexander caused Phyllis much chagrin. In revenge, she decided to humiliate the great philosopher. In the garden next to his study, she regularly appeared early in the morning with bare feet and dishevelled hair. She would proceed to sing seductively and dance voluptuously in the hope that Aristotle would become besotted with her. Eventually he succumbed to his desires and began to solicit her. But she insisted that before consummation she wanted to ride upon him as a horse. So he got onto his all fours and she saddled him and rode around the garden whipping him soundly, singing triumphantly, 'Master Silly carries me / Love leads on, and so he goes / By love's authority.' Alexander was appalled to see his master so humiliated, but he forgave them both even though lust had triumphed and destroyed Aristotle's credibility. This story achieved popularity in the late Middle Ages and was often represented in tapestry, drawings and paintings and captured in ivory on the sides of jewel caskets.

Aristotle and Phyllus,
adapted from Hans Baldung
Grien, 1513.

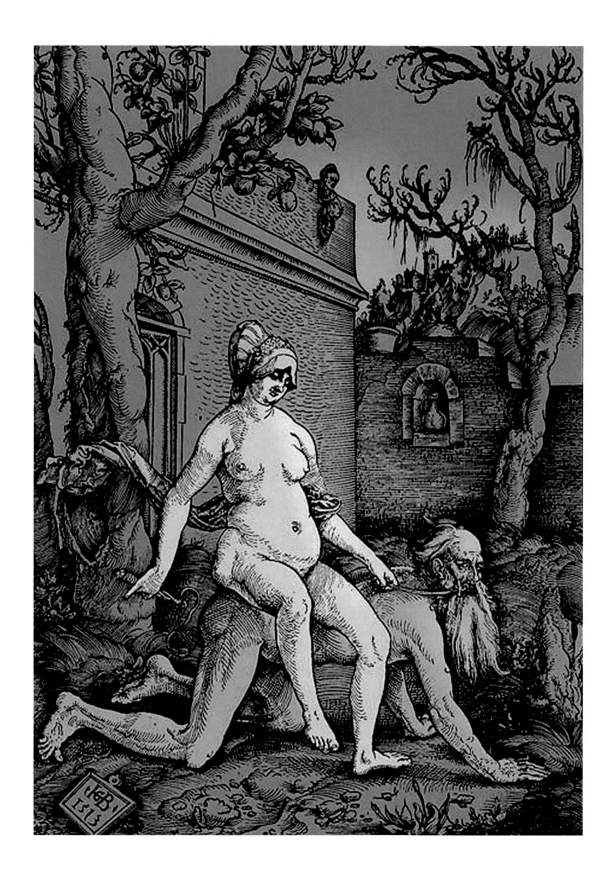

CATULLUS

Gaius Valerius Catullus, Rome's most erotic poet, lived through the turbulent last years of the Roman republic when Julius Caesar, Pompeii the Great and Crassus fought and intrigued for power. He moved in their circle and fell passionately in love with Clodia Mettelli, an unhappy wife of Metellus Celer, a senator and consul in 60 BC. Inspired by the poetry of Sappho, some of Catullus' poems describe his feelings for Clodia, who after having become his mistress he refers to as Lesbia. Over a number of years, Catullus wrote thirty poems about her and their relationship together displaying striking depth. *On the Death of a Pet Sparrow* the poet addresses his lover's pet sparrow (a bird with erotic symbolism), with which she often plays. He imagines that Lesbia plays with the sparrow because she misses the poet. He wishes that he could play with the sparrow the way Lesbia does, so that he would miss her less. The poet's intention is clear but he was engaged in a risky venture as the punishment of adultery was death. When Clodia's husband unexpectedly died Catullus harboured a hope they could marry but she fell for one of Catullus' friends; a younger, richer and more handsome man called Marcus Caelius Rufus. He also sported 'a fashionable little beard', which according to Cicero Clodia was especially fond of. After losing Clodia, Catullus' poems became quite bitter and he set about portraying her as the very symbol of sexual excess. However, his libido was unaffected by her rejection and he continued to have several other lovers, telling sweet Ipsitilla to expect an exciting afternoon, 'prepare yourself for nine consecutive fucks – I am poking through my tunic and cloak'.

Sparrow, my lady's pet,
with whom she often plays whilst she holds you in her lap, or gives you her finger-
tip to peck and
provokes you to bite sharply,
whenever she, the bright-shining lady of my love,
has a mind for some sweet pretty play,
in hope, as I think, that when the sharper smart of love abates,
she may find some small relief from her pain –
ah, might I but play with you as she does,
and lighten the gloomy cares of my heart!
This is welcome to me as (they say)
to the swift maiden was the golden apple,
which loosed her girdle too long tied.

Poem 2, GAIUS VALERIUS CATULLUS (87–54 BC)
Translated by Francis Warre Cornish.

Lesbia and her Sparrow,
Sir Edward John Poynter
PRA, 1907.

THE KISS

Let us live, my Lesbia, and love,
and value at one farthing
all the talk of crabbed old men.
Suns may set and rise again.
For us, when the short light has once set,
remains to be slept the sleep on one unbroken night.
Give me a thousand kisses, then a hundred,
Then another thousand, then a second hundred,
then yet another thousand, then a hundred.
Then, when we have made up many thousands,
we will confuse our counting, that we may not know the reckoning,
nor any malicious person blight them with evil eye,
when he knows that our kisses are so many.

Poem 5, GAIUS VALERIUS CATULLUS
Translated by Francis Warre Cornish.

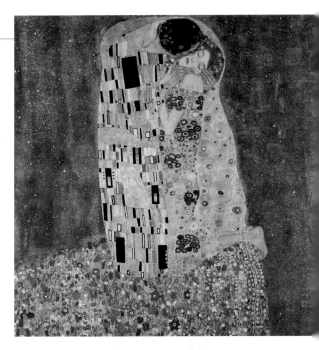

The Kiss, Gustav Klimt,
1907–08.

SUSANNAH AND THE ELDERS

The story of Susannah comes from *The Apocrypha* and appears in the Old Testament of the Bible. Susannah is a beautiful, married woman who bathes naked in her garden. Two elderly judges, who are friends of her husband, see her and are so overcome by her beauty that they threaten that unless she sleep with them they will publicly accuse her of sleeping with a young man. Susannah refuses to yield to their lechery and they carry out their threat and press their false claims. She is condemned to death. However, her prayers are heard and a young man called Daniel becomes her advocate. During his cross-examinations, he asked the two elders separately under which tree the adultery occurred. One said it was the Mastick tree and the other said the Holn tree. Condemned by such false witness they are put to death. Many artists, including Rubens and Tintoretto have depicted this scene but the prize, in my opinion, goes to Artemisia Gentileschi who was the most important female painter of early modern Europe.

In 1837 the British cartoonist H.B. [John Doyle (1797–1868)] could not resist drawing this image of the young virgin Queen Victoria riding between her two most lecherous Prime Ministers – Melbourne and Palmerston; both of whom were named in divorce actions when they held the office of Prime Minister. In 1863, in his eightieth year, Palmerston was cited in a divorce court by a certain Thaddeus O'Kane and the wits of the time said, 'We all know about Kane, but was Palmerston able.' Disraeli, his Tory opponent, refused to take advantage of Palmerston's situation and insisted

Susannah and the Elders,
Artemisia Gentileschi, 1610.

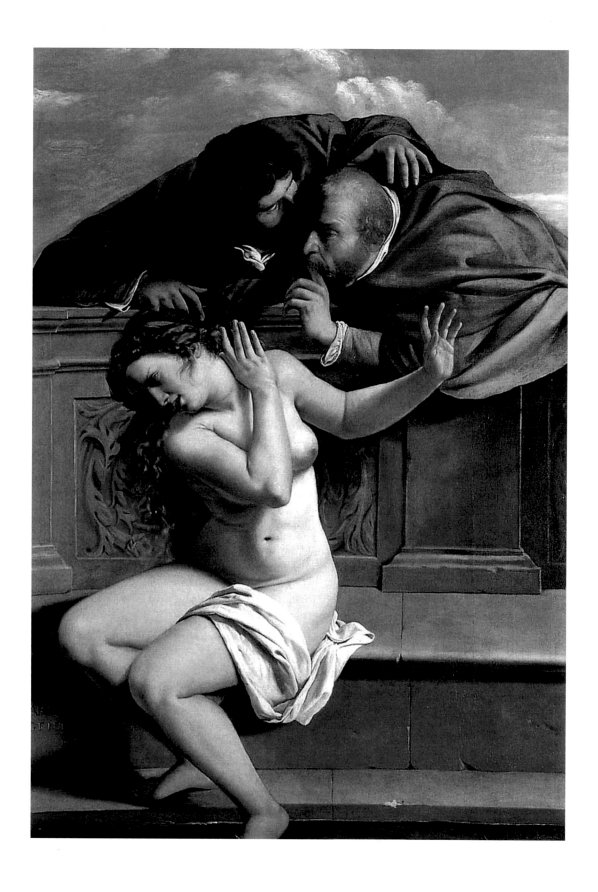

Susannah and the Elders (William Lamb, 2nd Viscount Melbourne; Queen Victoria; Henry John Temple, 3rd Viscount Palmerston), John Doyle, 1837.

that it must be kept secret because it would only do 'Old Pam' good. He was right: a few months later, after the action was dismissed, there was a general election in which 'Pam' increased his majority.

MESSALINA, WIFE TO THE ROMAN EMPEROR CLAUDIUS

Messalina (*c.* 17–48AD) was the third wife of the Emperor Claudius (10 BC–54 AD) and renowned as being sexually voracious. Virtually all the stories of Messalina and her sensual life were written by Suetonius and Tacitus some seventy years after her assassination at a time when much hostility surrounded the imperial line to which Messalina belonged. Her sexual notoriety was also recorded by Pliny the Elder and Juvenal. She was the ideal object for Juvenal's misogynistic *Sixth Satire* which described her working in a brothel.

This was a private Crime; but you shall hear
What Fruits the Sacred Brows of Monarchs bear:
The good old Sluggard but began to snore,
When from his side up rose th'Imperial Whore:
She who preferr'd the Pleasures of the Night
To Pomps, that are but impotent Delight,
Strode from the Palace, with an eager pace,
To cope with a more masculine Embrace:
Muffled she march'd, like *Juno* in a Cloud,
Of all her Train but one poor Wench allow'd,
One whom in secret Service she cou'd trust;
The Rival and Companion of her Lust.
To the known Brothel House she takes her way;
And for a nasty Room gives double pay;
That Room in which the rankest Harlot lay.
Prepar'd for Fight, expectingly she lies,
With heaving Breasts, and with desiring Eyes:
Still as one drops, another takes his place,
And baffled still succeeds to like disgrace.
At length when friend Darkness is expir'd,
And ev'ry Strumpet from her Cell retir'd.
She lags behind, and ling'ring at the Gate,
With a repining Sigh submits to Fate:
All Filth without, and all a Fire within,
Tir'd with the Toil, unsated with the Sin.
Old *Caesar's* Bed the modest Matron seeks;
The steam of Lamps still hanging on her Cheeks
In ropy smut: thus foul, and thus bedight,
She brings him back the Product of the Night.

Satire VI: The Decay of Feminine Virtue, DECIMUS JUNIUS JUVENAL
Translated by John Dryden.

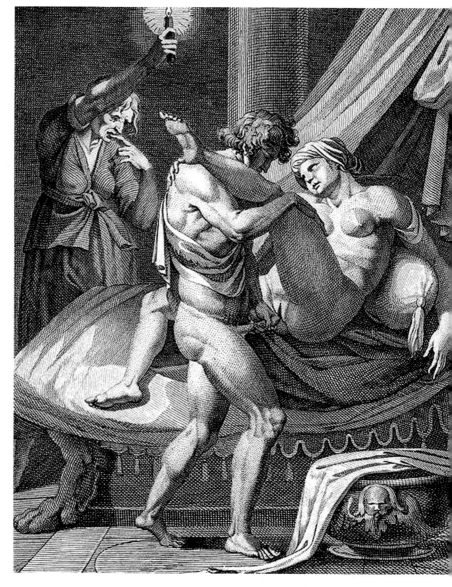

*Messalina in the booth
of Lisisca*, Agostino Carracci,
16th century.

This etching by Agostino Carracci (1557–1602) is after an engraving by Marcantonio Raimondi (*c.* 1470–1482 – *c.* 1534) who made a series of very explicit couplings published in a book *Sonetti Lussuriosi* (Lust Sonnets) by Pietro Aretino (1492–1556) in 1524. Aretino is generally recognised as the first literary pornographer.

Bestiary, with extracts from Giraldus Cambrensis on Irish birds, 13th century.

Around 1200, this may have been written by a priest, Nicholas of Guildford living in Dorset. This extract was translated by Brian Stone.

Medieval Groping,
The 'Smithfield Decretals',
13th century.

THE OWL AND THE NIGHTINGALE – MEDIEVAL GROPING

In summer peasants lose their sense
And jerk in mad concupiscence:
Theirs is not love's enthusiasm,
But some ignoble, churlish spasm,
Which having achieved its chosen aim,
Leaves their spirits gorged and tame.
The poke beneath the skirt is ended,
And with the act, all love's expended.

This is from a Middle English poem called *The Owl and the Nightingale*. Only two surviving manuscripts exist and it is difficult to date them precisely. The Nightingale's song represents love and lechery, while the owl's, representing the moral view of the church, is grumpy and resentful. In this extract the owl condemns the peasants lust for sex which has nothing to do with 'love's enthusiasm'. In another passage the owl declares:

My song most clearly tells mankind
To leave the life of sin behind;
I bid them cease from self-deceit,
For it is better and more sweet
On earth to weep with woe and care
Than be the Devil's friend elsewhere.

FRANCESCA DA RIMINI

And then I turned to them: 'Thy dreadful fate,
Francesca, makes me weep, it so inspires
Pity,' said I, 'and grief compassionate.

Tell me – in that time of sighing-sweet desires,
How, and by what, did love his power disclose
And grant you knowledge of your hidden fires?'

Then she to me: 'The bitterest woe of woes
Is to remember in our wretchedness
Old happy times; and this thy Doctor knows;

Yet, if so dear desire thy heart possess
To know that root of love which wrought our fall,
I'll be as those who weep and who confess.

One day we read for pastime how in thrall
Lord Lancelot lay to love, who loved the Queen;
We were alone – we thought no harm at all.

As we read on, our eyes met now and then,
And to our cheeks the changing colour started,
But just one moment overcame us – when

We read of the smile, desired of lips long-thwarted,
Such smile, by such a lover kissed away,
He that may never more from me be parted

Trembling all over, kissed my mouth. I say
The book was Galleot, Galleot the complying
Ribald who wrote; we read no more that day.'

The Divine Comedy, The Inferno, Canto V,
DANTE ALIGHIERI
Translated by Dorothy L. Sayers.

Paolo and Francesca,
Dante Gabriel Rossetti, 1855.

The second circle of Hell contains the souls of carnal sinners. Their souls are perpetually blown back and forth by the fierce winds of a raging storm and Dante recognises Francesca da Rimini and her lover, Paolo de Remini. For political reasons, she had been forced to marry Gianciotto, the deformed son of Malatesta, the Lord of Rimin. While in Rimini she fell in love with his handsome brother, Paolo. Even though Paolo was married their affair lasted for ten years in secret. When Gianciotto discovered that they were lovers he stabbed them both. After meeting Francesca in *The Inferno* Dante learns from her that their act of adultery started after reading together the story of Lancelot's illicit love for Guinevere.

LUST OF VENUS

In 1593 when Shakespeare published his long poem *Venus and Adonis,* only five of his plays had been performed. It was immediately popular, running to sixteen editions in just forty-seven years. During Shakespeare's life the poem was much more widely read than his plays, for only half of his plays were published in his lifetime. This poem is blatantly erotic and obscene as Venus, lying completely naked, tries to seduce the beautiful young hunter, Adonis, begging him to kiss her and embrace her body. She pleads, begs and implores him to have sex with her over a thousand times. Adonis rebuffs all her advances, pleading he is too young, and his only passion in life is to hunt the wild boar. This he does as soon as he escapes her wild clutches. However, he is later killed by a boar and so saved from sin, but at some cost.

Venus and Adonis, Titian, *c.* 1555–60.

Even as the sun with purple-colour'd face
Had ta'en his last leave of the weeping morn,
Rose-cheek'd Adonis hied him to the chase;
Hunting he loved, but love he laugh'd to scorn;
Sick-thoughted Venus makes amain unto him,
And like a bold-fac'd suitor 'gins to woo him.
…

'Vouchsafe, thou wonder, to alight thy steed,
And rein his proud head to the saddle-bow;
If thou wilt deign this favour, for thy meed
A thousand honey secrets shalt thou know:
Here come and sit, where never serpent hisses;
And being set, I'll smother thee with kisses:

'And yet not cloy thy lips with loathed satiety,
But rather famish them amid their plenty,
Making them red and pale with fresh variety;
Ten kisses short as one, one long as twenty:
A summer's day will seem an hour but short,
Being wasted in such time-beguiling sport.'
…

Look! how a bird lies tangled in a net,
So fasten'd in her arms Adonis lies;
Pure shame and aw'd resistance made him fret,
Which bred more beauty in his angry eyes:
Rain added to a river that is rank
Perforce will force it overflow the bank.

'Art thou asham'd to kiss? then wink again,
And I will wink; so shall the day seem night;
Love keeps his revels where there are but twain;
Be bold to play, our sport is not in sight:
These blue-vein'd violets whereon we lean
Never can blab, nor know not what we mean.
…

Who sees his true-love in her naked bed,
Teaching the sheets a whiter hue than white,
But, when his glutton eye so full hath fed,
His other agents aim at like delight?

Who is so faint, that dare not be so bold
To touch the fire, the weather being cold?

Venus and Adonis, WILLIAM SHAKESPEARE

Unfortunate Coincidence
By the time you swear you're his,
Shivering and sighing,
And he vows his passion is
Infinite, undying –
Lady, make a note of this:
One of you is lying.

DOROTHY PARKER (1893–1967)

'LAY DOWN THE TREASURES OF YOUR BODY'

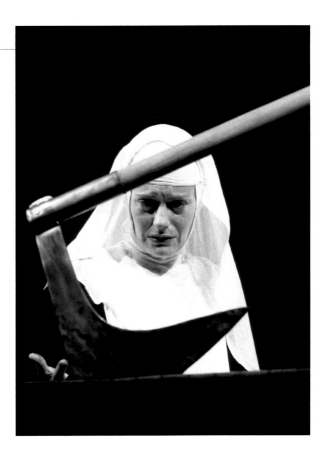

ANGELO: Who will believe thee, Isabel?
My unsoil'd name, the austereness of my life,
My vouch against you, and my place i' the state,
Will so your accusation overweigh,
That you shall stifle in your own report
And smell of calumny. I have begun,
And now I give my sensual race the rein:
Fit thy consent to my sharp appetite;
Lay by all nicety and polixious blushes,
That banish what they sue for; redeem thy brother
By yielding up thy body to my will,
Or else he must not only die the death,
But thy unkindness shall his death draw out
To lingering sufferance. Answer me to-morrow,
Or, by the affection that now guides me most,
I'll prove a tyrant to him. As for you,
Say what you can, my false o'erweighs your true.

Act 2, Scene 2, *Measure for Measure*, WILLIAM SHAKESPEARE

In Shakespeare's play *Measure for Measure*, the Duke of Vienna temporarily resigns his position to avoid enforcing the laws of chastity and leaves his Deputy Angelo as the interim ruler of the city to enforce a law that fornication is punishable by death. Serving as an example to other Viennese citizens, Angelo's first act is to imprison Claudio, for impregnating Julietta, his lover, before they were married, and sentences him to death. This deeply upsets Claudio's sister Isabella, a chaste and novice nun and she pleads to Angelo for her brother's life, but he is so obsessed by her beauty and purity that he offers to spare Claudio only if she will sleep with him. 'Lay down the treasures of your body.' She refuses but he insists she must decide by the next day between Claudio's death and her virginity. Lust, in a supreme act of hypocrisy, transforms the prosecutor of unlawful sexual activity to a perpetrator.

Anastasia Hille (Isabella) in *Measure for Measure*, Lyric Theatre, 1994.

AND WITH YOUR PASTIME LET THE BED-STEAD CREAKE'

'What madnesse ist to tell nights pranckes by day?
And hidden secrets openly to bewray?
The strumpet with the stranger will not doo,
Before the roome be cleere, and dore put too.
Will you make ship-wrack of your honest name?
And let the world be witnesse of the same.
Be more aduisde, walke as a puritan,
And I shall think you chaste, do what you can.
Slip still, onely deny it, when 'tis done,
And before folke immodest speeches shunne.
The bed is for lasciuious toyings meete,
There use all tricks, and tread shame under feete.

When you are up, and drest, be sage and graue,
And in the bed hide all the faults you haue.
Be not asham'de to strip you being there,
And mingle thighes yours ever mine to beare.
There in your Rosie lips my tongue-in-tombe,
Practise a thousand sports when there you come.
Forbeare no wanton words you there would speake,
And with your pastime let the bed-stead creake.

Ovid's Elegies, Book 3, Elegy 13, OVID (43 BC–17 AD)
Translated by Christopher Marlowe.

The Lovers,
Giulio Romano, *c.* 1525.

'OH MY AMERICA, MY NEW FOUND LANDE' 1633

To His Mistress Going to Bed

Off with that girdle, like heaven's Zone glistering,
But a far fairer world encompassing.
Unpin that spangled breastplate which you wear,
That th'eyes of busy fools may be stopped there.
Unlace yourself, for that harmonious chime,
Tells me from you, that now it is bed time.
Off with that happy busk, which I envy,
That still can be, and still can stand so nigh.
Your gown going off, such beauteous state reveals,
As when from flowery meads th'hill's shadow steals.
Off with that wiry Coronet and shew
The hairy Diadem which on you doth grow:
Now off with those shoes, and then safely tread
In this love's hallow'd temple, this soft bed.

...

Licence my roving hands, and let them go,
Before, behind, between, above, below.
O my America! my new-found-land,
My kingdom, safeliest when with one man mann'd,
My Mine of precious stones, My Empirie,
How blest am I in this discovering thee!
To enter in these bonds, is to be free;
Then where my hand is set, my seal shall be.
Full nakedness! All joys are due to thee,
As souls unbodied, bodies uncloth'd must be,
To taste whole joys ...

...

... Then since that I may know;
As liberally, as to a Midwife, shew
Thy self: cast all, yea, this white linen hence,
There is no penance due to innocence.
To teach thee, I am naked first; why then
What needst thou have more covering than a man.

JOHN DONNE (1572–1631)

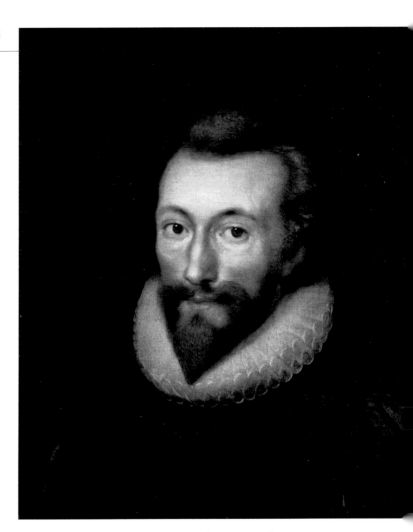

John Donne, after Isaac
Oliver, late 17th century.

In 1602 John Donne was elected an MP, however he fell out of favour with King James and was urged to take holy orders. Aged forty-three he was ordained in the Church of England. His advancement in the church was rapid, he became a celebrated preacher and the Dean of St Paul's in 1621. Donne did not write poetry for publication and only seven poems were published during his lifetime – the poems he released were circulated in manuscript to his friends. In 1633, two years after his death, the first printed edition of his work was published. He is now recognised as one of Britain's foremost metaphysical poets. While the composition date of his poems is not really known, it has been assumed that most of his religious poems were written rather late in his life, whereas his love poems were earlier. Some are very tender and others notable for eroticism. 'To His Mistress Going to Bed', must be one of the most erotic poems written in English, in which he poetically undresses his mistress. Never has lust been so eloquent.

JOHN WILMOT, 2ND EARL OF ROCHESTER (1647–1680)

Rochester was the most celebrated rake at the court of Charles II. He had many lovers, both female and male, and by the age of thirty-two he retired to his country estate to die from tertiary syphilis. His back was covered with sores, he urinated blood, and when an ulcer burst in his bladder it contained pus. In his suffering his sharp mind lapsed occasionally into incoherence. In *The Imperfect Enjoyment* he enraged:

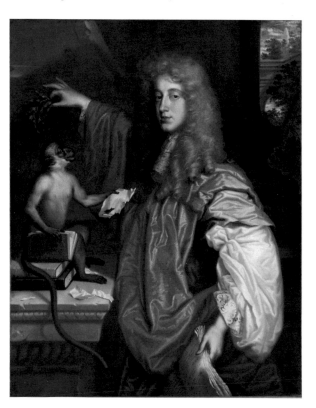

John Wilmot, 2nd Earl of Rochester, Jacob Huysmans, *c.* 1665–70.

> Mayst thou to ravenous chancres be a prey,
> Or in consuming weepings waste away;

The Debauchee

I rise at Eleven, I dine about Two,
I get drunk before Sev'n; and the next Thing I do,
I send for my Whore, when, for fear of a *Clap*,
I – in her Hand, and I spew in her Lap;
Then we quarrel and scold, till I fall fast asleep,
When the Bitch, growing bold, to my Pocket does creep;
Then slily she leaves me, and, to revenge the Affront,
At once she bereaves me of Money and –
If by Chance then I wake, hot-headed and drunk,
What a Coil do I make for the Loss of my Punk?
I storm, and I roar, and I fall in a Rage,
And missing my Whore, I B--r my Page.
Then, Crop sick all Morning, I rail at my Men,
And in Bed I lie yawning till Eleven again.

JOHN WILMOT, 2ND EARL OF ROCHESTER

NELSON SUCCUMBS

Dresden, 3 October 1800

It is plain that Lord Nelson thinks of nothing but Lady Hamilton, who is totally occupied by the same object. She is bold, forward, coarse, assuming, and vain. Her figure is colossal, but, excepting her feet, which are hideous, well-shaped. Her bones are large, and she is exceedingly *embonpoint*. She resembles the bust of Ariadne; the shape of all her features is fine, as is the form of her head, and particularly her ears; her teeth are a little irregular but tolerably white; her eyes light blue, with a brown spot in one, which, though a defect, takes nothing away from her beauty or expression. Her eyebrows and hair are dark, and her complexion coarse. Her expression is strongly marked, variable, and interesting; her movements in common life ungraceful, her voice loud, yet not disagreeable. Lord Nelson is a little man, without any dignity... Lady

Dido in Despair,
James Gillray's portrait of
Lady Hamilton, 6 February
1801.

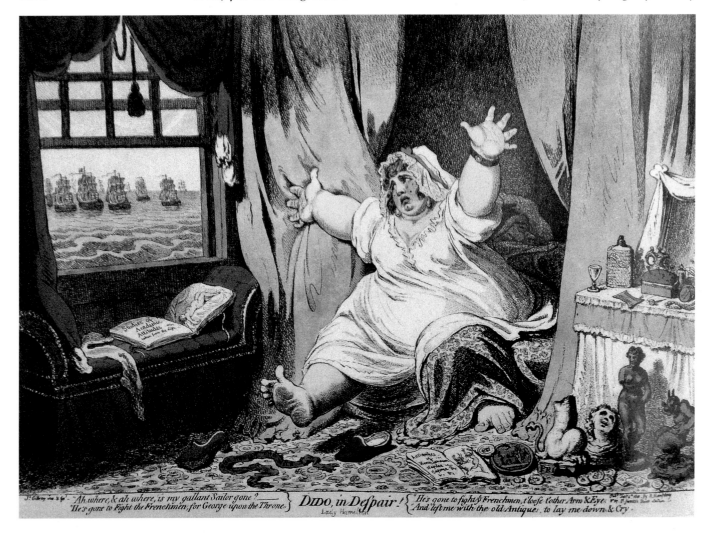

Hamilton takes possession of him, and he is a willing captive, the most submissive and devoted I have seen. Sir William is old, infirm, and all admiration of his wife, and never spoke to-day but to applaud her... After dinner we had several songs in honour of Nelson, written by Miss Knight, and sung by Lady Hamilton. She puffs the incense full in his face; but he receives it with pleasure, and snuffs it up very cordially. The songs all ended in the sailor's way with 'Hip, hip, hip, hurra,' and a bumper with the last drop on the nail – a ceremony I had never heard of or seen before.

The Remains of the Late Mrs Richard Trench, Being selections from her journals, letters, & other papers, MRS RICHARD TRENCH (1768–1827)
Edited by her son, Richard Chenevix Trench.

Regretting Nelson's promotion to Vice-Admiral as he had to go to sea, Lady Hamilton gave birth to a daughter, Horatia, on 31 January 1801.

CLERICAL RAPE

'Can I relinquish these limbs so white, so soft, so delicate; These swelling breasts, round, full, and elastic! These lips fraught with such inexhaustible sweetness? Can I relinquish these treasures, and leave them to another's enjoyment? No, Antonia; never, never! I swear it by this kiss, and this! and this!'

With every moment the friar's passion became more ardent, and Antonia's terror more intense. She struggled to disengage herself from his arms: Her exertions were unsuccessful; and finding that Ambrosio's conduct became still freer, she shrieked for assistance with all her strength. The aspect of the vault, the pale glimmering of the lamp, the surrounding obscurity, the sight of the tomb, and the objects of mortality which met her eyes on either side, were ill-calculated to inspire her with those emotions by which the friar was agitated. Even his caresses terrified her from their fury, and created no other sentiment than fear. On the contrary, her alarm, her evident disgust, and incessant opposition, seemed only to inflame the monk's desires, and supply his brutality with additional strength. Antonia's shrieks were unheard; yet she continued them, nor abandoned her endeavours to escape, till exhausted and out of breath she sank from his arms upon her knees, and once more had recourse to prayers and supplications. This attempt had no better success than the former. On the contrary, taking advantage of her situation, the ravisher threw himself by her side. He clasped her to his bosom almost lifeless with terror, and faint with struggling. He stifled her cries with kisses, treated her with the rudeness of an unprincipled barbarian, proceeded from freedom to freedom, and in the violence of his lustful delirium, wounded and bruised her tender limbs. Heedless of her tears, cries and entreaties,

A Monk Seducing a Woman in the 14th century after Joseph Guillaume Bourdet, 19th century.

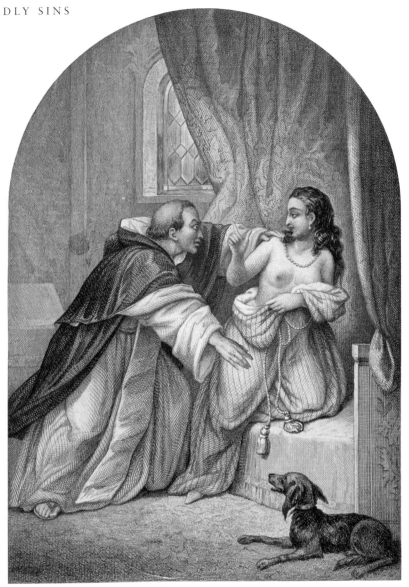

He gradually made himself master of her person, and desisted not from his prey, till he had accomplished his crime and the dishonour of Antonia.

Scarcely had he succeeded in his design than he shuddered at himself and the means by which it was effected.

The Monk: A Romance, MATTHEW GREGORY LEWIS (1775–1818)

Friar Ambrosio is the saintly superior of the Capuchins in Madrid, who is led off the straight and narrow by a wanton who gets into his monastery disguised as a boy novice. Once his soul is corrupted there is nothing that can stop him. The object of his desire is Antonia, one of his penitents, who he rapes and then kills. He is arrested and tortured by the Inquisition. He continues to proclaim his innocence hoping for God's pardon but the Devil, with whom he has made a pact, tells him there is none and his soul is eventually claimed by the Devil himself.

MRS BOND: A RIGHT-DOWN RUMMY DITTY, 1837

Air – *Will you come to the bower?*

Oh, I'm getting still more hot for you, my charming Mrs Bond,
And though you will not smile on me, I never will despond.
The moment when I write to you, indeed quite stiff I stand,
And – all that I possess is sweating in my hand.
Then won't you let me, won't you let me – tickle you, Mrs Bond?
Even randy little duchesses have lured me to their arms
And crumby little countesses have yielded me their charms.
Then, only give me leave to go a fishing in your pond,
I've got a rod so long and strong, and such fine bait, Mrs Bond.

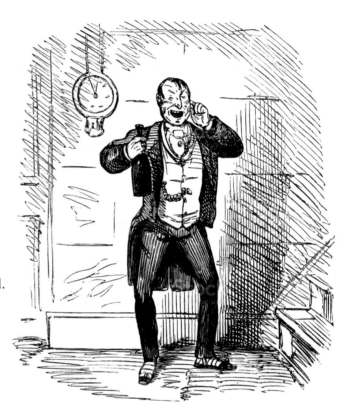

Every morning I view you at your toilette when you rise,
And watch the towel's motion as you wash your lovely thighs.
I pray for some enchantress to transform me with her wand,
To the chamber pot you hold betwixt your thighs, sweet Mrs Bond.
If the gods would grant my wishes and accomplish my request,
I'd seek to be a flea, to skip upon your breast,
Or, I'd pray to be a petticoat, of flannel or of blond,
To chafe your panting belly and your bubbies, Mrs Bond.
Then wont' you let me, won't you let me – tickle you, Mrs Bond?
At eve I seek the privy, which your presence may have blest,
And kiss the very timber which your lilly duff has prest.
Even the very paper on which I write this *billet-doux*,
It is gilt-edge, you see, by being s—t upon by you.
Even in my sleep I hourly am attacked.
My laundress and night shirt can testifye the fact.
My passions are so hot and so exquisitely fond,
My very f—ts have learned to trump the praise of Mrs Bond.
Then won't you let me, won't you let me – tickle you, Mrs Bond?

Mrs Bond, you must forgive me, but indeed I cannot wait,
So you'd better ope your pretty mouth and swallow all my bait.
There's one reflection left, to solace me beyond:
I'll never go a fishing, if it's not in your pond.
Then wont' you let me, won't you let me – tickle you, Mrs Bond?
Won't you let me, won't you let me – go, a fishing in your pond?

J.H.L.
(No further details known)

Taken from *The Ri-Tum Ti-Fum Songster: A Slashing, Dashing, Leary, Frisky, and Delicious Collection of Gentlemen's Songs, Etc.*

THE WAGES OF SIN

The Ruined Maid

'O 'Melia, my dear, this does everything crown!
Who could have supposed I should meet you in Town?
And whence such fair garments, such prosperi-ty?' –
'O didn't you know I'd been ruined?' said she.

– 'You left us in tatters, without shoes or socks,
Tired of digging potatoes, and spudding up docks;
And now you've gay bracelets and bright feathers three!' –
'Yes: that's how we dress when we're ruined,' said she.

– 'At home in the barton you said thee' and thou,'
And thik oon,' and theäs oon,' and t'other'; but now
Your talking quite fits 'ee for high compa-ny!' –
'Some polish is gained with one's ruin,' said she.

– 'Your hands were like paws then, your face blue and bleak
But now I'm bewitched by your delicate cheek,
And your little gloves fit as on any la-dy!' –
'We never do work when we're ruined,' said she.

– 'You used to call home-life a hag-ridden dream,
And you'd sigh, and you'd sock; but at present you seem
To know not of megrims or melancho-ly!' –
'True. One's pretty lively when ruined,' said she.

– 'I wish I had feathers, a fine sweeping gown,
And a delicate face, and could strut about Town!' –
'My dear – a raw country girl, such as you be,
Cannot quite expect that. You ain't ruined,' said she.

THOMAS HARDY (1840–1928)

*Reclining nude and
Picasso sitting,*
Pablo Picasso, 1902.

Past and Present, No. 1,
Augustus Leopold Egg, 1858.

Hardy's 'Ruined Maid' might have been a prostitute but it is more likely she was a kept woman, for they were quite a feature in Victorian England. Charles Dickens, Wilkie Collins and George Cruikshank, the great illustrator, all had a kept woman. The painter Augustus Leopold Egg painted a trilogy on the theme of a fallen woman. *Past and Present, No. 1,* is the first in the trilogy. The husband has discovered his wife's infidelity in a love letter from or to another man. She lies prostrate at her husband's feet accepting her fate. The room is full of symbols including a house of cards which is tumbling down.

Fallen women were considered dangerous by Victorian society because they had abandoned respectability and experienced sexual pleasure outside marriage. Adultery

was thought to be far more serious for a woman than a man and a threat to the very basis of society. In his second painting of the trilogy Egg shows the two grown-up daughters at night in their chamber a fortnight after the death of their father. They are living in poverty, praying for their lost mother. In the third painting the mother is depicted on the same night as her daughters in painting two. She is destitute and taking refuge under an arch near the River Thames. Under her shawl she shelters a child born of her adultery.

The fallen woman was the guilty one, while the lover walked away scot free. The 1839 Custody of Infants Act forbade a woman convicted of adultery from seeing her children. This was because she could assert an immoral influence upon them. In such circumstances her children were taken away and sent to a Foundling Hospital. In Victorian England, the lust of the lover and seducer escaped the law. The Matrimonial Causes Act of 1857 allowed men to divorce their wives for adultery while the husband's adultery had to be coupled to another misdemeanour.

The beginning of the end.

PROSTITUTION

A letter from Flaubert to his lover, Louise Colet, 1853

> It may be a perverted taste, but I love prostitution, and for itself, too, quite apart from its carnal aspects. My heart begins to pound every time I see one of those women in low-cut dresses walking under the lamplight in the rain, just as monks in their corded robes have always excited some deep, ascetic corner of my soul. The idea of prostitution is a meeting place of so many elements – lust, bitterness, complete absence of human contact, muscular frenzy, the clink of gold – that to peer into it deeply makes one reel. One learns so many things in a brothel, and feels such sadness, and dreams so longingly of love!

Flaubert's friend Maxime Du Camp took a more moralistic view on prostitution, writing of the activity in the third volume of his great work on Paris, *Paris: ses organes, ses fonctions et sa vie (1869–75)*:

> ...the chronic, morbid phenomena which are inherent in our species. The brutality of male passions, and the organic and moral weakness of women, have produced the same results, in every age and in every culture.

In a recent study of Athenian prostitution published by the Oxford University Press, Edward Cohen comments, 'Athenian poetry is replete with portrayals that have been identified as brothel scenes.' There was a great deal of commercial sex in Athens.

PHOTOGRAPHS FROM THE NEW ORLEANS RED-LIGHT DISTRICT

Around 1912

The photographer E.J. Bellocq died in New York in 1947 unknown and neglected, but eighty-nine glass plate negatives of portraits of female prostitutes in the Storyville red light district of New Orleans dating from 1912 were found in his desk. Another photographer, Lee Friedlander, acquired them, held an exhibition and published a book in 1971 of Storyville prostitutes. In 1996, Susan Sontag, the writer and activist, wrote the introduction to *Bellocq: Photographs from Storyville*.

Storyville Portrait, E.J. Bellocq *c.* 1912.

There is no clue as to why Bellocq took these photographs, possibly a commercial project, but they do not seem to have appeared amongst other images of that sort taken at that time.

It is a quite remarkable collection. The girls he photographed were not haggard, drug-ridden old harlots, although there were opium dens in New Orleans at that time which he had also photographed. Sadly, these latter plates have disappeared. The girls seem to be in their early twenties, some of the prostitutes are fully naked, some masked and some are seated in the elaborate settings of a brothel. Some are smiling looking cheerful and relaxed, proud of their work, happy to display their charms and be recorded for all time.

A good photographic portrait usually results from a successful collaboration between the photographer and the sitter. In these works, Bellocq manages to establish a good relationship with each of these girls. Perhaps made possible by the long exposure time necessary in 1912 for the plates.

PARTY PIECE

The One Night Stand

He said:
'Let's stay here
Now this place has emptied
And make gentle pornography with one another,
While the partygoers go out
And the dawn creeps in,
Like a stranger.

Let us not hesitate
Over what we know
Or over how cold this place has become,

But let's unclip our minds
And let tumble free
The mad, mangled crocodile of love.'

So they did,
There among the woodbines and guinness stains,
And later he caught a bus and she a train
And all there was between them then
was rain.

BRIAN PATTEN (*b.* 1946)

'A POET OF COMRADELY LOVE', 1982

The Miracle

'Right to the end, that man, he was so hot
That driving to the airport we stopped off
At some McDonald's and do you know what,
We did it there. He couldn't get enough.'
'There at the counter?' – 'No, that's public stuff:

'There in the rest room. He pulled down my fly,
And through his shirt I felt him warm and trim.
I squeezed his nipples and began to cry
At losing this, my miracle, so slim
That I could grip my wrist in back of him.

'Then suddenly he dropped down on one knee
Right by the urinal in his only suit
And let it fly, saying Keep it there for me,
And smiling up. I can still see him shoot.
Look at that snail-track on the toe of my boot.'

Thom Gunn in San
Francisco, 1996.

– 'Snail track?' – Yes, there.' – 'That was six months ago.
How can it still be there?' 'My friend, at night
I make it shine again, I love him so,
Like they renew a saint's blood out of sight.
But we're not Catholic, see, so it's all right.'

THOM GUNN (1929–2004)

AND I LOUNGED AND LAY ON THEIR BEDS

When I went to that house of pleasure
I didn't stay in the front rooms where they celebrate,
with some decorum, the accepted modes of love.

I went into the secret rooms
and lounged and lay on their beds.

I went into the secret rooms
considered shameful even to name.

But not shameful to me – because if they were,
what kind of poet, what kind of artist would I be?
I'd rather be an ascetic. That would be more in keeping,
much more in keeping with my poetry,
than for me to find pleasure in the commonplace rooms.

CONSTANTINE P. CAVAFY (1863–1933)
Translated by Edmund Keeley and Philip Sherrard.

Self Portrait with Costas,
Lesbos, *Shades of Love –*
Photographs Inspired by the
Poems of Cavafy by Dimitris
Yeros, 2001.

LUST LEADING TO PUBLIC DOWNFALL

Lord Sewell, the Deputy Chairman of the House of Lords, had the habit of calling in prostitutes to his flat in Dolphin Square, a huge apartment block close to Parliament. Two of the prostitutes in 2014 secretly filmed him sniffing up cocaine, wearing a red bra and appearing totally naked boasting of his sexual prowess; stupidly vainglorious. The *Sun* had arranged the story and dubbed him 'Lord Sewer' and 'Lord Coke'. Within two days of the story breaking he had to resign his post and leave the Lords.

Many politicians have ruined their careers by letting lust run free. In 1886 a leading Liberal and a potential leader, Sir Charles Dilke, was cited in a divorce action as the lover of Virginia Crawford, the wife of an MP. It emerged that he had also had an affair with her mother and there were rumours of three-in-a-bed.

In the twentieth century Cecil Parkinson, Chairman of the Conservative Party and former Cabinet Minister of Margaret Thatcher had to resign when his mistress revealed in *The Times* that he was the father of her daughter.

In September 2016, the *Sunday Mirror* revealed that Keith Vaz, the MP for Leicester East, Chairman of the Home Affairs Select Committee in the House of Commons and

Front covers of the *Sun*, 27 July 2015 and the *Sunday Mirror*, 4 September 2016.

a former Minister for Europe, posing as a washing machine salesman called Jim, had hired two male prostitutes from Eastern Europe. Their conversation which was recorded revealed that he offered to pay fifty pounds for each male prostitute they supplied and that he offered to take them to Moscow with more escorts. The very explicit conversation of their second meeting was made available on the internet. Within three days Vaz had to resign as Chairman of the Home Affairs Select Committee which had been overseeing an inquiry into prostitution laws so that soliciting and brothel-keeping were decriminalised. Vaz remained an MP but his reputation was permanently damaged.

LUST AND THE YOUNG, 2005

In 2005 the Economic Social Research Council published a research publication on *The Seven Deadly Sins: A new look at society through an old lens*, using the very large databases like the British Household Panel Survey, The Three Birth Cohort Studies, The British Election Study and many related studies, which allowed them to take an unconventional look at the deadly seven. On avarice they looked at executive pay in the United States; on pride they explored attitudes of pride and prejudice amongst the

A survey by the French polling institute (Ifop) in 2016 found that 44% of Parisian men confessed to having sex with someone without knowing their name.

Protestant and Catholic Communities in Northern Ireland, and on sloth they examined the growing voter apathy in recent elections.

For lust they explored trends in sexual activity through the National Survey of Sexual Attitudes and Lifestyles. They discovered that during the period from 1950 until 2000 there was a significant increase in sexual activity among the young. 'For men and women reaching sexual maturity in the 1950s the average age at first intercourse was twenty and twenty-one respectively. But by the mid-1990s it was sixteen for both sexes.' The change from the 1930s was even more marked, 39% of women and 14% of men born in the early 1930s married before having sexual intercourse and a further 14% of women and 6% of men were engaged to be married before doing so. Part of the increased sexual activity resulted from the advent of oral contraception in 1961, making the pill available to single women in 1972 and making pills widely available through the NHS in 1976. Quite apart from this there was also a change in attitude to abortion, to homosexuality, which was decriminalised in 1967 and to divorce, with the passing of the Divorce Reform Act in 1969.

But the studies in 1990 and 2000 noted a countervailing view to this permissive trend, especially regarding sexual relationships outside regular ones. In this instance, four out of five men and women were strongly disapproving of sexual infidelity.

In Paris, however, it was rather different. A survey by the French polling institute (Ifop) in 2016 found that 44% of Parisian men confessed to having sex with someone without knowing their name. It also found that a quarter of Parisians have indulged in group sex, nearly one in six have traded partners at a Swingers' Club (of which there are plenty), and the capital's dwellers now boast of nineteen sexual partners each. Such vigour can possibly only occur in countries where the practice of confession is widespread.

A LOT OF WHAT YOU FANCY DOES YOU GOOD

John Betjeman's statement towards the end of his life that he should have had more sex has been corroborated by a research survey conducted by the Universities of Oxford and Coventry, published in *The Journal of Gerontology* in 2017, which established that more frequent sexual activity is linked to higher cognitive function in older adults. Seventy-three healthy people aged between fifty and eighty-three were asked whether they engaged in sexual activity weekly, monthly or never. Those who were most sexually active scored two percentage points higher in certain tasks than those who had sex monthly, and four points higher than those who never had sex. Apparently sexual activity is linked to the secretion of neuro-hormones such as dopamine or oxytocin that transmit signals to the brain.

Helpless Desire,
Thomas Rowlandson,
c. 1800.

LATE-FLOWERING LUST

My head is bald, my breath is bad,
Unshaven is my chin,
I have not now the joys I had
When I was young in sin.

I run my fingers down your dress
With brandy-certain aim
And you respond to my caress
And maybe feel the same.

But I've a picture of my own
On this reunion night,
Wherein two skeletons are shewn
To hold each other tight;

Dark sockets look on emptiness
Which once was loving-eyed,
The mouth that opens for a kiss
Has got no tongue inside.

I cling to you inflamed with fear
As now you cling to me,
I feel how frail you are my dear
And wonder what will be –

A week? or twenty years remain?
And then – what kind of death?
A losing fight with frightful pain
Or a gasping fight for breath?

Too long we let our bodies cling,
We cannot hide disgust
At all the thoughts that in us spring
From this late-flowering lust.

JOHN BETJEMAN (1906–1984)

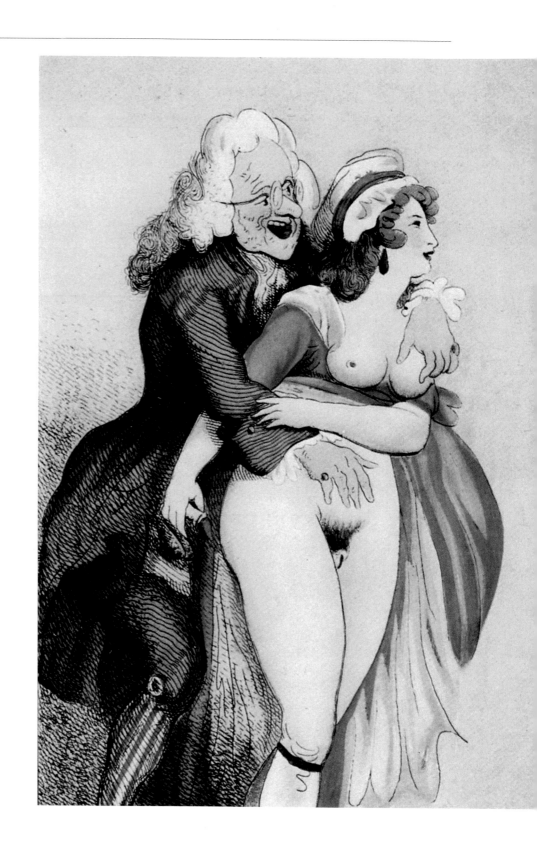

THE PUNISHMENT FOR CARNAL SINNERS

In *The Divine Comedy* Dante portrays carnal sinning as relatively unimportant as it involves two people succumbing to their passion. It might almost be redeemed if it was true love in the first place. But sin it still is and just as lovers drift into it, carried away by their feelings, so they will float in eternity tossed about by gusts of wind.

The Circle of the Lustful: Francescs da Rimini, William Blake, 1826–27.

Into this torment carnal sinners are thrust,
So I was told – the sinners who make their reason
Bond thrall under the yoke of their lust.

Like as the starlings wheel in the wintry season
In wide and clustering flocks wing-borne, wind-borne,
Even so they go, the souls who did this treason,

Hither and thither, and up and down, outworn,
Hopeless of any rest – rest, did I say?
Of the least minishing of their pangs forlorn.

And as the cranes go chanting their harsh lay,
Across the sky in long procession trailing,
So I beheld some shadows borne my way.

The Divine Comedy, The Inferno, Canto V, DANTE ALIGHIERI Translated by Dorothy L. Sayers.

Epilogue

I HOPE THAT YOU HAVE ENJOYED and been interested and amused by this journey through the history of the Seven Deadly Sins. If the early Desert Fathers who first defined and described the temptations that beset all mankind were to be reincarnated today they would, I suspect, after their astonishment at our contemporary civilisation, find that human nature has not changed all that much. Over the last two thousand years the human race has developed physically and intellectually, and created complex societies with new and different patterns of behaviour, but the temptations are still there. Without them life would be dull, banal, unadventurous, boring and unchallenging and each generation has devised different ways either to surrender to or to overcome these challenges.

It was much easier in the earlier centuries when the tenets of a religion and going regularly to a place of worship, and holding a belief in a faith, fashioned human behaviour. Today the more secular, consumerist, individualist culture of the Western world has to fashion new ways, new incentives and recognise the punishments to cope with the crooked timber of humanity. It is all the more difficult as half of the world becomes less religious and the other half more.

I hold it to be the inalienable right of anybody to go to hell in his own way.
ROBERT FROST (1874–1963)

Index

Illustration Credits

Endpapers: *A Little Tighter* © the author; *A Little Bigger* © the author; Frontispiece: *Contemplating Ruin* © Mary Evans Picture Library; Title Page: *Demon pushing the Damned* © The British Library Board, All Rights Reserved (Yates Thompson 13 f. 139v); Frontispiece: Berners Hours, *Adam and Eve* Goucher College Special Collections & Archives; p4: *Hell – Dieric Bouts* © Palais des Beaux-Arts de Lille; Bernard Quaritch 7DS catalogue Reproduced with the permission of Bernard Quaritch;p6: Adolf Hitler & Japanese Foreign Minister preparing to invade Russia & Pearl Harbour Getty Images; p7: *The Shag* Reproduced with the permission of Peter Brookes; p8: *Red Carpet Treatment* Reproduced with the permission of Peter Brookes; p9: *Devil Presenting Saint Augustine with The Book of Vices* © Alte Pinakothek, Munich; p10: *The Torment of Saint Anthony* © Kimball Art Museum, Fort Worth, Texas; p12: Devil appears over a man in his deathbed © The British Library Board, All Rights Reserved (Arundel MS 484 BL); Powers of the Cross protect St Anthony, from The Devil, Genevieve and Tom Morgan © Chronicle Books; p13: Tympanum of Cathedral of Autun © Adrian Fletcher; p15: Yanluo, King of Hell © Bernard Quaritch Ltd; pp16–17: *The Orgy, Rake's Progress* Sir John Soane Museum; p18: *Recovery of a Dormant Title or a Breeches-Maker become a Lord* © the author; p20: *The Fall of Icarus* © Prado Museum; p22: *Belshazzar's Feast* © National Gallery London; p25: Paradise Lost, Book I, 44–49 © The University of Adelaide Library; p26: *Pope Julius II, 1503–1513* © National Gallery London; p29: *Alfonso II d'Este* © Prado Museum; p31: *The Duchess of Malfi* Alamy Stock Photo; p33: David Suchet as Augustus Melmotte © Sanna at Bricksite.com; p34: *Godolphin Horne* © Lisa Ripperton at mainlesson.com; p36: Jonathan Aitken © PA Images, Stefan Rousseau; p39: Hilter and Matsuoka reception Getty Images; p41: Iraq "We did it our way" © Peter Schrank; p42: BREXIT – Cameron and Johnson as wasp © Dave Brown; p43: *The Drawings for Dante's Divine Comedy* (Giants) detail from *Inferno* Canto xxx1 © Kultur Forum, Berlin; p44: The Colonel implores his daughter to be reasonable © H M Bateman Designs Ltd; Anger from *The Table of the Seven Deadly Sins and the Four Last Things* © Prado Museum; p48: *The Vengeance of Orestes*, from 'A Vision of Greece' Bridgeman Images; p49: Woodcut vignette of *Alboin*, Nuremburg Chronicle © Cambridge University Library; p53: *King Lear* Reproduced with the permission of the Furness Theatrical Image Collection Kislak Center for Special Collections, Rare Books and Manuscripts University of Pennsylvania; p55: The Poison Tree © Trustees of the British Museum; p56: *Portrait of William Hazlitt* © National Portrait Gallery; p58: Trollope holding the Dean © The Trollope Society; p59: *Portrait of William Makepeace Thackeray* © National Portrait Gallery, London; p61: *The Marquis of Steyne* from *Vanity Fair* © Victorian web.org; p62: *Maud* © Eleanor F Brickdale; p64: *Trust no Fox on Green Heath and no Jew on this Oath* (cover page) © The National Holocaust Centre and Museum; pp64–65: *Trust no Fox on Green Heath and no Jew on this Oath* (inside pages) © The National Holocaust Centre and Museum; p66: Sir John Reith Alamy Stock photo; p69: The End of the affair Alamy Stock photo; p70: Jerzy Bohdan Szumczyk Getty Images; p72: Two young Fulani men © Reuters, Joe Penney; Christians protesting at the murder of Shahbaz Bhatti © Reuters, Mian Khursheed; p73: ISIS crucifixions; p74: King Aethelbert © The British Library Board, All Rights Reserved (BL Cotton MS Claudius D VI); pp74–75: The sin of anger is punished in Hell by impaling, Le grant kalendrier des Bergiers © Nicolas le Rouge; p76: *Gone Fishing* © Searle Estate; p79: *The Land of Cockaigne* © Alte Pinakothek, Munich; pp79–80: Desidia, *Sloth* Albertina,

Vienna; p81: John Bunyan, *Pilgrim's Progress* © Prawny Vintage; p82: *Specimen of Moral Songs, The Sluggard* © Isaac Watts; pp83–86: *Fate of the Idle 'Prentice* © Hogarth's Graphical Works; p86: *Edward Gibbon* © National Portrait Gallery, London; *Magdalen College, Oxford* © Wellcome Images; p88: *Mr Skimpole facing arrest by a debt collector* © Victorian web.org; p90: *Say I'm Busy* © Punch; p91: *Lotus-eaters* Reproduced with the permission of Genie Melisande; p93: *Utopia, Limited, or the Flowers of Progress* © Alice Havers; p95: *In Praise of Idleness* dustjacket © George Allen & Unwin Ltd; p97: *Sloth, Interior with Sleeping Maid and her Mistress (The Idle Servant)* © National Gallery, London; p99: Marlene Dietrich in *Stage Fright* © Everett Collection; p100: *Evelyn Waugh* © Douglas Glass; p103: *Tobacco shareholders and his children* Library of Congress, Prints & Photographs Division, FSA/OWI Collection, LC-USF34-019737-E [P&P] LOT 1498, Dorothea Lange; p104: *The Pupil who excelled his master* © H M Bateman Designs Ltd; p106: Billy Budd and Claggart Reproduced with the permission of ArenaPAL, Clive Barda; p108: *Ignore them. It's just the politics of envy* Reproduced with the permission of Jacky Fleming; p109: *Cain Slaying Abel* © Courtauld Gallery, London; p110: *The First Mourning* © Museo Nacional de Bellas Artes, Buenos Aires; p111: Tomb of Jacopo di Ranuccio Castelbuono, Bishop of Florence © Museo Bardini; p114: Chiwetel Ejiofar as Othello. Ewan McGregor as Iago Alamy Stock photo;p115: Billy Budd and Claggart Everett Collection Inc / Alamy Stock Photo; p117: Tattycoram, *Little Dorrit* © Victorian web.org; p119: From *Under the Deodars* © Messrs. A. H. Wheeler & Co; p120: Snow White and the Wicked Witch: Alamy Stock Photo; p121: Goebbels Fire Speech © FTD; p123: how to spend it (cover page) *Financial Times* how to spend it magazine January 2017. Used under licence from the Financial Times. All Rights Reserved; how to spend it (inside page) *Financial Times* how to spend it magazine January 2017. Used under licence from the Financial Times. All Rights Reserved. ; p124: Clive James © fairfaxmedia; p125: The Schismatics and Sowers of Discord: *Mosca de' Lamberti and Bertrand de Born* © National Gallery of Victoria, Melbourne Felton Bequest, 1920; p126: *The Money Bag* Bridgeman Images; pp128–129: *The Tax Collectors* © Liechtenstein Collection, Vienna; p131: *Christ Driving the Moneylenders out of the Temple* © Gemäldegalerie, Berlin; p133: *The King's Wine Turns into Gold* Bridgeman Images; p134: *Volpone* © Aubrey Beardsley; p135: *The Money Changer and His Wife* © Louvre, Paris; p136: Tulip price index 1636–37 © Jay Henry; *A Satire of the Folly of Tulipmania* © Frans Hals Museum, Haarlem; p139: *South Sea Bubble* Bridgeman Images; p141: *Ignorance and Want* © Victorian web.org; p143: *Mr Merdle becomes a borrower* © Victorian web.org; p144: Phil Says Relax © KTB/ Eagle Press; p145: *Henry James* © National Portrait Gallery, London; p146: *Panorama (Down with Liebknecht)* © 2015 Estate of George Grosz/Licensed by VAGA, New York; p149: *Harlequin* © Victoria and Albert Museum, London; p151: The Waugh Family Bridgeman Images; p153: Still from the film *The Rocking Horse Winner* Alamy Stock; p155: Still from *Wall Street* Bridgeman Images; p157: *Toads of Property* Bridgeman Images; p159: David Beckham © Dailymail.co.uk; p160: *Hoarders and Wasters* © Cassell, Petter, Galpin & Co. London (1890); p161: *Death and the Miser* © Groeningemuseum, Bruges; p162: *The Last Drop* © the author; p166: Mr Creosote © Monty Python; p167: *Tacuinum Sanitatis* (public domain) ; p168: A German Medieval woodcut from a translation by Heinrich Steinhowel of Boccaccio's *de Mulieribus Claris* (Concerning Famous Women), Circe Rare Book and Manuscript Library – Incunables, Penn Libraries; p169: The

Luttrell Psalter © The British Library Board, All Rights Reserved (MS 42130); p170: In defence of Gluttony, *Tom Jones* Alamy Stock Image; p172: *A Voluptuary Under the Horrors of Digestion* Library of Congress, Prints & Photographs Division, LC-USZC4-3142; p173: *Germans Eating Sour-Krout* © the author; p174: *The Surpriseing Bett Decided* © the author; p175: *L'Arrivée* © Trustees of the British Museum; *Le Départ* © Trustees of the British Museum; p176: *Byron as Don Juan with Haidee* Private Collection; p177: *The Drunkard's Home* Wellcome Images; p178: The effects of Intemperance © National Gallery, London; p179: Barry MacSweeney, 1948–2000 Reproduced with permission of the Barry MacSweeney estate; p181: Albert Finney – *Under the Volcano* Alamy Stock Image; p183: Dustjacket of *Maxim and Fyodor* by Vladimir Shinkarev, Seagull Publishing House, 1980 Reproduced with permission of the Author; Illustration from *Maxim and Fyodor* by Vladimir Shinkarev, Seagull Publishing House, 1980 Reproduced with permission of the Author; p186: *The Gout* © the author; p187: *The Capitalist's Dinner* © New York Review of Books; p188: *Drawings for Dante's Divine Comedy* © The Gemäldegalerie, Berlin; p190: *Contemplating Ruin* © Mary Evans Picture Library; pp192–193: *The Loves of Helen and Paris* © Louvre, Paris; p194: Attic red-figure kalpis representing two satyrs near a sleeping maenad © Musée-Métropole-Rouen-Normandie, Yohann Deslandes; *Rape of Persephone* Bridgeman Images; p195: *The End of Lust* © Maurice Sinet; p196: *Christopher Marlowe* © Corpus Christi College, Cambridge; p197: *Sappho* © Manchester Art Gallery; pp200–201: *Lesbia and her Sparrow* Private Collection; p202: *The Kiss* © Österreichische Galerie Belvedere, Vienna; pp202–203: *Susannah and the Elders* © Schloss Weißenstein collection, Germany; p204: Queen Victoria riding between Melbourne and Palmerston © the author; p205: *Messalina dans la loge de Lisisca* © Agostino Carracci; p206: *The Owl and the Nightingale* © The British Library Board, All Rights Reserved Harley MS 4751, f. 47r; *Medieval Groping* © The British Library Board, All Rights Reserved Royal MS 10E Royal 10 E IV f. 139; p207: *Paolo and Francesca* © Tate, London; pp208–209: *Venus and Adonis* © Prado Museum; p210: Anastasia Hille (Isabella) in *Measure for Measure*, Lyric Theatre © Photostage Ltd, Donald Cooper; p211: *The Lovers* © The State Hermitage Museum, St Petersburg; p213: *John Wilmot, 2nd Earl of Rochester* Private Collection; p214: *Dido in Despair* Gillray's portrait of Lady Hamilton © the author; p216: *Clerical Rape* Bridgeman Images; pp218–219: *Picasso reclining nude* © Museu Picasso, Barcelona. MPB 50.489, Gassull Fotografia; p220: *Past and Present, No.1* © Tate, London; pp222–223: Photograph from New Orleans Red-Light District © E J Bellocq; pp224–225: From *Photographs inspired by the Poems of Cavafy* Reproduced with permission of Dimitris Yeros; p225: Photograph of Thom Gunn © Contemporary Poetry Review; p226: Busted, from *The Sun* © News Syndication; Labour MP Keith Vaz and the Prostitutes at his flat, *Sunday Mirror* © Mirrorpix; p229: *Helpless Desire* © Thomas Rowlandson; p230: Hell, Canto V, carnal sinners © Birmingham Museum and Art Gallery

Selected text sources

p154: Caryl Churchill Taken from *Serious Money* by Caryl Churchill, published by Bloomsbury Methuen Drama, an imprint of Bloomsbury Publishing Plc; p179: Brian MacSweeney, Reproduced with permission of the author; pp183–184: Vladimir Shinkarev, Reproduced with permission of the author; p225: Thom Gunn estate © Faber & Faber

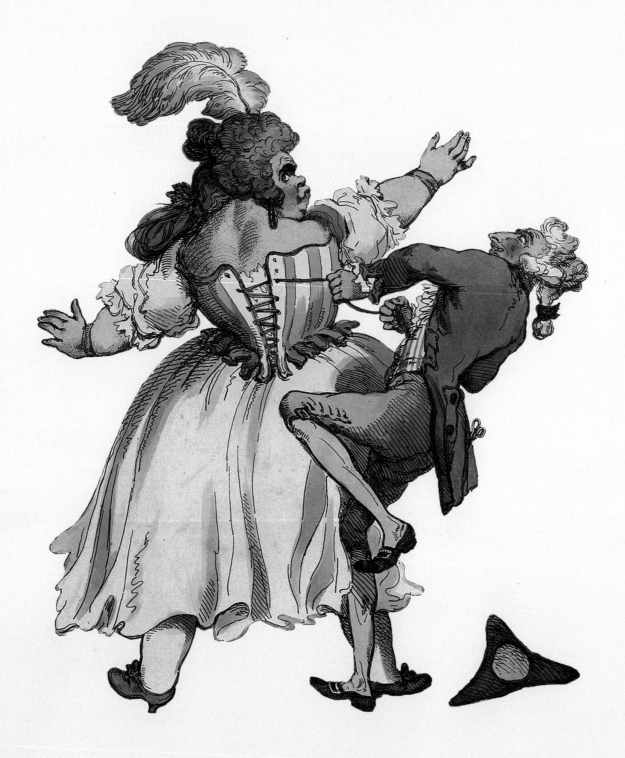

A LITTLE TIGHTER, 1791
Thomas Rowlandson (1757–1827)
Hand-coloured etching